To Mom
with Love
Christmas 1986
From
Chuck + Dede
Holly, Karie + Justin

FLOWER
PAINTING

FLOWER
PAINTING

*25 flower painting projects illustrated step-by-step
with advice on materials and techniques*

Jenny Rodwell

North Light

A QED Book

Copyright © 1985 QED Publishing Ltd

Published in North America by
North Light, an imprint of Writer's Digest Books
9933 Alliance Road
Cincinnati, Ohio 45242

ISBN 0-89134-158-7

This book was designed and produced by
QED Publishing Ltd
The Old Brewery, 6 Blundell Street
London N7 9BH

Senior Editor Jane Rollason
Design Graham Davis, Sarah Collins, Kevin Ryan
Art Editor Marnie Searchwell
Photographers Ian Howes, David Burch

Art Director Alastair Campbell
Editorial Director Jim Miles

Typeset by Text Filmsetters Ltd, Orpington
Color origination by Hong Kong Graphic Arts
Printed by Cayfosa, Barcelona Spain
Dep. Legal B. 24779/85

CONTENTS

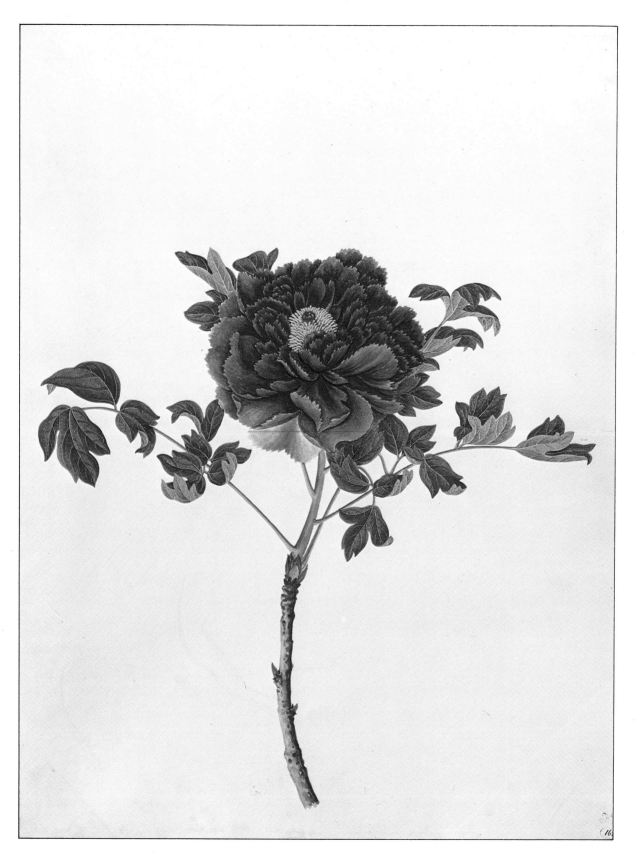

HISTORY AND DEVELOPMENT

Today flower paintings are much sought after and have a place in galleries and art history books the world over. Their tranquillity and timeless content provide islands of peace in a hectic world. Yet centuries of history, medicine, art, religion and human discovery lie behind these colorful facades.

Peony by Chinese artist
(19th century)

Flowers are more varied, more elaborate and more colorful than almost any other subject available to the artist, including the human figure. Compared with much of what we see in our natural surroundings, and most of what we have achieved in our modern, manmade environment, the flower stands out as an object of almost alien beauty.

Yet, paradoxically, the painting of flowers for their own sake has rarely been a main theme in the history of Western art. We know that the Greeks, and later the Romans, decorated their homes with mosaics and frescos of flowers and other still lifes, and there are many beautiful manuscripts surviving from the Middle Ages in which the decorative floral borders and illumination seem to dominate the written content. But apart from the drawings and woodcuts which were used to illustrate the numerous herbal books popular until well into the sixteenth century, there is little in European art that can truly be called flower painting until the advent of the great Flemish and Dutch masters of the late fifteenth and sixteenth centuries.

Only in the East, where it has been popular for at least a thousand years, has the painting of flowers enjoyed consistent artistic status in its own right.

EARLY CHINESE FLOWER PAINTING

In Europe the tendency to paint things naturalistically, that is, to make the image look three-dimensional on a flat surface, died with the late Middle Ages.

But in Asia the concept of naturalism took a more lasting hold. China, for instance, experienced a high standard of naturalistic art in the twelfth century – a field in which flowers played an important part.

The Sung Dynasty (AD960–1279) was particularly famous for its 'flower and bird' paintings, the artists being influenced by Buddhism and the Confucian philosophy, which taught them to revere nature in all its forms. An appreciation of flowers for their own sake, and a striving to be 'at one' with the subject, enabled the Chinese artists of this period to capture the essence and simplicity of flowers in a way which has rarely been achieved since.

HERBAL ILLUSTRATORS IN EUROPE

Strangely enough, it has not been the purely aesthetic motive that has produced the most prolific output in the representation of flowers.

Their medical and practical use has probably accounted for more drawings and paintings of flowers and plants than any higher motive. A host of illustrated books, known as herbals, appeared throughout the Middle Ages in Europe and elsewhere. Many of them had been influenced by the work which long remained the best-known of the herbals – the five-volume herbal by the Greek, Dioscorides, which had been written in the first century AD and was generally acknowledged as an authority on the subject until the seventeenth century.

Dioscorides' herbal was copied many times. The often crude results were typical of the rough imitations which illustrated many of these early books. Most European herbals were illustrated with poor facsimiles of Greek and Roman originals – a regrettable tradition which lasted into the twelfth century. A tendency developed wherein people looked to stylized methods, and copied other pictures, rather than looking at the flowers themselves.

A notable exception to these generally poor products is an Anglo-Saxon herbal produced in Suffolk in 1120. Here the illustrator seems to have worked from real flowers and, although the pictures sometimes bear no relation to the text, the book is designed with a visual awareness unusual for the time.

Because of a widespread belief in herbal remedies, which survives today, medicine and botany remained the same subject for centuries. The center of such studies was Sicily, and later southern Italy, where the Greek tradition had been kept alive by Arabic scholars whose influence persisted there for many years after the Arab invasion of the Mediterranean countries.

It was here, in Salerno, that the *Liber de Simplicibus*, the book of medicinal plants, was compiled. The work was remarkable in its accuracy and originality, and its illustrations – though still rather stylized – pointed the way to the naturalism of the future, and heralded the end of hundreds of years of sterile, derivative flower drawing.

There followed another extraordinary herbal by the Italian, Francesco Carrara, in 1397. Illustrated by an anonymous artist from Padua, the realistic and sensitively expressed pictures were the first convincing flower paintings to emerge from the herbal tradition. Others were quick to accept and match the new standards. There was a surge of superbly illuminated herbals, most of them originating from northern Italy.

The German woodcuts of the fourteenth and fifteenth

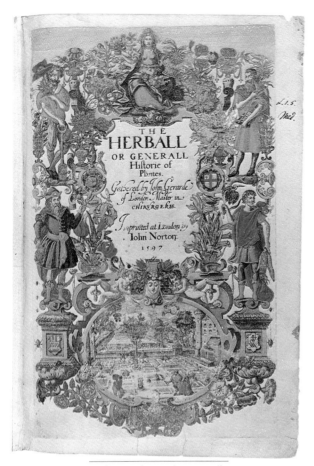

Title page from John Gerard's
The Herball (1597) by William
Rogers. One of the earliest
examples of English
copperplate engraving.

centuries typify the herbals of that country. Particularly influential were the *German Herbarius* (1485) by Peter Schoffer, and Otto Brunfels' *Herbarum Vivae Eicones*. These woodcuts, mainly line drawings done from the actual subject, were simple and elegant with plenty of scope for the hand coloring which was very fashionable at that time, and which was invariably added by the purchaser of the book.

Of the English herbals, John Gerard's *The Herball or Generall History of Plants* (1597) is among the best-known, but by now the herbal tradition was coming to an end. Medicine and botany were emerging as separate study areas, and the need for the homegrown remedy was

beginning to be a thing of the past.

After being in the hands of scientists and doctors for more than 1,500 years, flower painting was at last given a place in the artist's studio.

BOTANICAL ARTISTS

Botanical gardens were started in 1545 in Pisa and Padua. These were the first of many, and soon there were similar establishments springing up throughout Europe. This growing interest in flowers and plants for their own sakes, rather than as useful medicinal cures, underlined the need for some means of classifying the different species. It also increased the demand for accurate visual records.

In 1730, a gardener from the Chelsea Physic Garden in London completed the *Gardener's Dictionary*, an important and serious attempt to catalog and illustrate the increasing number of new plants. Five years later Linnaeus published his *Systema Naturae*, the Latin genus and species classification which is used to this day.

Botany was now established as a rapidly expanding science, and with it came a demand for artists who could illustrate the books and catalogs which accompanied this new knowledge.

One of the most notable flower illustrators of the early eighteenth century was Maria Sybilla Merian. The daughter of a Swiss engraver, Mrs Merian's books on natural history show her to be one of the finest flower painters of her time. Among her most memorable works is a book on the flowers and insects of Surinam, in South America, published in 1705. Mrs Merian, who was 51 when she embarked on this project, spent two years in Surinam.

Another great botanist, whose work was influenced by Linnaeus, was Robert John Thornton, an English doctor. Thornton gave up medicine to devote himself entirely to botany. He spent the rest of his life and all his money on the production of a massive botanical publication, *A New Illustration of the Sexual System of Linnaeus*.

One part of this work, known as the Floral Temple, is better-known than the rest of the book, chiefly because of the exotic and beautiful illustrations. These pictures, which show rare and wonderful flowers against romantic backgrounds, were the work of a team of artists and engravers enlisted and supervised by Thornton himself. Although their work has been criticized as occasionally lacking in scientific accuracy, the originality and artistic merit of the

Gentian from *Choix des plus Belles Fleures* 1827-33 by Pierre-Joseph Redouté (1759-1840). The artist invented his own engraving process.

illustrate the plants in her garden at the Château of Malmaison. This and other subsequent works established Redouté as one of Europe's greatest flower artists – a reputation which has survived until this day. One of the reasons for Redouté's success was undoubtedly the method he used to reproduce his work. This was usually done by skilled craftsmen who used the new stipple engraving, a method of printing which Redouté himself invented, and which enabled tone and color to be reproduced in finely graded dots, instead of the usual, cruder method of cross-hatching.

Although the invention of lithography in the nineteenth century improved the standard of reproduction generally, botanical illustration at this time was at its lowest ebb for 200 years. Possibly this was because of the increase in the number of magazines which accompanied the new enthusiasm for gardening at the beginning of the century, and which demanded speed and a more commercial approach on the part of the artist. Whatever the reason, the result was a sad decline in botanical art, and the elegance and painstaking care of the eighteenth century disappeared for ever.

ARTIST EXPLORERS

From the sixteenth century until the beginning of the seventeenth century, artists accompanied explorers and scientists on voyages round the world. These journeys of discovery, looking for economic resources as well as information about people and natural history of other lands, took artists to the East, to Africa and to the Americas. They came back with specimens and pictures of new plants, many of which were so unusual and exotic that European flowers seemed dull by comparison.

These early expeditions often included an official artist, whose job it was to make maps and to document the local flora and fauna. Among the few works from this time which have not been lost or destroyed are the woodcuts of one trip made to Mexico in the 1570s by the Spaniard, Francisco Hernández. The illustrations by the team of artists on this voyage were published in Hernández' book, *Thesaurus,* almost a century later, and included many flowers which had never before been heard of in Europe – one of which was the first picture of a dahlia.

An expedition to North America in 1564 included the artist, Jacques le Moyne. Although few of le Moyne's original paintings from that trip have survived, one of his later works

illustrations cannot be faulted.

The first truly scientific flower book, which did much to introduce the Linnaeun system, was illustrated by Georg Dionysius Ehret. This book, the *Hortus Cliffortianus* – so called because it was based on the garden of George Clifford, Linnaeus' patron – was actually compiled by Linnaeus. The pictures are in black and white, but the delicacy with which Ehret has drawn the individual parts of the flowers make them a milestone in the history of botanical art.

Although Ehret was probably one of the greatest scientific flower painters in history, his popularity was usurped a generation later by the Frenchman, Pierre-Joseph Redouté. Redouté was employed by the Empress Joséphine to

is of special interest to flower painters – the watercolor miniature, *Daughter of the Picts*, showing a young Ancient Briton painted from head to foot with flowers. Although the figure is highly romanticized, the flowers are the focal point of the picture. They are painted with a realism and imagination which make the painting exceptional in an era which was primarily concerned with discovery and documentation. The inspiration behind them was based on what le Moyne had seen on his North American trip, as well as on his observations in Europe.

A young artist friend of le Moyne's, the Englishman, John White, was appointed official artist on a later expedition to Virginia in North America. Once there, he and a fellow artist, Thomas Harriot, set about painting the strange fruits and flowers which they found along the coastline. Many of their Virginian works have not survived, but other pictures by the two artists give us some idea of the sort of impact these

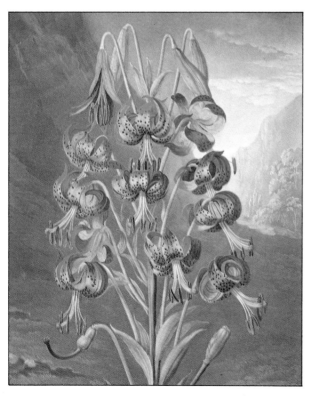

The Superb Lily, a mezzotint from R. J. Thornton's *Temple of Flowers* (1799-1807) was one of the most popular prints in the book.

weird and wonderful discoveries must have had, and how considerably they influenced other painters on their return to the Old World.

As new frontiers opened up, more and more flower paintings found their way back to Europe. During the seventeenth century Maria Sibylla Merian visited South America, bringing back her vivid pictures of Surinam. Francisco Hernandez visited Mexico, making a detailed study of the natural history of the region. Various voyages to North America produced works of hitherto unknown flowers, such as the now familiar sunflower; and the German artists, Hans Eckhout and Engelbert Kaempfer, were taking their talents further afield – Eckhout to Brazil, and Kaempfer to Russia, Ceylon and Japan.

At the beginning of the eighteenth century, many of the flowers throughout the world were known, and pictures of some of them had been published in Europe. There was a widespread interest in the new plants, some of which were introduced into the great European botanical gardens. Gardening became a pastime for the rich, and every garden boasted its latest acquisitions.

The Age of Enlightenment, as this period has since been called, had a beneficial effect on all fields of art and science. Wealthy people were often cultured people, who could afford to pay for the advancement of their knowledge. Artists of the time enjoyed sympathetic patronage, and the wealth of botanical painting done at this time is testimony to the generous support of many of these rich enthusiasts.

One such patron was the president of the Royal Society, Sir Joseph Banks. His special talent was finding artists and scientists, and using them for the work for which they were best suited. It was Banks who sent two artists and two naturalists on Cook's expedition to the South Pacific in the *Endeavour*. The artists, Sydney Parkinson and Alexander Buchan, produced between them more than 6000 drawings during the expedition.

Banks' work continued until his death in 1820, but his influence continued for many years after that because subsequent voyages were organized along the lines he had drawn up.

The German Bauer brothers had particular reason to be grateful to Banks. Francis Bauer was, for many years, a draftsman at Kew Gardens and was responsible for drawing all the plants and flowers which were brought there from expeditions from all over the world – a project

Rocks and Bamboo in Snow by Kao Feng-han (1683-1743), a highly individual Chinese artist who captured nature with just a few brushstrokes.

which was paid for by Banks. The second brother, Ferdinand, joined a voyage to Australia – a country already well established on the botanical map by Banks – where he made an extensive and influential study of local plant life.

FLOWER PAINTING IN THE EAST

If we compare the history of painting in the East with that of the West, the difference in the concept of visual reality becomes apparent.

In the West a realistic painting is one which imitates the subject as faithfully as possible. The light and shade are studiously copied in order to create the illusion of three-dimensional space on a flat surface, and the visible details are considered essential if the picture is to look 'real'.

Realism in Japan and China, however, has a completely different meaning. To an artist from the East, a realistic painting is one which captures the 'essence' of the subject rather than one which attempts to make an exact copy. A feeling of life and movement is the important factor, and this can often be accomplished more effectively with a few brushstrokes than with several hours' work.

The basic contrast in attitudes between East and West is nowhere more important than in the field of flower painting. In Europe, flowers came into art through the meticulous and demanding channels of science; in China and Japan, flower painting developed from a way of thinking – from the idea that nature is something to be

understood and felt and not, as it always was in the West, a collection of items to be analyzed or copied.

In the East, the materials were usually watercolor or ink because these were the most suitable for the flowing, freehand expression of natural forms. Artists often worked with a brush on silk or paper scrolls, applying carefully selected color in supple, suggestive strokes. Because the silk and paper were usually rolled, colors had to be thin and flexible. It was probably for this reason that oil paint has never been popular, and was hardly used at all until the last hundred years.

CHINA

We have already mentioned the high standards of realism, or naturalism, achieved by the artists of the Sung Dynasty in China (AD960-1279). These men were well in advance of their Western counterparts who were just emerging from the Dark Ages, and who still had several hundred years to go until the Renaissance which – with its revival of classical values – encouraged artists to work directly from nature.

The Mongol invasion brought the Sung Dynasty to an end, and official support of the artists who were responsible for beautiful 'bird and flower' paintings came to an abrupt halt. From this time onward, Chinese painters showed less interest in working directly from nature. Their work evolved into a more decorative style as it became necessary to produce art which pleased the rich, private clients of the

new aristocracy.

When the country was eventually restored to the Chinese Ming Dynasty in 1368, artists once again became officially recognized and subsidized, but their art had changed. There was a subdued delicacy and refinement in the new art, but little actual observance of nature, and the minimal brushstrokes and confident realism of earlier days had vanished, giving way to the quiet taste and harmony which was an important factor in Chinese art right through to the nineteenth century.

During these years there were many individual artists in China who did not paint in the official court tradition. One of these was the flower painter, Yun Shou-Ping, who worked in what was sometimes called the 'boneless' tradition – a method of painting which relied on areas of tone and color to define the subject, instead of the fine lines which were generally used. His beautiful flower paintings, done in delicate washes of graded color, were very popular during his lifetime (1633-90) and many artists in both China and Japan tried unsuccessfully to copy his style. Kao Feng-han (1683-1743) is another flower painter who worked in his own way, without regard for the style of the majority of court artists. His paintings use the minimum of color and line to give an instant impression of the subject, and many of his flower shapes are represented with just a single, rapid brushstroke.

Many of these artists, official and independent, worked on a fairly small scale. This is because the main forms of art in China were hanging scrolls or handscrolls and the scale of the work was tailored to meet those requirements.

JAPAN

In Japan, the traditional paper screens which were used in most houses provided the means for artists to work on a larger scale. These screens, usually movable, were often several feet high and the large expanse of plain, white paper offered a tempting proposition to the prolific Japanese flower painters.

Painting on screens goes back a thousand years, to the time when they were first adopted as a convenient means of dividing and shutting off rooms. The favorite subject has always been brightly colored flowers, often depicted with bamboo trees and other foliage.

The sixteenth century is outstanding for its screen painting, and rich families vied with one another in hiring the best artists to use the latest styles of decoration and technique. Much of the work was done on rich gold and silver backgrounds, and the flowers were increasingly ornate and bold to make them stand out against their heavy surroundings.

The Kano school, the officially recognized artists, developed the decorative technique to an extraordinary degree. Their style of painting, with its typically black outlines and traditional pigments, continued well into the last century.

Painting onto solid gold and silver backgrounds became a trademark of another school of screen painters, the Rimpa

The Maple Tree by the Japanese Kano School (established in the 16th century). A traditional screen with a gold background.

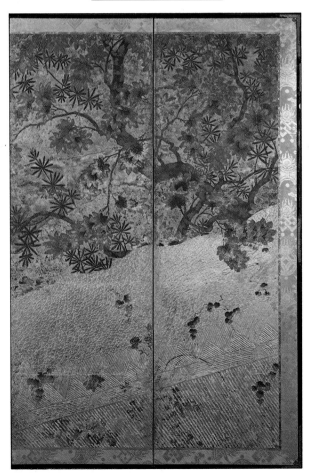

artists. Their work emerged in the seventeenth century and their expert use of certain techniques makes their products unmistakable. In many ways they were more creative and less conventional than the Kano artists, and they often used accidental effects to give their flowers a lively and spontaneous quality. One of their methods was to use pigments which did not mix. The result was rather like the mottled effects which we get if we try to use oil and watercolor together.

Although Japanese screen painting played a dominant part in the art of Japan, its role was not exclusive. There were artists who worked more directly from nature, and on a much smaller scale than the screen painters. On the whole, these artists were more prevalent in the eighteenth century, when European influences began to have some effect on Eastern art.

FLOWERS IN ART

It was not until the fifteenth century that flowers began to appear in paintings in a way that was not purely decorative. Even then, they were rarely an important part of the composition, but from this point it is possible to trace the history of flowers as they were used in art, rather than as botanical specimens drawn for scientific reasons.

Tiny flowers growing in the foreground were common in Italian paintings from this time, and remained popular throughout the Renaissance. Although they were too varied and prolific to be realistic, each flower was usually painted in absolute detail with every petal and leaf depicted. Treated in this way, flowers often made a picture look magical and enchanted, and many artists, such as Giovanni di Paolo (1399-1482), Fra Angelico (1387-1455) and Fra Filippo Lippi (1406-69), gave their angels and saints a carpet of flowers to walk on – a setting which was certainly more heavenly than earthly.

Flowers were also used symbolically in the art of the fifteenth century. Almost all painting at this time was religious, and Christian symbols were prevalent in every form of church decoration, including painting. Annunciation scenes inevitably included a lily – the symbol of purity, and the different saints could often be identified by their particular floral emblem.

Despite these humble beginnings, the status of flowers in art did improve – although it was another hundred years before they became a subject in their own right. Their

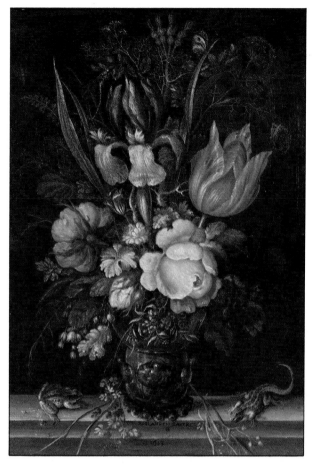

A Still Life of Roses, Tulips and Other Flowers by Roelandt Savery (1576-1639), one of the founders of flower painting in northern Europe.

increasing importance is demonstrated in a painting by the Flemish artist, Hugo van der Goes, in 1475. The work is the Portinari Altarpiece in Florence, and one of the panels, The Adoration of the Shepherds, is composed around two vases of flowers in the center of the picture. This change of emphasis can be seen in many paintings after this date, and as artists became more interested in working directly from their subject, so the realism of the painted flowers increased.

Interestingly, flower painting made no real progress during the High Renaissance, a time when artists were generally going through a time of change and new ideas.

Only Leonardo da Vinci (1452-1519) showed any specific interest in flowers, and his studies of plants and flowers show a knowledge of growth and structure which were far in advance of the time.

SYMBOLISM

Flowers are so much a part of our lives today that we tend to take them for granted. We grow flowers in the garden. We buy flowers to make the house look pretty. At weddings and funerals, flowers are an important part of the occasion. If people are ill in hospital, we send them a bunch of flowers. But rarely do we stop to think why, or how, flowers came to be such an indispensable part of our lives.

In days gone by, however, flowers did have a meaning. Each flower represented something particular or carried its own special message, and this symbolic flower language was generally understood.

We have already mentioned the symbolic use of flowers in painting, and how this was particularly common in the fifteenth century. Artists of that time knew, for instance, that lilies of the valley indicated modesty and humility; that lilies were a sign of purity; and that carnations, as the name suggests, were symbols of the reincarnation of Christ. Paintings of the Virgin Mary often included these flowers and their meaning was understood by those who saw them.

Although much of the symbolism in art is of Christian origin, many flowers had their own special meaning before the arrival of Christianity. The rose, for instance, was the Roman symbol of victory and, although the Church soon changed this to mean martyrdom, and later, love, it is interesting to remember that the rose once stood for something rather less peaceful.

Sadly, this primitive and magical language did not survive into the modern age of logic and common sense, and by the eighteenth century flower symbolism had almost completely died out. Painters no longer sent enigmatic messages to their public in the form of bunches of flowers, and the flowers themselves lost their mystical meaning.

FLOWER PAINTING

It was not until the sixteenth century that flower painting, as we think of it today, really came into its own. Until then flowers had played a peripheral role in European art, but nobody had either commissioned or painted an actual portrait of flowers, with the flowers as the central subject.

As with all histories, it is not easy to point to any one person as being the first in a particular field – especially with a subject like flower painting, which developed from such diverse sources. But there are certain artists who are generally acknowledged founders of what was soon to become recognized as a genre in its own right.

Albrecht Dürer (1471-1528) painted flowers for their own sake, rather than adding them as insignificant details or decorative afterthoughts. He was exceptional in his own lifetime for the way in which he treated every flower separately, each with its own characteristics and irregularities – an approach very similar to that of a portrait painter – and his watercolor studies were a direct influence on the founders of the independent Dutch flower artists at the end of the sixteenth century.

The first of these independent flower painters was Ambrosius Bosschaert (1573-1621) who, with other Dutch

Narcisses Blancs by Henri Fantin-Latour (1836-1906). Flower paintings were among the artist's most popular works.

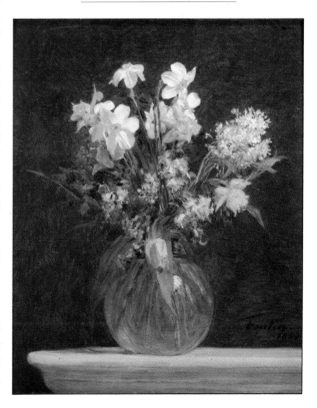

artists in the last quarter of the century, specialized in bouquets and vases of flowers, each bloom being painted separately and every detail faithfully included. These perfect specimens were not painted from life, but from studies made throughout the year. The many varieties of flower in any one painting often bloomed at completely different times of the year.

There was widespread interest in gardening at this time, and wealthy gardeners often commissioned what were literally 'flower portraits' of their favorite species. Watercolor studies and detailed sketches were used by artists time and time again as reference for paintings, and these precious items were often handed down in the artist's family, or passed on to other painters. The same flower can sometimes feature in several paintings, not necessarily by the same painter.

Although it was not exclusively a Dutch phenomenon – Caravaggio was painting flower pieces in Italy at about the same time – it was certainly in Holland that flowers were first recognized by a group of artists as being worthy subjects in their own right.

Jan Bruegel, Jacques de Gheyn and Roelandt Savery were all important independent flower painters, more or less contemporary with Bosschaert. The work of these early artists often seems unnaturally composed, with each flower presenting a perfect angle to the viewer. No bloom is ever less than immaculate, and no flower ever blocks another from view. The pictures cannot accurately be called naive, but compared to later flower paintings, these early efforts do sometimes seem rather stiff.

By the seventeenth century, however, flower painting had lost much of this rigidity. The pictures were still commissioned by enthusiasts, and the artists were still conscious of the botanical content of their work. But their style was more sophisticated, the compositions less artificial, and the subject less formal.

Part of the reason for this was the increasing influence of French taste on European art. The work of the Flemish

Basket of Flowers by Albrecht Dürer (1471-1528) is one of the paintings which had a profound influence on flower painters of the late sixteenth century.

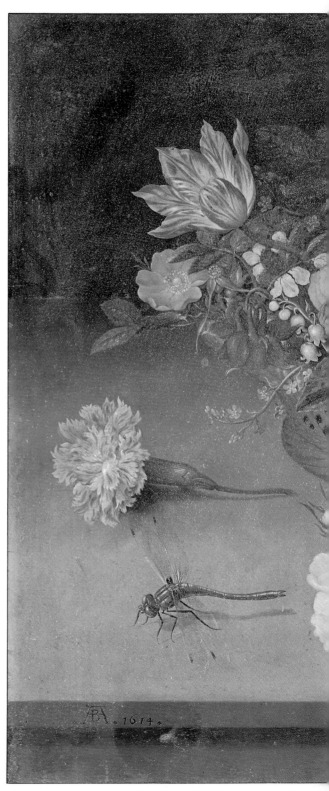

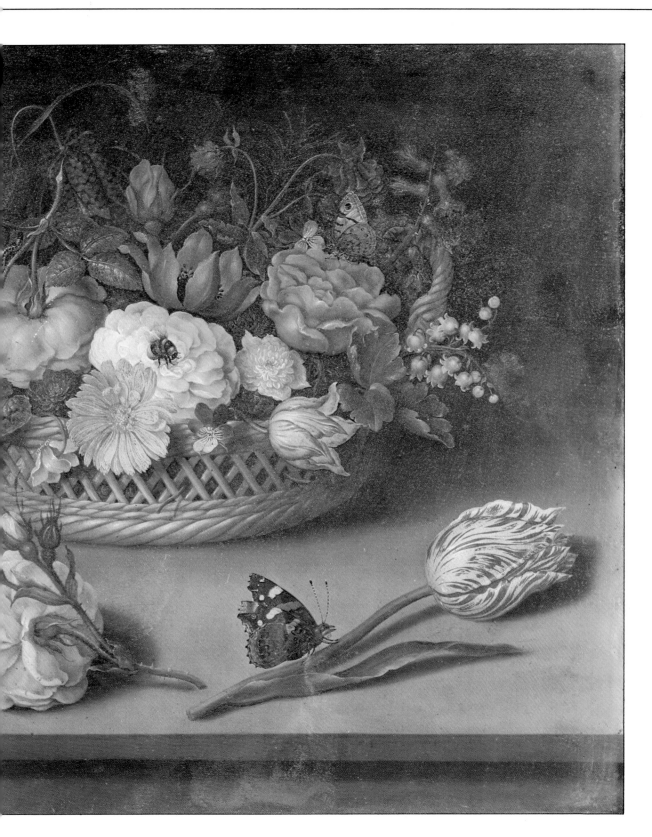

painter, Frans Snyders (1579-1657) is a good example of this new flower painting – his rich composition and fresh approach being closer to the art of Louis XIV and the taste of the French court than to the paintings of his northern predecessors.

One of the most important flower painters of the eighteenth century was the Dutchman, Jan van Huysum (1682-1749). His works were detailed, his compositions crowded – very much in the Dutch tradition – and his style had an enormous influence on many painters. But many other Dutch artists were drawn towards France at this time, and Paris soon replaced Flanders and Holland as the artistic center of Europe.

France also offered other possibilities to the flower artists of Europe. Many of the designs on the French tapestries and silk were the work of painters, as were the floral decorations on the famous Sèvres porcelain. In Paris, artists found rich patrons anxious to employ their talents to beautify and decorate their elegant homes.

Generally, flower painters at this time enjoyed greater recognition and wealth than ever before. Their skills were in demand all over Europe, keeping pace with the fashionable elegance which the wealthy demanded, and it was not long before another great European city, Vienna, became a second center for flower painters. Here the art flourished until the middle of the nineteenth century, in what was later known as the Old Vienna School.

Since those fortunate times the story of flower painting becomes more difficult to tell. The history ceases to be that of a particular subject which can be traced back through time. It emerges, instead, in the work of individuals. Most of these artists – from the Impressionist, Manet, to the contemporary painter, Ellsworth Kelly – did not confine themselves exclusively to flowers, and it would be misleading to look at the flower pictures out of the context of the rest of their work.

FLOWERS IN MODERN PAINTING

One of the most famous pictures of modern times is *Sunflowers* by Van Gogh (1853-90). Yet the great orange and yellow heads are not related in any historical way to the history of flower painting. They do not follow on easily from any established tradition, or school of thought. Van Gogh chose them as a subject for a picture in the same way as he chose his multitude of other subjects – for their basic, visual

usefulness rather than because they were flowers. He used them as a vehicle to express his own way of seeing the world. Similarly he would use other objects such as pots, landscapes, interiors and people. He looked at the texture of the sunflower and put it into paint in the same way as he would look at the texture of a woven chair seat and express that in painterly terms.

This is typical of the way flowers make their appearance in the work of many modern artists – not as the central themes of their art but as incidentals.

At least one striking exception is Odilon Redon (1840-1916). Although he painted many other subjects he is particularly well known for his depiction of flowers. His colorful, semi-impressionistic vases of flowers have a familiar place in the history of recent art.

Sometimes Redon represented flowers as straightfor-

Vase of Flowers by Odilon Redon (1840-1916). Redon's personal, impressionistic style rejects rigid realism in favor of a more individual interpretation.

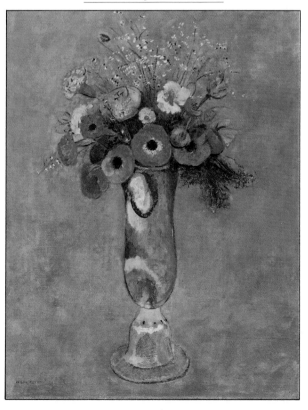

ward still lifes, always vividly. Quite often he used them as part of his strange fantasy scenes – dreamlike pictures of people and animals. Phantoms such as plants with human heads appear.

Another work which springs automatically to mind when reviewing modern art is the series of huge canvases, *Water Lilies*, by Claude Monet (1840-1926). He devoted much of his life to planning and growing an elaborate garden. The flowers therefore take a genuinely central place in his work. For most of his life he had flower painting in hand. He painted them at different times of the day – for instance, one would be in progress each morning to catch the morning light, and another might be continued later to exploit the evening light.

For Monet, the flowers themselves almost dissolve into light and color. Many believe that these paintings herald the beginnings of abstract art, when the form – such things as the design, technique, material and mood – started to take precedence over the content.

Emile Nolde (1867-1956) produced fields of shimmering color rather than tightly defined objects, in his watercolors of flowers. For about three years in the early twentieth century Nolde went through what many see as his flower period. His flowers have a less tortured appearance than many of his later pictures which concentrated mainly on landscapes and figures done with a turbulence typical of the German Expressionist movement to which he belonged.

These are just a few of the great painters who, in modern times, occasionally used flowers as subjects or as major parts of works that focused on other themes.

Flowers have continued to attract artists. People as diverse as the hard-edged abstract painter, Piet Mondrian (1872-1944) and Oskar Kokoschka (1886-1980) have turned to flowers occasionally as their subjects. The contemporary American painter, Georgia O'Keeffe, has taken flowers into a new dimension. She has produced big canvases, each one completely filled with a flower head – massive, colorful, organic shapes which can project surprisingly the abstracted image of a delicate form on a gigantic scale.

Many other contemporary painters have followed her example and used flowers and plants, not literally as the flower artists of the past did, but as a starting off point for their own personal, abstracted images.

Avon chintz by William Morris (1834-96). A fine example of the intricate way Morris used flowers in designs for prints, textiles, wallpaper and glass.

Nowadays you can see flowers everywhere in design, in fabrics, tiles, wallpaper, furniture and so on. One of the main movements which helped set the scene for modern design was Art Nouveau. This school, which started in the 1890s, was principally a style of architecture and interior design. It was typified by the elegant, twisting plant shapes seen in the work of such artists as Aubrey Beardsley (1872-98) and William Morris (1834-96). Beardsley was a member of the Art Nouveau movement proper. Morris was too early to be a central figure in the movement, but his work, with its formal flower designs, is considered a forerunner of the style.

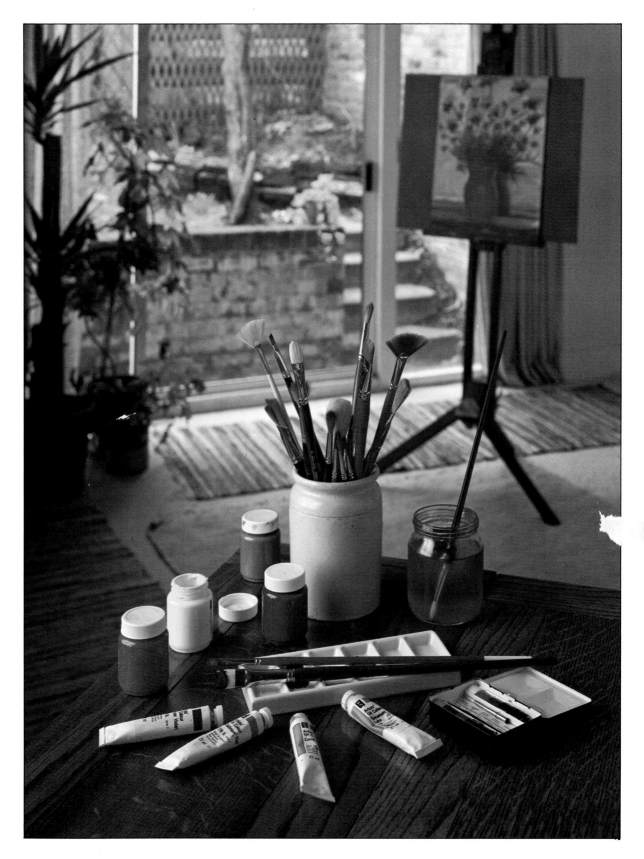

INTRODUCTION TO MATERIALS

The old idea that bad workers always blame their tools falls sadly short of the truth when it comes to art. Certain basic equipment is absolutely essential to the artist, and in the following pages we discuss the broad categories of materials and other items available to the flower painter.

Every painter develops preferences for certain paints, certain colors, certain ways of working. Just as no two artists work in the same way, so every studio contains different materials and equipment.

Acrylic

Tissue-paper

Ink

Many people are easily put off from painting by the fear that they will have to go out and buy a host of highly expensive materials, and will be confronted by a bewildering choice in stores run by scornful experts. But do not be intimidated. Those experts can often be helpful, and by working through this book you will encounter most of the materials you will need and you'll find that the expense can be kept to a minimum. Throughout, we have paid careful attention to the problem of cost.

Even when we advise on a particular piece of equipment, you can often improvise, although obviously you will have to buy paints and brushes. For instance, we have advised on what types of palette and mixing dishes to obtain, but for watercolor you could use saucers or other dishes, and for oil paint and acrylic you could make use of a sheet of glass or something similar. Obviously palettes have advantages: they were designed especially for the purpose, and will spare your kitchen equipment.

Nevertheless, improvisation, especially at first, will save a large outlay of money. You can always build up your collection of equipment and materials gradually.

An important factor in the area of equipment is the selection of the right sort of surface on which to work. Purchasing a ready-prepared surface – such as a canvas which is stretched and primed – is almost always expensive, especially if you are using acrylics and oil paints. In the following chapters we will try to show how to make your own surfaces.

The materials needed for the painting of flowers will differ somewhat from those required for general painting. A flower painter needs an extremely wide range of colors, especially for subtle, delicate work such as representing petals.

Any painter entering the world of plants will have to pay particular attention to achieving the variations of green. Different painters get into the habit of using their own color preferences. but because the color of foliage varies so much in nature, there are some subtle shades of green which you will never really be able to achieve without great difficulty. Sap green, Hookers green, viridian and terre verte are among those which you will be best advised to buy, rather than trying to mix their equivalents.

We shall try to help you select your materials by dividing them into sections in this book. At the start of each section there is a more detailed guide to what you need. As well as

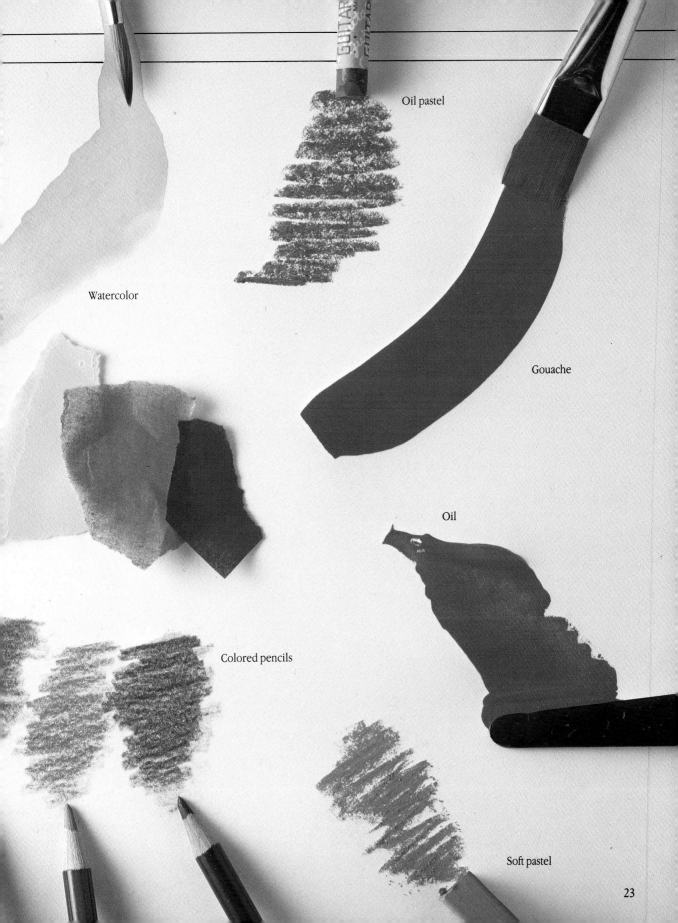

Oil pastel

Watercolor

Gouache

Oil

Colored pencils

Soft pastel

23

for the main fields of oils, watercolors and acrylics, we shall give basic guides to materials required for less well-known areas such as collage work. For instance, in the drawing section we have included some advice on use of the drafting pen, which is not an orthodox tool in flower drawing.

You will notice that there will be times when the sections overlap. This is because there are no clear boundaries in the world of art, and some materials and techniques apply to more than one material. We also want you to get used to using materials together. For instance, in the watercolor and gouache sections, we have introduced stenciling, masking and other mixed media.

It is essential that you become familiar with the basic types of paint. As you work, you must become more and more at home with the characteristics, the textures and the mixing qualities of the various paints you will encounter.

Although as you gain experience you will find yourself attracted to perhaps one area of your own particular liking, you should at first become acquainted with the whole range of materials, to build up your general confidence. As with all other areas of fine art, the painting of flowers has much to do with a craftsman-like skill in the knowledge and use of materials and equipment.

When you begin to paint flowers, keep an open mind and review the rich variety of possibilities. Do not feel you have to plunge too early into any narrow speciality. Consider how different are the simple ink paintings of the Far East,

the detailed oil paintings of Jan Van Eyck, the flamboyant sunflowers of Van Gogh, and the cut-out flowers of Matisse. All these required different materials as well as different techniques. They serve as a reminder of just how broad the subject matter is.

The flower painters of Japan and China used inks and watercolors. These materials are still as popular as ever, because of their availability and the gift they have of capturing the translucent quality of flowers and plants.

Inks are used as a drawing material as well as a painting medium, which is why they are included in two sections of this book.

Watercolors can be used tightly, to depict every small detail as would be the case in botanical drawings. Yet they can produce areas of flat color to achieve a looser, impressionistic image. Thus with watercolors you are in a free-ranging and flexible area. Emile Nolde, Oskar Kokoschka and Raoul Dufy are among the many modern painters who have developed their own loose ways of using watercolors, to produce personal images of their flowers, totally unlike the intricate and scientific style of botanical work.

Gouache is a more opaque form of watercolor. It is particularly useful for quick sketches. For flower painting it is also useful in conjunction with watercolor. Then you can paint the more specific parts of the flowers as well as

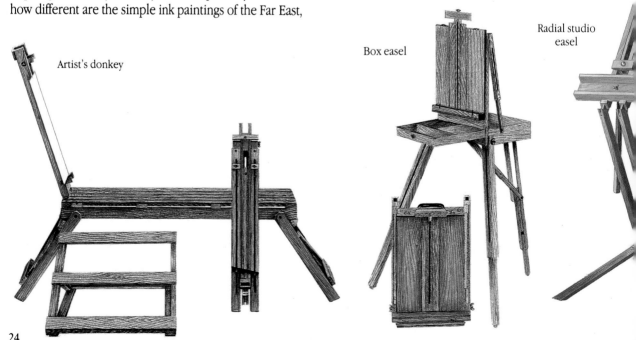

Artist's donkey

Box easel

Radial studio easel

capturing the elusive and transparent characteristic of flower colors.

Oils invite a different approach, one that can make use of their thicker texture. They are less suitable for making studies of individual flowers, but ideal for complete paintings. The major advantage of oils is that they can be manipulated – almost molded – on the canvas itself. The oils do not dry instantly on the surface. Therefore you can develop the subject and the background together, changing colors and tones to bring up exactly the right contrasts between the different areas of the picture.

Not a lot of flower painting has been done in acrylic, a new and still not fully explored medium. Many do not find acrylics sympathetic because they dry quickly, forming a plastic skin. This quick-drying characteristic can, however, be an advantage, enabling the painter to press on rapidly with the next stage.

Pastels are sticks of color. You can obtain soft chalky pastels which are ideal for creating tones and textures because of their chunky characteristic, enabling you to create broad areas of color as well as make lines. They are good materials for energetic, expressive and spontaneous work. Alternatively, you can obtain oil pastels, producing a heavier look. For the flower artist, these would be more suitable for broad views, perhaps of masses of flowers, rather than the single bloom.

As well as discussing coloring materials, we have covered a broad range of drawing equipment, such as pencils, pens and charcoal. Here the variety is enormous. Charcoal gives a broad soft line like a pastel, but the drafting pen makes a hard, even line. Watercolor pencils allow you to combine line with color.

You can begin flower painting by resting your surface on any support, such as an ordinary table. But eventually you will probably want an easel, enabling you to choose your work position, the exact angle you want, and the ability to look at the subject from exactly the same height each time you start work.

Easels are common to all sections. A vast array of these is available, differing in size and weight. For heavy supports, which you would use with acrylics and oil paintings, you could use a studio easel. This is very sturdy and easily adjusted, but it takes up space and is not collapsible. For outdoor work, you can obtain a special collapsible easel, light but fairly firm. Another common sort is the radial easel which can be tilted backward and forward. For the artist who likes to work sitting down, you can obtain an artist's donkey, enabling you to sit astride a bench while you work. For sketching you can obtain a light, compact wooden or aluminum frame known as a sketching easel. You can use this for watercolor, but in this case you may wish to place a wash on the surface, and you will need to fix your board in a horizontal position to avoid the paint running off. Two types cater for this problem – the Hunter and the Kingston both of which can be adjusted to any plane.

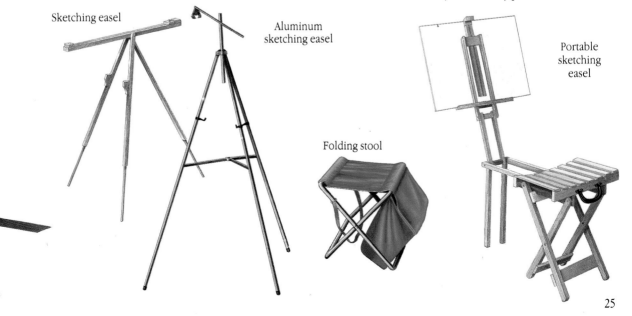

Sketching easel

Aluminum sketching easel

Folding stool

Portable sketching easel

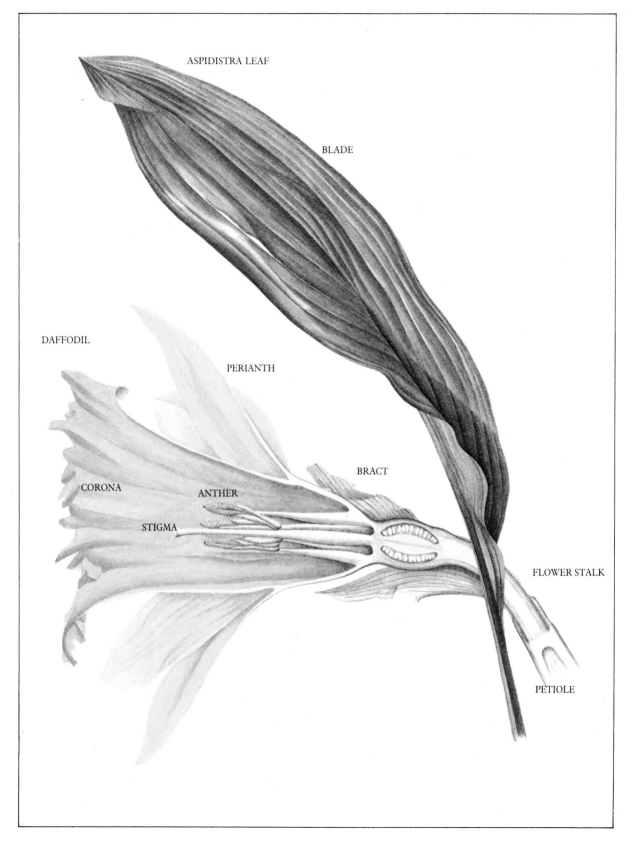

ASPIDISTRA LEAF

BLADE

DAFFODIL

PERIANTH

BRACT

CORONA

ANTHER

STIGMA

FLOWER STALK

PETIOLE

ANATOMY
OF
FLOWERS

Why are flowers so beautiful, delicate and colorful? As soon as we ask this question we become scientists as well as artists. The explanation of the flower's beauty lies in the fundamental problem of its survival, and for the painter a brief look at the science of botany will give a fascinating insight into the reasons behind the aesthetic form of the subject.

A cross-section of a daffodil, showing both the male and female parts of the flower, and an aspidistra leaf showing the blade and petiole.

Leonardo da Vinci, who was very much a scientist of the Renaissance, made a series of intricate drawings of the anatomy not only of human beings but also of plants. In his work, he was in fact illustrating how important it is for the artist to understand what makes the subject work, as well as its aesthetic value.

In order to understand the visual structure of plants it is essential to keep in mind the fact that the basic function of the flower – that is, the bloom on the end of the stem – is reproduction.

Nature has decided that it is best, genetically, for flowers to cross-fertilize, to reproduce by uniting the pollen with the stigma of different plants.

For this reason, the male and female parts of a flower are usually designed in such a way that they cannot meet. The pollen must go elsewhere in search of another flower of the same species but in a different spot.

In many flowers the central feature is the female reproductive mechanism, known as the pistil, usually a stem-like structure. A flower may have one or more of these. At the end of the pistil is the stigma, a sticky object on which the pollen grains will germinate. Below the stigma is the style, a stalk which joins the stigma to the ovary.

The male parts of the flower are known as stamens. Again, a stamen is a stalklike structure. At the end is the anther, which holds the pollen grains. Anthers vary in shape. They split open to free the pollen which is then ready to be picked up and carried to another flower.

Because it is generally better to reproduce by means of cross-fertilization – rather than having flowers pollinate themselves or other flowers on the same plant – nature often structures the flowers to make it impossible for

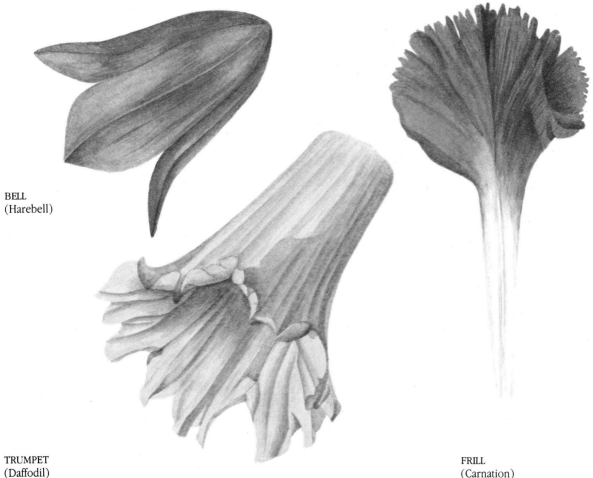

BELL
(Harebell)

TRUMPET
(Daffodil)

FRILL
(Carnation)

self-pollination to take place. Some flowers have only pistils or stamens. In many flowers, the anthers and stigma are placed in such positions that they cannot reach each other.

If you watch out for these characteristics as you study the central hearts of flowers, your painting cannot help but be improved by increasing your awareness of the mechanisms you are representing on the canvas.

The flower must now find a way of sending off its pollen to another plant. Its structure and colour will show how it has adapted in order to do this.

THE PETALS

Most flowers rely on insects or birds, or on the wind, to distribute their pollen. To attract insects, for instance, flowers may rely on scent and color. To attract by sight, the flower makes major use of the petals, its most conspicuous

features. These are often brightly colored, and sometimes have patterns designed to draw the insect into the flower towards the nectar, as it searches for food. The pollen which has rubbed off on to the insect can then be carried elsewhere, to be brushed against another flower.

The petal structure of some flowers is adapted to cater for specific insects; the stamens and pistil being positioned to ensure contact with that particular species.

Some flowers open at dusk, to attract moths and evening insects, and these usually have white or pastel colors. This is often supplemented by an extra strong scent.

When flowers make use of the wind to carry pollen, they are often the less conspicuous of blooms. The wind-pollinated plants often bloom before the leaves are developed, and they produce large quantities of pollen, ready for a method of distribution which is even more random than the visits of insects. Many grasses fall into this category.

The petals, which come in various numbers and combinations, are known collectively as the corolla. As well as their reproductive role in attracting insects, they have another function – to protect the delicate parts of the flower, especially when it is in bud.

There are cases where the petals close when the sun goes in. In this way they protect the stamens and pistil from rain. And factors like these can provide the painter with a rich variety of ideas for pictures.

Petals vary enormously. They appear in a multitude of sizes, in such shapes as hearts, ovals, frills, trumpets, tubes and bells. As with petals that close in rain, be on the watch for changing shapes, such as petals in the bud stage which slowly open and alter their structure and color. The texture of petals also varies, from a silky, smooth surface to thick, waxy and paper-like.

Outside the petals there is often an outer casing which helps in the protective role. This is made up of sepals, which look like a cross between flowers and small leaves, sometimes forming a green outer circle at the base of the flower. They are occasionally found in other colors.

HEART
Petals fuse to form
tube (Polyanthus)

OVAL
(Chrysanthemum)

THE LEAVES

When you come to paint leaves, notice how they vary in the ways in which they are joined to the rest of the plant, as they struggle to gain light and absorb energy from the sun.

Leaves usually have two parts: a blade, known as the lamina, and a stalk called the petiole. They may be joined to

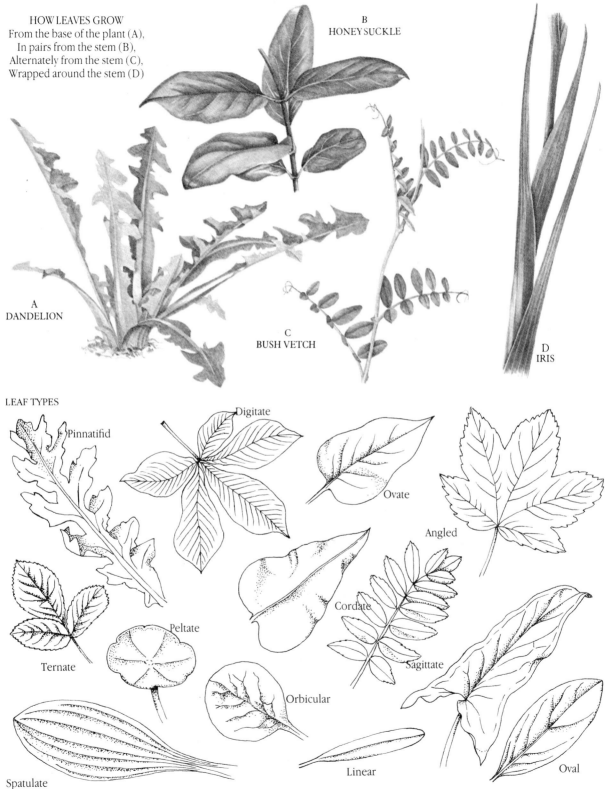

HOW LEAVES GROW
From the base of the plant (A),
In pairs from the stem (B),
Alternately from the stem (C),
Wrapped around the stem (D)

B
HONEYSUCKLE

A
DANDELION

C
BUSH VETCH

D
IRIS

LEAF TYPES

Pinnatifid

Digitate

Ovate

Angled

Cordate

Ternate

Peltate

Sagittate

Orbicular

Spatulate

Linear

Oval

the stem of a plant by means of the stalk. If they simply consist of a blade, with no stalk, and are joined directly to the stem, they may clasp the stem, extending downward wrapped around it like a sheath. Leaves may also grow directly from the base of the plant.

The outside of the leaf comprises close-fitting cells to protect it from damage and disease and to reduce evaporation and retain moisture. A network of veins carries water and minerals to and from the leaf, and these are arranged in a variety of patterns. Look at the vein pattern in any leaves that form part of a composition before you begin to draw.

Leaves can be surprisingly subtle in appearance. They may be arranged in circles around a stem, in what is known as a whorled formation. You may find two leaves opposite each other all the way up a stem, or they may be joined to the stem in alternate positions. Their surface may be wrinkled, hairy, smooth, velvety, dotted, rough or shaggy.

And when you look closely you may find that the edges of leaves are more complex than they seemed at first glance. The edges may be entirely unbroken, or they may be formed into teethlike indentations. Sometimes the teeth will bear even smaller teeth. They may be saw-like or wavy.

Simple leaves, which appear as straightforward blades, also vary. Look more closely and you will find a host of different shaped spears or spades.

THE STEM

Stems, too, are of various types. Their main function is to carry substances to and from the leaves and flower, and therefore they must be able to resist the wind and rain and the occasional brushing of passing animals. They are not always solidly cylindrical. Some are more hollow than others, and some are square or oval. Watch for the ways in which nature chooses to protect their outer surfaces. There may be thorns, hairs, fluff, or the surface may be strong and smooth. They usually taper toward the top, presenting a difficulty for the painter when trying to place them in perspective.

Here we have given just a rough outline of the botanical aspects of flowers. As you become more interested in the painting of flowers and plants, you will probably find yourself collecting your own small library of botanical books. You will then get to know the names and the natural history of the subjects you paint, deepening your knowledge and your enjoyment.

STEM TYPES

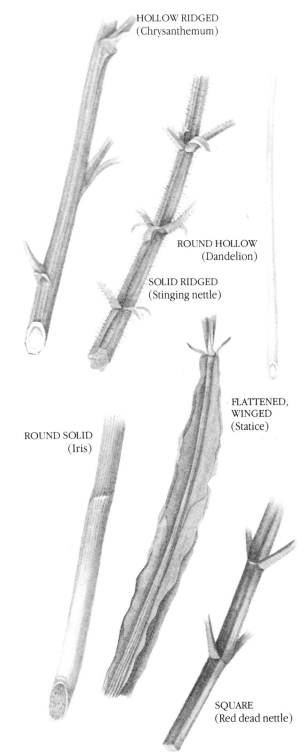

HOLLOW RIDGED
(Chrysanthemum)

ROUND HOLLOW
(Dandelion)

SOLID RIDGED
(Stinging nettle)

FLATTENED,
WINGED
(Statice)

ROUND SOLID
(Iris)

SQUARE
(Red dead nettle)

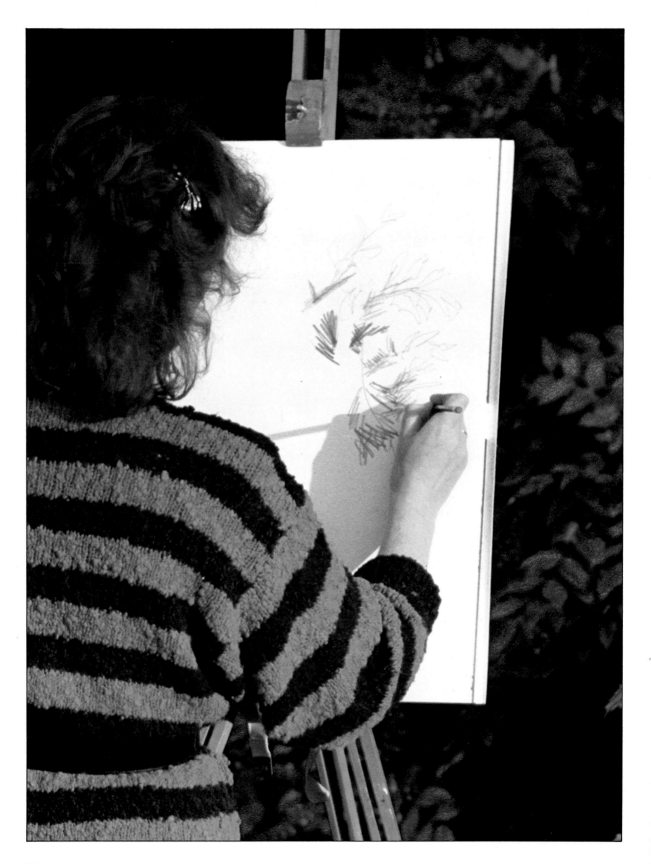

CHOOSING
A
SUBJECT

Whatever the time of year, the flower painter need never be at a loss for a subject. In this chapter we look at some of the possibilities and make suggestions, as well as examine a few more unusual ideas about subject matter.

The artist works on the spot, drawing the fresh flowers in their natural surroundings.

The painting of flowers can be an indoor or outdoor activity, with the apparatus of the studio or with a light sketchbook under the arm as you clamber over rocks in search of some rare plants in some wild location. You can follow the growth of a favorite cluster of plants throughout the seasons, visit the enclosed hothouses to sit before a variety of exotic blooms, or paint flowers in your home.

You can paint a host of subjects. There are cut flowers from the florist, potted plants – which include such unusual subjects as the flowers from tomatoes and the weird shapes of cacti and succulents – flowers in the garden or window-box, and wild flowers in their natural habitat. You can also study and paint the stray flowers that push their way up through the concrete of city pavements.

Your subject does not consist merely of the traditional vase of flowers on a table, although this can provide you with enormous satisfaction and challenge. Flowers can be represented against almost any background in almost any environment, to create pictures ranging from the intricate to the dramatic.

HELPING PRESERVE FLOWERS

The importance of conservation of the countryside cannot be stressed too much when considering what subjects to paint. If millions of enthusiasts prowled the woods and fields, tearing plants from the ground in order to take them home or into the studio to paint them, there would soon be nothing left to inspire the artist.

You do not have to feel guilty, however, when you paint cut flowers, as these are supplied from the florist as part of a thriving industry, grown in nurseries to be cut and distributed.

FLOWERS INDOORS

To build your interest in cut flowers, tour the shops and nurseries, and visit flower-shows and street markets. Learn the names of the species. Find out when they are in bloom, and work out a painting schedule with this in mind; painting flowers can be a long and sustained activity, and it is as well to know what subjects are about to become available.

Cut flowers have the advantage of being readily available and easily manageable indoors. The vase or container is important. Its shape, color and texture form as much a part of the composition as the flowers themselves. You can also use devices such as plasticine or wire to keep flowers in place for an intricately-planned arrangement.

But the flowers in their vase, nicely arranged on your table, are already dying. Take steps to prolong their life. Crush the ends of their stems when you first place them in water, letting them absorb more moisture. Some people

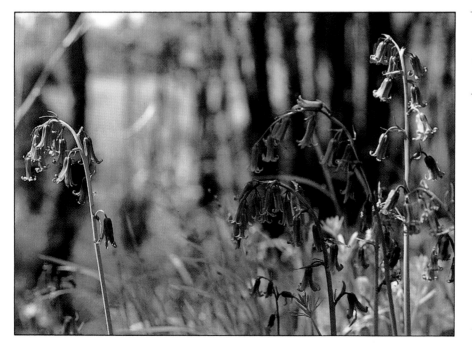

Wild flowers, such as these bluebells, should not be picked but there is no reason why you shouldn't paint them in their natural habitat.

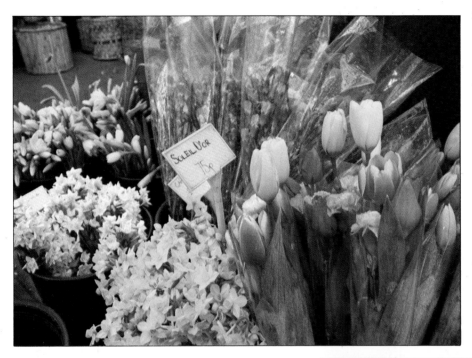

This flower stall *left* is typical of hundreds which provide freshly cut flowers all year long.

Flowers can be arranged exactly as you want to paint them. A piece of chicken wire is used *below* to hold the flowers in position.

crumble an aspirin into the water because they believe it makes the flowers last longer. Do not place the vase in a hot part of the room.

You cannot hold up the process of decay for long, so once you have started your picture you should carry on painting until it is finished. This is not a project to be left. Do not start off with too complex a subject. You can always take a photograph of the flowers in their fresh state, if you feel panicky. Alternatively, you could make notes of the colors, or make a quick color sketch.

Cut flowers also change their appearance during the day. They close up at night, and open out in the morning. They can actually change their entire shape according to the temperature and light.

Some painters prefer to buy not a bunch but one or two flowers at a time. Each time they buy a flower, they paint it into the picture. Thus their flower arrangement is made not in the real world but straight onto the picture. The early Dutch and Flemish flower painters worked in this way and a lot of their ornate flower arrangements were in fact put together on canvas.

Plastic and silk flowers can sometimes be used to offset the problem of decay, but usually this is only done if flowers are to be a small part of a bigger composition, perhaps contributing a splash of color in a large still life or interior.

A garden like this *left* offers a vast selection of plants and blooms which can either be painted individually or as part of a broad vista.

Our artist found this exotic orchid *above* nestling among the colorful foliage in a glasshouse at the botanical gardens.

They are not so good if you want to concentrate on the flower, because they do not have the details and freshness of nature.

FLOWERS IN POTS

Potted plants can make a most satisfactory subject for the flower painter because they last longer and maintain their freshness without too much trouble. You cannot manipulate the arrangement as precisely as you can with flowers in a vase or container. But you can overcome this problem to some extent by arranging several pots together, choosing their colors and shapes to make an interesting composition. Potted plants are available in a variety of shapes, sizes and colors. You can choose succulents and cacti, for instance, as well as more traditional flowers.

You can buy dried or everlasting flowers, supplemented perhaps by bunches of dried grasses, to provide yourself with an interesting subject which will not die or wilt and which has echoes of Victorian and Edwardian days, when the painting of dried and pressed flowers was a popular hobby.

If you prefer painting flowers outdoors, and if you do not possess a garden, you can paint flowers in a growing environment, by simply making use of a window-box.

FLOWERS OUT OF DOORS

For those fortunate enough to have a garden, the painting of flowers provides endless entertainment and can last through all the seasons.

In this case, it is advisable to combine the interests of the painter and the gardener. Plan your flowerbeds so that they provide blooms in winter. Even though flowers are often in short supply at certain times of the year, you can make up an arrangement with evergreens, twigs and berries.

Working in the garden means that you can plan a more leisurely approach to your painting, selecting work-times according to the light. Like the landscape photographer, you can wait for the right moment.

A conservatory or greenhouse provides a rich source of subject material. Even the most humble greenhouse can enhance a painting by being an attractive element in itself. You can paint flowers behind glass, using the shimmering effects of reflected light. You can also use the structure of the greenhouse as part of your picture. In large conservatories, such as those found in botanical gardens, you can create endless subjects and vistas of architectural space, to make up compositions of flowers and their background. Here is where you will find the most exotic shapes and diversity of scale.

LOOKING FOR WILD FLOWERS

One of the finest ways to enjoy flower painting and drawing is to go outdoors, and search for your subject in its own environment. In this way, you can observe and paint a variety of plants without tearing them up and disturbing the balance of nature.

Wild flowers look their best in their own natural surroundings, or in some surprising environment such as shooting through the rubble of a ruined building or bringing some delicate color into a drab urban corner.

To capture them properly you must seek them out. You can either make a drawing on the spot, and take this home and make a painting of it, or you can photograph it. Probably the most satisfying course is to set up your equipment at the site and complete the painting there. This is where you begin to understand the advantages of light, portable equipment – a folding easel and stool, a handy box in which to carry your paints, and unbreakable containers for water and turpentine.

Keep an open mind. Remember that to the artist there is no difference between flowers and weeds. Although the gardener might regard the dandelion as a pest, it is in fact as intricate and colorful as any cultivated bloom.

One absorbing project would be to seek out a spot, preferably a hidden and undisturbed patch of ground, and visit it regularly throughout the seasons, making a series of paintings or sketches of the same site to record its changing appearance.

As soon as you move outdoors to paint, you can combine the work with other activities, such as walking, traveling abroad, or studying plant life. Once you have begun to understand more about plantlife, you will find that wherever you are, whether for business or pleasure, you will want to explore the local flora.

As your interest grows, you will find yourself becoming an ally of the conservationist and the botanist. You will probably find yourself seeking to preserve the habitats of flowers and discovering more about their ecological role.

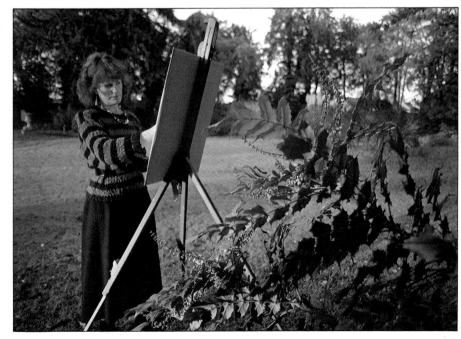

Flowers are at their best in their own surroundings. The artist *right* uses a light portable easel to work outdoors.

LOOKING AT FLOWERS

The Chinese have an ancient proverb that the way to walk a million miles is to take the first step. Keep this in mind when looking at seemingly complicated flowers, and instead of being put off by the subject as a whole, think instantly of the first step. This chapter will enable you to overcome some initial fears and help you to know instinctively how to start your picture.

A single bloom such as this offers endless possibilities to the enthusiastic and imaginative flower artist.

Getting started is the most daunting part of painting, and is the reason why most people are put off. The problem is that you have grown accustomed to looking at objects with an accumulated knowledge of their size and how they fit into three-dimensional space, and of what it really is that the objects represent. For instance, you know that the far side of a vase of daffodils is farther away than the near side, and you have no idea why it appears to be so.

You know that you are looking at a tulip or a snowdrop, and therefore you usually fail to see how these objects are actually shaped. Your mind has been programmed to recognize a certain shape instantly and then instantly forget its visual aspects. Evolution has programmed you to see a tiger not as an interesting shape but as a threat. Therefore you have automatically become efficient at recognizing but not seeing – which means dismissing at once the visual structure in order to jump to conclusions about what it really is, ie what it can do, such as 'threat object'.

Thus with flowers, you have become used to seeing-in-order-to-identify, rather than seeing the visual structures before you.

This is why the beginner often suffers a mental block when confronted with an object and an empty canvas. To overcome this psychological problem is one of the main objectives of this chapter. We have suggested specific techniques, first to look at and draw the plant in simple terms, then to show a series of different ways in which you can start a painting.

THE ANALYTICAL APPROACH

A single flower can be an intimidating object when you have to draw it. It is fragile and yet it is highly structured. It is made up of seemingly simple components, but each petal is made up of a multitude of planes. And it is also so familiar that in some ways it is actually difficult to look at with fresh, inquiring eyes.

The best approach is to forget that you are looking at a dahlia or a delphinium, or whatever flower you happen to be drawing. Try to think of it as a pure object, one which has no name and which you have never set eyes on before. Imagine you are describing it on paper for the benefit of an alien, someone who does not even know what a flower is.

In this way you will have to think in terms of basic shapes and forms otherwise the purpose of the exercise is lost. For instance, you will be forced to draw a stem and make it look

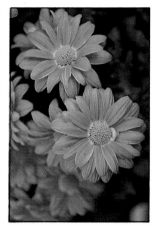

Circular flowers, such as these marigolds *left*, are constructed within basic ellipses, and the petals and details are built up within these simple geometric guidelines.

Almost every flower can be analyzed and simplified into basic structures. The most common of these are the various ellipses, bells, cups and tubes *bottom*.

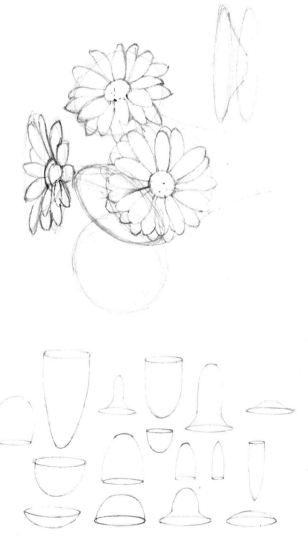

The foxglove flowers *left* are not regular shapes, but each flower can be seen clearly as a hollow globe which hangs from the main stem in a particular way. The key to the construction is the position of the stem and the scale of the flowers in relation to each other. Our artist has used simple shading to describe the forms and clarify the shapes *below*.

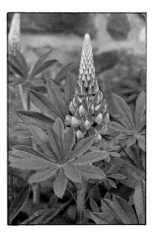

The lupin *left* is a daunting prospect for the artist, with its tiny petals and confusing tones. But once the flower is seen as a simple conical form it becomes less formidable *above*. The leaves are established as ellipses and positioned carefully in relation to the main stem; each leaf is attached to the stem by a stalk and the leaves radiate outward from this point.

like the three-dimensional tube it really is, otherwise your alien friend will assume it is flat. And you will have no option but to think about the structure and formation of a flower head rather than concentrate too soon on superficial pattern and detail.

Just as a good figure painter needs a basic knowledge of anatomy, and needs to understand how bones and muscles affect the external shape of the human form, so the flower artist needs to understand the structures and underlying forms of different plants and flowers.

It is a good idea to tackle your drawing by sketching in the main shapes, and 'breaking down' the subject into almost geometric forms. For example, a daisy head is basically a circle – or an ellipse, if you are looking at it sideways – with a series of shapes radiating outward from the center. So, before you start drawing complicated petals and flower centers, put in these basic construction lines to guide the rest of the drawing. These lines can always be rubbed out at a later stage.

The drawings on these pages show several such studies of various flower shapes. The artist has approached each one as an abstract, almost architectural structure, and thought carefully about the volumes and shapes which make up the actual plant.

This scientific, rather analytical attitude, has in fact resulted in the drawn flower looking more like a flower than it would have if the artist had set out in the first place to imitate it as a whole.

Do not simply paint, or draw, a stigma or a leaf or a stem or some such portion of the body itself. Try to see the shapes of the spaces between the parts of the subject, such as the space between the leaves, and make sure that you actually draw pieces of space as well as the objects themselves. When looking at space, remember that it too is three-dimensional. Think of it as a volume of space, rather than as a flat shape.

DIFFERENT WAYS OF STARTING

Experiment with different ways of starting a picture, even though you will eventually develop your own individual method which will probably become your favorite way of setting out.

Illustrated here is a vase of tulips. We asked our artist to demonstrate some different ways one could begin a picture, using the same subject. Remember that you are not

obliged to follow any of these methods exactly. One reason we have explained them is to emphasize that there is no rigidly correct way in which to do a painting.

A rather unusual way to begin would be, as is shown in Picture D opposite, by putting the background in first. In this example, the background was seen as a positive area with its own shape and the flowers were left merely as negative space, to be filled in later.

If you work in this way, by establishing the background first, you will have established a predominant tone right from the beginning. Every other color from now on can be related to this initial tone, and thus the background method of starting can give you a useful signpost.

Using negative shapes like this is also a good way of drawing. If you can draw the shapes of the flowers by accurately representing the spaces between them, this will effectively ensure that the parts of your composition will relate to each other correctly.

In many ways, doing the background first is an ideal means of counteracting the problem of being intimidated by the empty space on the paper. You are certainly attacking the problem in the most direct way possible!

If you are working in an opaque medium such as gouache, oil or acrylic, and if you are doing a general composition, another way is to sketch in the outline of the main shapes. This leaves you to develop the image in paint, redrawing and clarifying, bringing more and more detail gradually into the picture.

Once you have sketched in the outline, either in charcoal, pencil or paint, you can start developing this in several directions. One method is to use a single color, usually a neutral one, with which to block in the dark and light tones. Thus before you add any further colors you are in effect working out the light and dark patterns of the picture.

Alternatively, you could start by roughing in the main areas of local color. You either do this very approximately, again leaving the finer details to a later stage; or you are slightly more precise right from the first stages. You will eventually hit upon the right style for your own individual taste and technique.

You could also start your picture by making a very precise line drawing, adding the color bit by bit. As you add a color, you relate it carefully to its neighboring tone, gradually building up what will then become a consistent image. This is the way many illustrators work, but it is not

A. Starting with a charcoal line drawing.
B. Using charcoal to indicate broad areas of tone. C. Painting each part of the picture in detail from the start.
D. Establishing the background first.
E. Working out the tones of the composition before adding color.
F. Simplifying the colors into two or three basic shades — for example, reducing the tulip heads to patches of light, medium and dark red.
G. Blocking in the whole picture in broad areas of tone and color before developing detail.

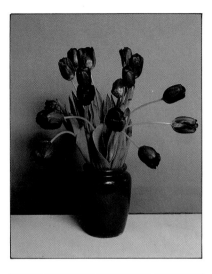

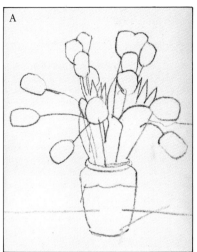

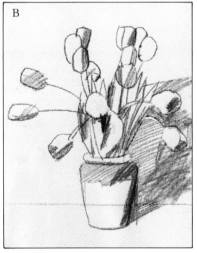

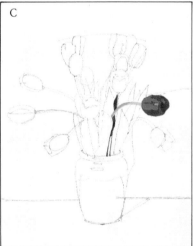

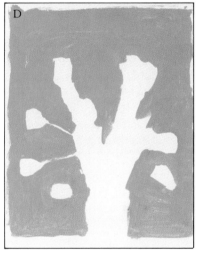

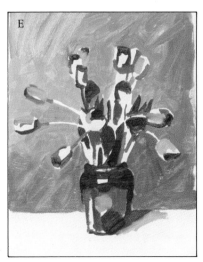

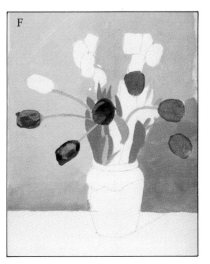

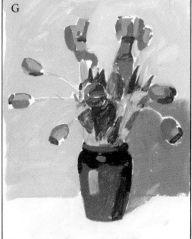

unknown for painters to approach the subject in a similar, gradual way.

COMPOSITION

Every painting has a composition. As soon as you make your first mark on the paper or canvas, you have made a decision about where the subject is going to be placed, how big or small it will be, and how much – if any – of the surroundings you will include in the picture.

All too often these decisions are made without care or thought, and without really considering all the alternatives. And while your instinctive choice may well be a good one, be aware of the many possibilities before you start work.

Flower painters are particularly likely to overlook this important aspect because the subject is often so simple. If you are painting a vase of flowers or a single bloom it might seem obvious to place the subject fairly centrally in the picture with an even amount of space around it. This does not necessarily make for the most interesting picture – especially if you always work in the same way.

Remember that your painting will exist long after the flowers are dead. It is an object in its own right, and will possibly be seen by people who were not, as you were, familiar either with the subject or the surroundings.

When people look at a picture they do not immediately see everything in it. In a split second their eye alights on the

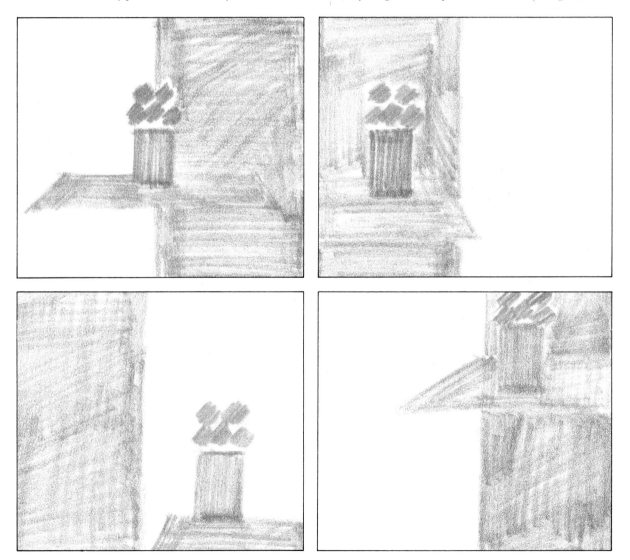

most dominant thing – usually a strong shape, a dominant color or an object they can immediately identify – and is led around the rest of the picture from one point to another, until the picture registers on the brain as a complete entity. This process is very swift, but lasts long enough for your viewer to make a subconscious decision as to whether to continue looking or move on to something else.

Conventionally, a good composition is one which leads the eye around within the picture, without the distraction of any uncomfortable lines and shapes to direct it off the edge of the canvas. You can do this quite easily by imagining an oval within the rectangular picture shape and not placing anything important outside the edge of this hypothetical oval. This is not difficult when painting flowers, because the subject often fits naturally into such a shape.

One of the most important decisions for the flower painter is how to arrange the background. Quite often the subject is on a table or some other surface, sometimes with an upright division, such as the corner of a room, behind it. The problem is how to use these horizontal and vertical lines to divide the canvas in the best way, to enhance the composition rather than destroy it.

One traditional method is to use what is known as the Golden Section. This technique divides a rectangular shape into what many consider to be the most satisfying and harmonious proportions possible. These proportions are

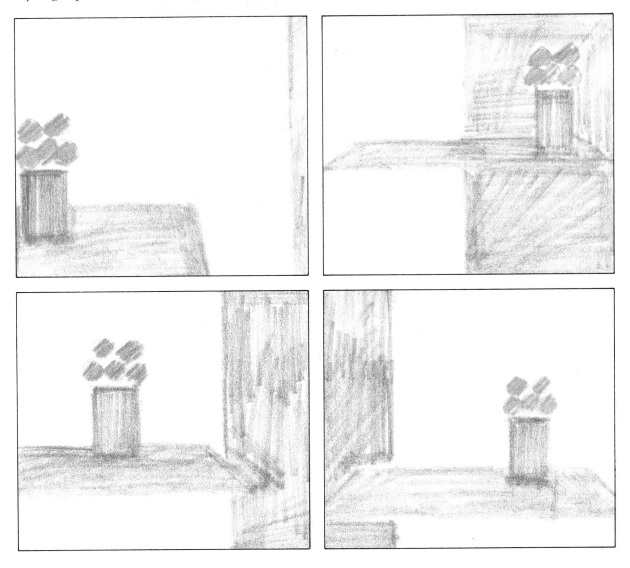

worked out geometrically and depend to some extent on the shape of the canvas in the first place. Although you probably will not want to go to such lengths, it is surprising how often good compositions, which have been decided visually rather than mathematically, actually include Golden Section divisions.

There are, in fact, no rules about what makes a good composition. The choice is personal, but it is important for every decision to be a conscious one. For instance, if you decide to flout convention by dividing your background exactly down the center, this is fine, but you should know why you are doing it. You may have decided to move the subject to one side to counteract this symmetrical back-ground. Or you may want to paint one half of the back-ground a stronger color, and offset the division in this way You might even want a picture which is totally symmetrical. Whatever the reason, the result should be one of choice – not of accident.

LIGHTING

When we look at an object we do not see it. That is, we are not looking at something whose appearance is permanent, whose color and shade and tone remain always the same. How we see the shape and form of the subject depends on how the light falls upon it. Light makes patches of shadow and reflection which enable us to see how a flower's leaves

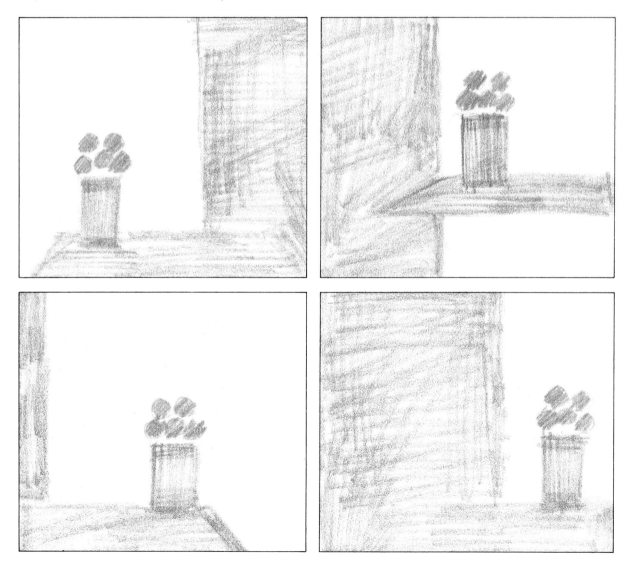

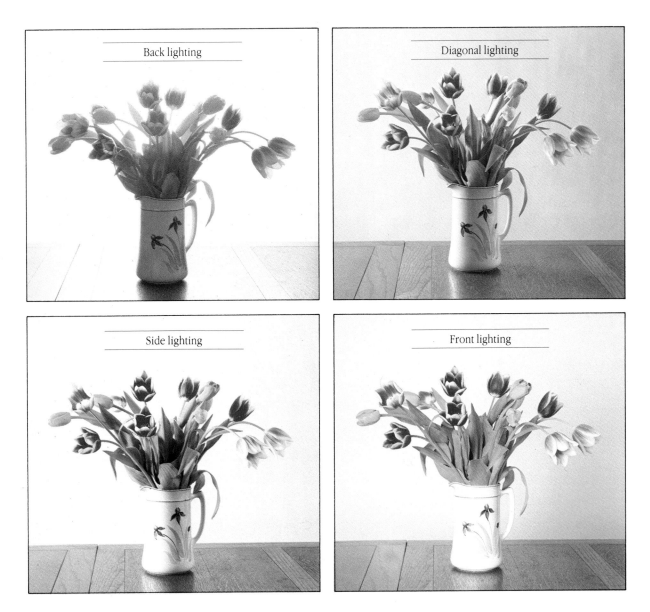

| Back lighting | Diagonal lighting |
| Side lighting | Front lighting |

curve, how the petals are shaped and how the plant is structured. It also shows up veins, ridges and textures.

Harsh, direct light creates a lot of contrast – areas of extreme light and dark. A diffused, softer light shows the subject as a series of subtle tones. Flower petals are usually mat and therefore absorb the light, making it more difficult to see the exact shapes.

The way the light falls onto objects, and the shadows cast from them, indicates the position of the light source. You can often use these shadows in a positive way when planning a picture, making them into a definite part of the

composition. If you are working indoors by artificial light, you can alter the position of the light source to change the shape of the shadows, making them elongated or squat, hard or soft – whichever suits your particular requirement.

Lighting also affects the mood of the picture. For instance, a dim, subdued light can evoke a melancholy atmosphere while bright, clear lighting expresses cheerfulness and energy. Although such devices are normally employed by portrait and landscape artists who often want to convey a particular mood, they are equally available to the flower painter.

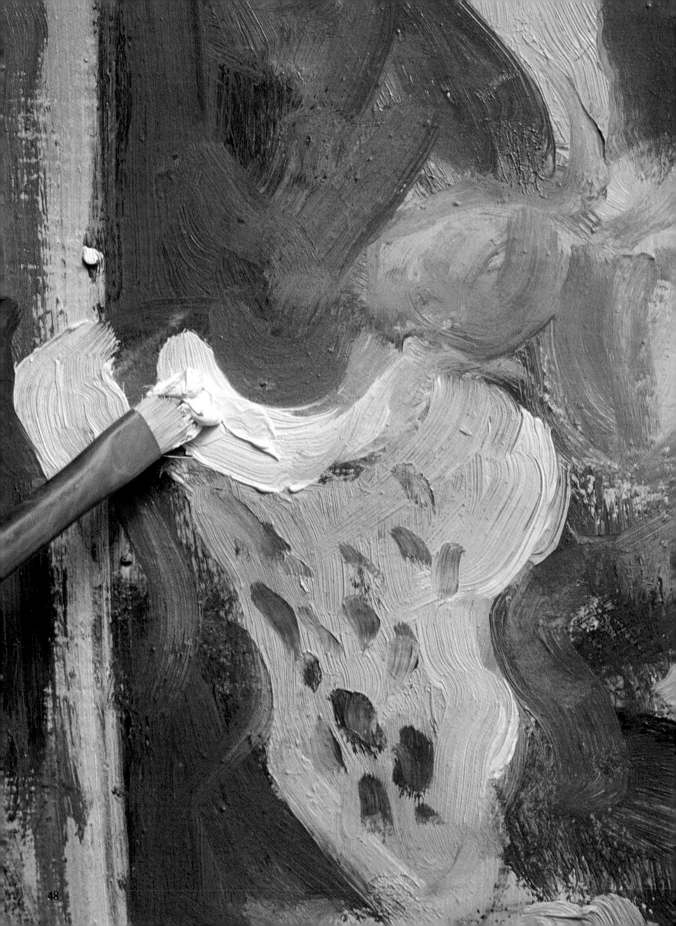

48

Oil

O il paint is perhaps the most popular painting medium, with a versatility which makes it suitable for any subject and many different techniques.

It is slow drying and you can manipulate the paint on the picture surface for several hours after it has been applied, allowing time for the image to evolve and for changes to be made across the whole painting.

This flexibility also enables you to change the tones of both the subject and the background many times before reaching a final decision – and whole areas can be lightened or darkened to tone with each new element or color as it is introduced into the painting.

There are basically two different approaches to painting with oils. The direct method, sometimes referred to as 'alla prima', involves painting directly on to the canvas or board, often without any drawing or underpainting. A more traditional approach is to plan the picture carefully, and to draw the image on to the canvas in some detail before starting to paint. This is usually followed by a thin monochrome underpainting, which establishes the tones of the picture before the color is applied.

For the flower artist, oil paint invites a broader, more 'painterly' approach than watercolor or other popular flower media. It provides a good opportunity to put the subject into a context and to treat it as part of a composition, rather than paint an arrangement of flowers as an isolated study against a white background.

OIL PAINTS

CANVAS BOARD

DALER BOARD

OIL SKETCHING
PAD

Materials

Absolutely essential oil painting materials include a selection of paints, some brushes, a palette, a bottle of turpentine and something to paint on – such as a piece of board or a canvas. As the medium becomes more familiar, other items can be added, but initially, equipment and materials are best kept to a minimum.

Paints

Oil paints are obtainable in two grades: the best ones are called Artist's colors, the lower grade are often known as Student's colors. The quality is reflected in the price, and many beginners start off with the cheaper variety, changing to the Artist's colors as they get more proficient.

Because the pigments of the Artist's colors are so much brighter and purer, however, the flower painter should start off with at least some of the good quality paints.

Some pigments are less permanent than others, and fade when they are exposed to light or when mixed with certain other colors. Most brands are graded – those with a higher degree of permanence being the most expensive – and it is better to avoid these 'fugitive' colors.

Oil Media

Oil paint is diluted with turpentine in the same way that watercolor is diluted with water. Real turpentine is the best, but you can buy turpentine substitute, or wood alcohol, at a fraction of the cost.

Turpentine on its own produces a dull, lifeless surface, and is usually

COTTON DUCK

WOODEN
WEDGES

PRIMER

HARDBOARD
(SMOOTH SIDE)

HARDBOARD
(ROUGH SIDE)

PLYWOOD

TURPENTINE

used in conjunction with an oily medium to give texture and body to the paint. The most common of these substances is linseed oil. The linseed oil should be mixed with the turpentine in a ratio of approximately 60:40. If you want a thicker mixture which dries more quickly, you can add a little varnish to the turpentine and linseed oil.

Various other media are available to the oil painter, each designed to make the paint easier to handle. Beeswax medium, a mixture of turpentine and beeswax, dries slowly with a mat finish; synthetic resin media, sometimes known as 'gels' give extra body to the paint; Maroger's medium, which can also be purchased ready-made, is another means by which you can bring your palette to life.

Supports

Most oil painting is done on prepared canvas, although wood and paper are both suitable supports provided that they have been properly prepared. Size, price and texture are things you should bear in mind when choosing a surface to work on – purchased supports can be expensive and are only available in limited sizes.

Canvas is the most popular and widely used surface for oil painting. You can buy it from art stores, stretched, sized, and ready to use. Although it is quick and easy, it is also the most expensive way of obtaining a support. Some stores sell unstretched primed canvas by the yard or in rolls.

Commercially prepared boards and canvas boards are also available from art stores. These come in different textures, and a range of sizes, but again, they are expensive items – especially if your output is prolific.

Making supports at home is by far the cheapest solution. You can choose your own proportions and have a stock of cheap surfaces to practice on.

WOOD
ALCOHOL

LINSEED OIL

OUGHT STRETCHED
NVAS

WOODEN
STRETCHER

SYNTHETIC RESIN MEDIUM
(WIN GEL)

NO. 3 ROUND

'TEAR-OFF' PAPER PALETTE

PAINTING KNIFE NO. 4

If you do decide to stretch your own canvases, there are various fabrics to choose from. The best one is pure linen because it stretches well and provides a taut, receptive surface for the paint. Cheaper alternatives are linen crash, cotton, or a mixture of linen and cotton. Wooden stretchers can be purchased in different lengths and fitted together to make rectangles of all sizes.

To stretch your own canvas, assemble the frame by slotting the wooden supports together. Cut your canvas slightly larger than the frame – a margin of about 8 cm/3 in all round should be ample. Place the canvas on the floor and lay the frame on top of this. The wooden supports are often beveled along one edge, so make sure that this edge is facing the canvas. Start with the center of one of the longest sides and fold the canvas round the frame, pinning it or stapling it to the wood. Repeat this on the opposite side of the canvas. Now continue to staple or pin the canvas to the frame, starting at one of these central points and working along to the corner. Repeat this on the opposite section, and continue in this way until all the sides have been firmly fixed.

Whichever fabric you choose, it must be sized and primed before use. Size is a type of glue which dries and tautens the canvas it also protects the canvas from the long-term rotting effects of the primer and paint. The best types are leather waste size, bone glue, and casein size.

When the size is dry, apply a coat of ground to the canvas. This seals the fabric and provides a good surface to paint on. Proprietary grounds are available – be sure to ask for one which is suitable for oil paint – but many artists use ordinary household undercoat paint quite successfully.

Acrylic primers, available from art stores, can also be used for oil paint. Oil primers, however, cannot be used for acrylics.

DIPPERS

PAINTING KNIFE NO. 11

PAINTING KNIFE NO. 6

PALETTE KNIFE NO. 1

NO. 4 LONG FLAT

NO. 6 SYNTHETIC FLAT

NO. 8 SHORT FLAT

For very cheap surfaces, hardboard, cardboard and paper can be quickly cut to any size and easily prepared. As with canvas, the surfaces must first be sealed with size, and given a good coat of ground or undercoat. Hardboard has a tendency to warp, but you can prevent this by nailing two wooden battens to the back.

Brushes
There are various types of brush, each designed for a particular purpose – the stiffer ones are made of hog's hair, and the softer ones from red sable. The basic shapes are round, bright, flat and filbert. Brights and flats are similar, but the flats have longer bristles and are good for long, tapering strokes; rounds are good, general-purpose brushes, and it is useful to have them in a range of sizes; filberts are flattened, but have slightly rounded ends, to produce a more controlled stroke.

These four basic brushes are sufficient for most general purposes, although there are other, specialist shapes, each designed to produce a specific effect. The most useful of these is probably the fan brush, which is specially made for blending colors together.

NO. 8 ROUND SABLE

Palettes
Oil painting palettes are usually made of wood, and these should be treated with linseed oil before use.

Painting and Palette Knives
Painting knives are used for applying paint. Palette knives are longer and more flexible, and can be used for mixing paint on the palette as well as applying it to the painting.

NO. 4 FAN

WOODEN PALETTE

NO. 11 SYNTHETIC ROUND

Sweet Peas

The best way to start with oil paints is to use what is known as the classical approach, a method in which the whole picture is first blocked in using one color. You then work on this monochrome base, bringing the composition gradually to life.

First, you choose one color, which will be a theme running through the whole composition – not one which jars with the overall image. For instance, in the illustrations, the artist has chosen blue, and you can see at a glance that this color, although it does not overwhelm all others, is a constant theme.

The method is one favored by the old masters, especially Rembrandt and Titian. It is also suitable for the beginner, as it helps to break up the process and enables you to deal with one problem at a time – that is, you tackle the tones before introducing color. It also means that when you do introduce the remaining colors, they will quickly become integrated into the picture because you have already established a tonal base.

When you have established the initial image in the 'theme color', you can then build up the picture gradually by painting over it, modifying its tones and bringing out the full clarity in the final stages.

The first stage, however, is crucial. It is here that you have to pay careful attention to tone. You must make sure that you capture the correct patterns of light and shade which will be present at the final stage. You look at your subject and decide which areas are the lightest and which are the darkest. These, and all the tones in between the two extremes, have to be laid down in correct relationship to each other – so you have to ask yourself each time whether a tone is lighter or darker than its neighbor.

There are two ways of helping yourself in this initial establishing of tone. You could imagine you are looking at a monochrome photograph. Here, there would be nothing but tone, and it becomes easier to tell which shades are lighter and darker. Another method is half closing your eyes as you look at the subject. This eliminates some of the color and helps you to see it tonally, in terms of light and shade.

Notice that the subject has been carefully arranged in the first place. The upright vase and the blue cloth have been used to break up what would otherwise have been uncompromising horizontal divisions in the picture.

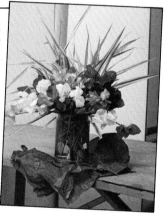

1 In this still-life arrangement *right* the surroundings and the background are almost as important as the flowers. The strong horizontal lines of the table are broken by the carefully placed blue cloth, and the vertical background shapes enclose the radiating pattern of the flowers and leaves.

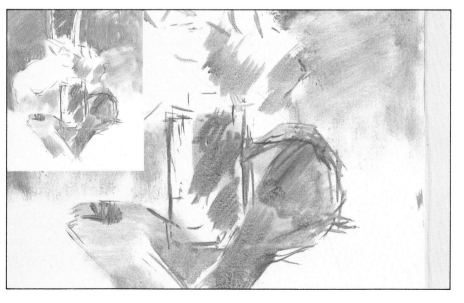

2 The artist uses a No.6 bristle brush to block in the basic lines and shapes of the composition *right*. The paint is thinly diluted with turpentine, and the artist is working in cobalt blue – a color which is repeated throughout the subject.

To establish these basic shapes the artist carefully observes the relative tones of the colors in the subject and roughly sketches these out in the monochrome underpainting. The colors will eventually be painted into this tonal layout.

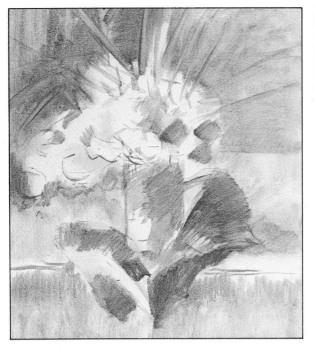

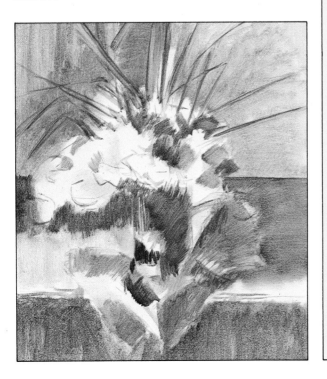

3 The dark tones are strengthened with cobalt and alizarin crimson, and the flower shapes developed in more detail *above*.

4 The artist works into the foliage, gradually introducing green, brown and grey into the painting *below*.

BUILDING UP COLOR

When you have completed the tonal underpainting, it is time to start adding color. Try not to be too inhibited or to stick too rigidly to the monochrome base – use it as an approximate guide.

Here the artist is adding bold areas of local color, working over the blue underpainting which shows through in places to give a harmonious theme to the picture, and coordinates the composition.

5 The artist works into the flowers, drawing in small shapes of red, pink and white *right*. Form and solidity are suggested by variations of density and tone.

Depth of tone and color intensity are increased as darker, stronger colors are worked into the picture *below left*. The blocks of solid color. are applied with the No. 6 bristle brush; some of the drawing is refined with the tip of a No. 3 bristle brush.

The artist completes the picture by brushing over the background with a thin layer of blue mixed with a little red *below right*, and develops the blues in the foreground with a full range of dark and light tones. Small dabs of color are added to the flowers, and the foreground tone is darkened to pick up the dark tones in the rest of the picture.

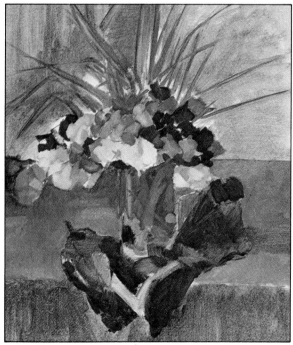

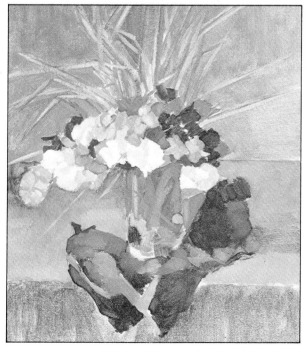

What the artist used

In this painting the artist used oil paint diluted with pure turpentine and linseed oil – these were mixed in the proportions of 6 parts oil to 4 parts turpentine. A little gel medium was added to give extra body to the paint.

Cobalt blue was the most important color on the artist's palette because this was used for the monochrome underpainting – a color which seemed to be repeated throughout the whole still-life arrangement – although, traditionally, a more neutral color, such as a raw sienna or burnt umber, would have been used for the tonal blocking in. However, there is no reason why any other color should not be used instead.

The artist chose oil paint as the best medium for this type of subject. It keeps its true color as it dries, unlike watercolor which tends to lose its brilliance. It also mixes more subtly than acrylics and can be manipulated on the surface for several hours before it starts to dry. This makes it the most suitable medium to describe the range of vivid color and the veiled shadowy hues of the subject.

A prepared canvas board measuring 16 × 20 inches was used because the artist wanted to start work immediately before the short-lived subject had time to wilt, otherwise a stretched canvas would have been equally suitable.

The artist used two flat bristle brushes – Nos. 3 and 6 – and a No. 5 filbert. Most of the initial blocking in was done with the large flat bristle brush.

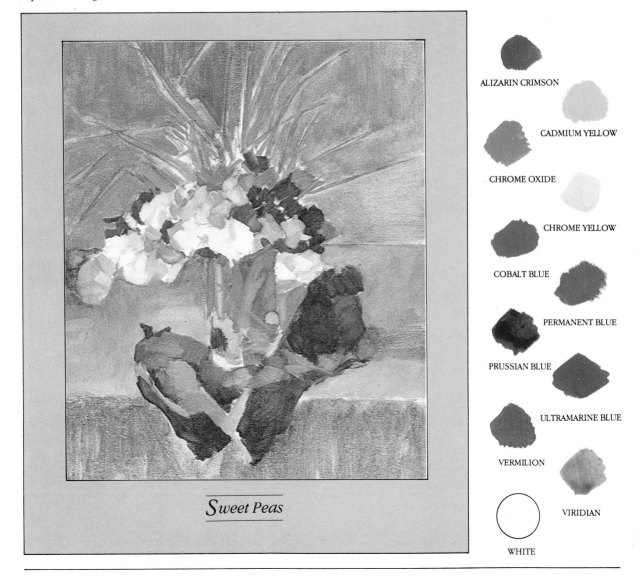

Sweet Peas

ALIZARIN CRIMSON

CADMIUM YELLOW

CHROME OXIDE

CHROME YELLOW

COBALT BLUE

PERMANENT BLUE

PRUSSIAN BLUE

ULTRAMARINE BLUE

VERMILION

VIRIDIAN

WHITE

In the Conservatory

Usually flowers appear in paintings against simple backgrounds. They stand out against plain walls, or are quite often simply painted as cutouts against white paper.

Here, we have an exception. What interested the artist about this scene was the contrast between the organic, growing shapes of the flowers and plants, and the inflexible manmade structures around them. The spiral staircase is a particularly interesting example of the 'hard' shape, because in this case the winding spiral also echoes – in its own architectural way – the curving shapes of the plants. Therefore we have contrast, yet a kind of harmony at the same time.

The artist did not paint this picture on the spot, but used a selection of drawings and then borrowed different components from each to put together into a composition.

This is an oil painting, but to begin with, the artist painted a wash of mid-green over the whole board in acrylic. The acrylic dried quickly, allowing the artist to start painting almost straight away.

Mid-green had a special task. The artist wanted to get rid of the bright white of the primed board, because it is impossible to see colors and tones correctly when surrounded by this glaring brightness. Mid-green is a tone from the middle of the color spectrum. Thus the artist had a 'signpost' against which to compare each color, showing it up in its true tone instead of being distorted by too much brightness.

The picture also exploits an important characteristic of oil painting. When oil is laid thickly, the painting has another dimension – that of the texture of the paint itself. This technique is known as 'impasto', and the artist has used impasto brushstrokes to emphasize the shape and form of the plants. A good example is the white flower in the foreground, where the heavy paint has been used to give an impression of the velvety texture of the petals.

There is an opposite technique, called 'glazing'. This is when a very thin layer of paint is laid over another color. It enables one color to be seen through another, producing a shimmering or translucent effect.

The two techniques can be used together. You can glaze over impasto, achieving both texture and translucency.

2 The artist gives the primed board a coat of green acrylic to block out the bright white background and to establish a medium-toned background on which to work. The outline is then drawn with charcoal *above*.

3 Using the green base as a middle tone, the artist blocks in the darker colors with thin paint. A mixture of sap green, cadmium green pale and oxide of chromium is used for the broad areas of background foliage *below*.

1 This painting is being done in the studio from the black and white sketch *right*. The artist uses the drawing as a rough guide, relying on imagination and memory for color and some parts of the composition.

4 This initial blocking in is done with a large brush – here the artist uses a No. 11 bristle brush and a mixture of sap green and burnt sienna *left*. At this stage it is not necessary to worry about detail or accuracy.

5 The light tones of the staircase are painted in white, the shaded areas being a mixture of white, ultramarine and black *below*. When painting architectural shapes such as this, the structural lines must be accurate. One wrong or indecisive element can put the whole construction out, so the artist looks carefully before painting the stairs correctly and confidently.

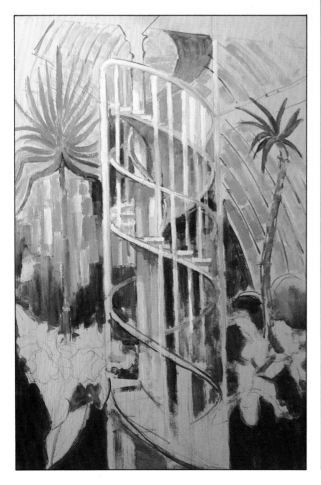

IMPASTO AND GLAZING

Impasto is often used when a thick, textural effect is required. Apply the paint with a brush or knife, without adding any turpentine or thinner to the mixture.

This can be used in conjunction with glazing, which produces a thin, transparent layer of color. Do not dilute the paint with turpentine alone, because this makes the color go flat and dull. Instead, use a special glazing medium, available from art stores. It is possible to apply several layers of glaze, without obliterating the colors underneath.

IMPASTO

GLAZING

6 The flower shapes are blocked in boldly and thickly, and the direction of the brushstrokes used to form the petal shapes *above*. Here the artist is using a No. 4 flat bristle brush.

7 Gradually the artist establishes the tones of the composition, darkening the foreground areas and developing the lighter parts, such as the panes of glass *right*.

8 Working across the whole picture, the artist adjusts the tones, changing certain colors by making them lighter or darker to relate more accurately to the tones and colors around them. The panes of glass are lightened *above left* and the staircase shadows made darker *above right* to tone with their surrounds.

9 Interesting textures can be obtained by brushing stiff, undiluted paint across another color *left* and *right*. This technique is sometimes referred to as 'scumbling'.

What the artist used

All the brushes used for this painting were of the flat variety – Nos. 3, 6, 7 and 11 – with the exception of a No. 6 sable which was used for some of the details.

The oil colors were mixed with turpentine and linseed oil, in the approximate proportions of 6 parts linseed oil to 4 parts turpentine. This was done to improve the texture of the paint and make it easier to apply.

The artist used a special glazing medium where it was desirable to make the color transparent. Although it is possible to dilute the paint with turpentine alone, this is not good practice because the color often looks dead and the binding power of the paint is weakened, sometimes resulting in a cracked surface.

The hardboard support measured 36 × 24 inches and was treated with oil primer. In this case the artist used the smooth side of the hardboard to work on, but it is quite possible to paint on the rough surface when a more textural effect is required. When working on large pieces of hardboard, pin narrow battens of wood lengthways on the back of the support to prevent it from bending.

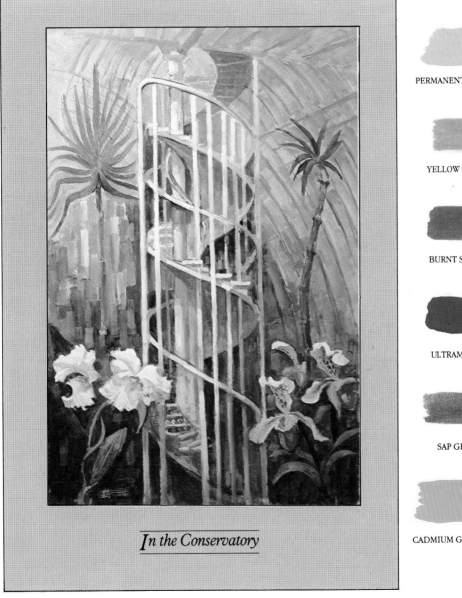

In the Conservatory

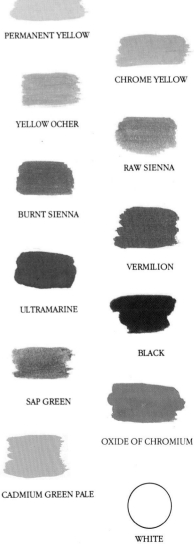

PERMANENT YELLOW

CHROME YELLOW

YELLOW OCHER

RAW SIENNA

BURNT SIENNA

VERMILION

ULTRAMARINE

BLACK

SAP GREEN

OXIDE OF CHROMIUM

CADMIUM GREEN PALE

WHITE

Red Geranium

A potted plant such as this geranium, can be quite a daunting subject, with its several stems, mass of leaves and complex flowers. All the growth radiates from the main stems, creating a complicated arrangement of shapes and spaces.

Take time to look at the subject and to think about how you are going to paint it. The arrangement of the composition is entirely within your control, so move the plant around and consider the appearance from different viewpoints. In this case the artist decided to put the geranium against a two-tone background so that the light and dark shades on the flowers and leaves would be seen differently against the two contrasting shades.

As you start to lay in the preliminary drawing, look carefully at the shapes. Do not try to interpret the subject, or you will become confused by the small details of the leaf and petal shapes. In this initial stage you should try to establish the main shapes rather than try to draw 'a plant'. Your plant will look much more like a geranium if you concentrate on the main shapes and forms rather than try to draw what you think a geranium should look like. If possible, try to treat the familiar plant like a completely unknown object, something you have never seen before and cannot put a name to. This will force you to look at the plant with truly inquiring eyes.

Get into the habit of putting out more colors on the palette than you will actually need. Don't limit yourself to the obvious colors which you know you will use. If you haven't put out a color, you may be tempted to do without it – to the detriment of your painting.

Of course, there are occasions when you will deliberately start out with a limited range of colors on your palette – this is a different matter, not just laziness or meanness!

When you are confronted with a confusing mass of tone and color, as is the case with the leaves and petals of the geranium, try to make life easier for yourself. Limit the tones of each color, rather than try to mix every little variation separately and exactly. The artist here mixed a range of four reds and four greens, and used these few tones for all the leaves and blooms.

Lay the colors side by side in small patches, leaving the colors to work with each other, rather than blending them together. In other words, let the colors mix in the eye, or 'optically', rather than on the support.

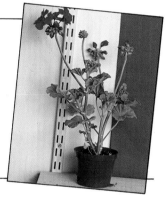

1 The potted geranium *right* has several stems with leaves radiating outward from each one. Although it is a complicated subject, the artist felt it needed the added interest of the shelf and divided background to transform it into a satisfying composition.

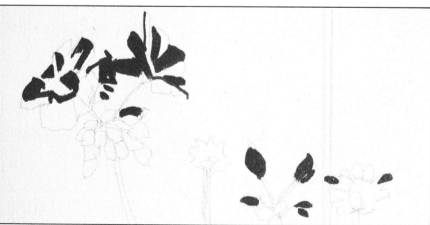

2 A detailed line drawing is done on the canvas with a B pencil *left*. The artist simplified the painting by reducing each main color – the red and the green – to a limited number of tones. Starting with the flower, the medium tones are applied in scarlet lake *above* in small, flat areas of color.

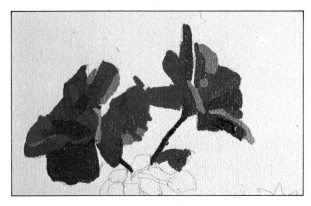

3 The dark and light tones are added *above*. For the darkest red, a mixture of scarlet lake and black is used; for the light areas, scarlet lake and white.

4 The greens are treated in a similar way *left*. For the dark tone the artist uses chrome green, yellow ocher and a little red. The light green is mixed from sap green and white.

USING A MAHLSTICK

A mahlstick is a long cane with a pad at one end which is rested on the canvas to steady the arm. They can be bought, but are actually very easy to make with a bamboo cane and a bundle of rags.

Here the artist is resting the pad on the canvas, but if the paint is wet, it can be rested on the edge of the stretcher to prevent smudging.

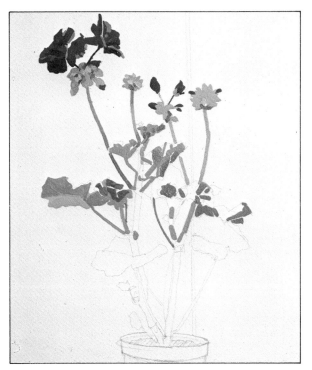

5 The plant is partially blocked in with the basic green and red tones *left*. Remember it is easier to pick out the different tones of a subject by looking at it through half-closed eyes.

6 Using a No. 3 sable brush, the artist defines the inside of the pot with black paint and uses dark reddish brown for the inside rim *right*.

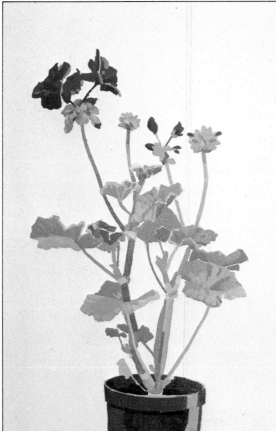

7 The pot is completed in the same simple areas of color *above*. Notice how the flat shapes combine to give the impression of a three-dimensional object.

8 The painting is near completion *right*, but the background is too stark and awaits the addition of the darker color.

10 For the lighter section of background, white is mixed with small amounts of colours used elsewhere in the picture *above*. This off-white is less stark than pure white and integrates the background into the rest of the composition.

The artist takes the color up to the edge of the plant, carefully redefining the leaves *below left*.

Again, the shapes of the leaves and flowers are redefined *below*. Here the artist is using a mahlstick to prevent the wet paint already on the canvas from getting smudged.

9 With a sable brush and a ruler *left*, the background is carefully divided into two unequal sections. The warm brown echoes colors used in the painting.

What the artist used

In this painting the oil color was mixed with turpentine and linseed oil. These were used in the most usual proportions of 6 parts oil to 4 parts turpentine.

The outline was drawn in some detail with a B pencil, and the artist chose flat bristle brushes Nos. 2, 4, 6 and 8 for most of the blocking in. Fine details were added with a No. 3 sable brush.

A mahlstick was used to support the artist's hand because of the large areas of background color and the slow-drying characteristic of oil paint. Mahlsticks are available in different sizes, and should be chosen according to the scale of the work in hand. Traditionally they have a bamboo handle and a chamois leather pad, although nowadays they are available in other materials, notably aluminum with rubber pads.

The support is stretched cotton duck treated with acrylic primer, measuring 20 × 16 inches. Cotton duck was chosen because it has a more regular weave than linen canvas and the artist wanted an even surface for this particular painting. Two coats of acrylic primer were applied directly to the stretched canvas.

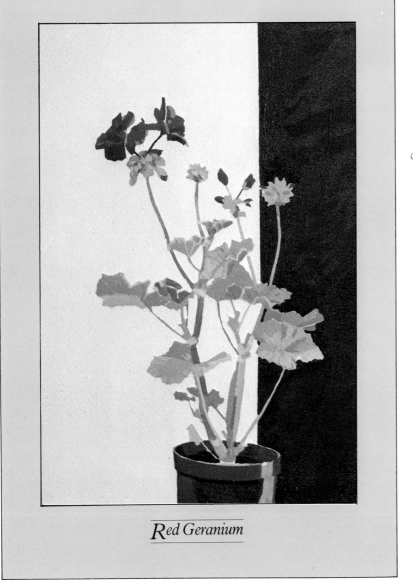

Red Geranium

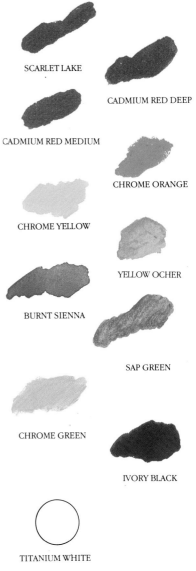

SCARLET LAKE

CADMIUM RED DEEP

CADMIUM RED MEDIUM

CHROME ORANGE

CHROME YELLOW

YELLOW OCHER

BURNT SIENNA

SAP GREEN

CHROME GREEN

IVORY BLACK

TITANIUM WHITE

*A*crylic

The use of acrylics in flower painting is one of the latest and most modern techniques. Acrylic, a paint based on synthetic resin which was developed in the 1920s, was originally used by mural painters because oil paints did not last long in exterior weather and polluted conditions. It soon gained popularity as an art medium for indoor as well as outdoor work.

Acrylic is versatile. It can be used thickly, like oil paint, or it can be diluted to make a material very like watercolor.

The American abstract expressionist, Jackson Pollock, used acrylics in the thickest possible way, squeezing and dribbling them on to his enormous canvases, sometimes building up an almost three-dimensional effect. In contrast, acrylic was used very thinly – practically as a stain – by the American abstract painter, Mark Rothko.

In some ways acrylics have not yet been fully explored. Painters tend to use them as substitute oil paints or watercolors, rather than in their own right. And acrylics are never really successful when pretending to be other media.

Do not be too disappointed when first using acrylic. It is a medium which takes practice to master. Although you can put it on to the canvas like oil paint, it dries quickly and is not a flexible, soft material like oil. You can however buy retarders to slow down the drying, and there are other media which make it shiny or mat, give it more body, and so on.

Although you may not be happy at first with acrylics, you will have the satisfaction of knowing that you are becoming familiar with a material in which some of the most exciting new developments in art are likely to be made. We have probably not yet seen the best of acrylics in the world of fine art.

ACRYLIC PAINTS

Materials

The main advantage of acrylics is that they are harder and more permanent than traditional media. They are also resistant to atmospheric conditions, such as oxidation and decomposition and, once they are dry, they keep their color and texture.

Paints

You are in a very modern world with acrylics, and one of the exciting results of this is the production of some new colors. These have impressive techno-scientific names like Indanthrene blue, Napthol crimson, Dioxazine purple and Phthalocyanine green – colors which come from the new chemical combinations and are produced as a result of laboratory research.

But you will also find the traditional colors lined up alongside these ultra-modern ones. You should beware of piling too many colors on your palette, which can only cause confusion when you can probably achieve all you require with a range of about twelve colors.

Several paint manufacturers produce their own range of acrylics. The cheapest are PVA colors, but they are also the least permanent. Other brands with large ranges of colors are Winsor and Newton's acrylics, Rowney's Cryla, Liquitex and Aquatec.

You are not confined only to the basic acrylic paints when you use this medium. Acrylics are particularly useful because they can be mixed with other materials. They are used a great deal for collage work, which is a

SHEET OF GLASS

THICKENER

MAT MEDIUM

BRUSHMARK MEDIUM

MODELLING PASTE

TEXTURE MEDIUM

method of sticking one material on top of another. A characteristic which makes acrylic ideal for collage is that it is adhesive, so you can actually stick a shape or cut-out directly on to the wet paint. For flower painters who are more interested in the design aspect of the subject, this method is easy and quick to use and opens up exciting possibilities of working with new effects and color.

Another very useful aspect of acrylic paints is that they can be used with oil paints. The two types of paint cannot literally be mixed because one is water based, and the other oil based, but acrylic can be helpful in the early stages of oil painting. For instance, you can block in the main shapes of a composition with acrylic, and then paint in the more advanced stages in oil. An advantage here is that the acrylic dries in minutes, allowing you to press on rapidly with your second stage, whereas oil may take days.

For covering large areas of flat color, Rowney's special 'Flow Formula' paint is suitable. It is very liquid compared to ordinary acrylic, and yet it retains its opacity.

Media

When you use acrylics, you can buy various substances, or media, which you can then mix with the paint to achieve different effects. Two principal types of medium are those which make the paint shinier, and those which make it more mat. Another useful medium is a retarder, made of glycerine, which prevents the paint from drying instantly and gives you more time to correct the image, adjust the tones and manipulate the paint.

Acrylics have often been used as a substitute for other types of paints, but less often for their own characteristics. Acrylics have a certain lightness and delicacy. They can be diluted to produce subtle effects, which makes them

MAT PICTURE VARNISH

WHITE PLASTIC PALETTE

GLOSS PICTURE VARNISH

69

SYNTHETIC FAN NO. 14 SYNTHETIC FLAT NO. 8 SABLE FLAT NO. 4 SABLE ROUND NO. 6 FILBERT

HARDBOARD
(SMOOTH SIDE)

particularly interesting in the painting of flowers. As you will find later, you will be able to tread new ground by experimenting with the dilution effects of acrylics to represent the water transparency of some of the world's most delicate flowers.

You do not have to buy acrylics in tubes. If you need large quantities of paint, you can purchase acrylic in powder or liquid pigments, and then mix them with raw acrylic medium, a binding gel which is easily obtainable from art stores.

NO. 7 SHORT FLAT

Brushes

For acrylic you use basically the same brushes as for oil paint or watercolor, depending on how thick or thin you are using the paint. But because acrylic dries so quickly the brushes are easily ruined unless washed immediately after use. This point cannot be stressed enough. Many artists find that synthetic brushes are easier to use and keep clean when using acrylics.

As with oils, be selective about buying brushes rather than wasting money on a wide range, and concentrate on acquiring a workable collection of a few useful sizes and shapes.

Supports

Supports, too, are similar to those used in oil painting, with some

HARDBOARD
(ROUGH SIDE)

PAINTING KNIFE NO. 10

PALETTE KNIFE NO. 7 PAINTING KNIFE NO. 1

PLYWOOD

WOODEN STRETCHER

BOUGHT STRETCHED CANVAS

NO. 4 LONG FLAT

NO. 8 ROUND

difference in the way they are treated.

You do not need to size the surface as you would with oil paints, but a special acrylic primer, obtainable from art stores, is normally used. Oil grounds and primers cannot be used because after a short time the acrylic paint would begin to come off. Nor are ordinary emulsion grounds compatible with acrylic.

You can purchase specially prepared boards and canvases, but make sure they have been treated for acrylics and not for oils.

If you do not want to spend a lot of money, there are cheaper alternatives. Hardboard, cardboard and paper can be used – again, treated with the appropriate acrylic primer. Only good quality thick paper should be used. As with oils, it is possible to stretch your own canvases as described in the oil painting section. Remember to use acrylic primer instead of the treatment recommended for oil paint.

Other Equipment

There is not a lot of difference between the other items of equipment you would use with acrylics, and those used for oil and watercolor. The only real exception is that it is better to obtain a white, plastic palette instead of the usual wooden one, because it is easier to clean off the hard acrylic paint from a plastic surface.

PRIMED
CANVAS BOARD

PAINTING KNIFE NO. 6

PRIMED PAPER

ACRYLIC PRIMER

PRIMED BOARD

71

Anemones in an Earthenware Jar

In this painting of a jar of anemones, the color was built up from thin washes of acrylic paint.

The artist found the work difficult, because the colors in the flowers were particularly luminous and it underlined a slight tendency of acrylic paint – for some bright colors to lose their brilliance when they dry. Nevertheless, the artist carried on, trying to increase the impact of the color by placing the flowers in a neutral-colored vase, on an equally drab-colored wooden box. The idea was that this would show up the color of the flowers.

It was decided that the only way to arrive at these vivid colors, and avoid a 'dead' look, was to build up the picture in glazes rather than use the paint thickly. This tendency is particularly common when using light colors. For instance, if you try to mix white and red to get a light red, the white will make the color look chalky. The best way to achieve your result is to put the red on thinly, so that the white paper plays a role in the final color.

In this case the artist made a feature of the symmetry of the composition, instead of trying to offset it. Because the flowers were the focal point, and the only strong color in the picture, it was decided to emphasize this by making them quite small in relation to the rest of the composition and to surround them by a wide expanse of light, neutral-colored background.

When you are working in this way, building up layers of transparent paint, you cannot work from dark to light. In other words, you cannot start with the dark colors and hope to paint light ones on top of them. In this painting the artist used acrylic as a wash, laying the pale colors in first. But if the paint had been used thickly, without being heavily diluted with water, the acrylic would show its usual opaque qualities and good covering capacity.

In order to achieve the effect of the grain on the wooden box, first paint in a light wash – the equivalent of the lighter tone of the wood. When the wash is dry, paint over this in a darker tone of the same color, rolling the loaded brush across the paper to give the impression of the grainy wood texture.

2 A B pencil is used to make an outline drawing of the subject *left* on stretched watercolor paper. The drawing is done in some detail to act as a guide for the eventual color, but the lines are kept faint to prevent them showing through the washes of paint and affecting the final picture. Plenty of space is left around the subject to avoid the flowers looking cramped.

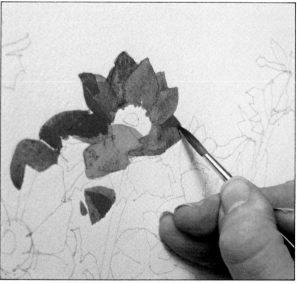

1 The bright anemones are deliberately arranged in neutral surroundings *right* to show off their brilliant colors to the best advantage. The artist wanted a simple, symmetrical composition, so the flowers were placed centrally on the wooden box against a plain white wall.

3 The artist uses a No. 4 sable brush to block in the main petal shapes *above* with a very diluted mixture of cadmium red medium, napthol crimson, cobalt blue and ultramarine.

4 The remaining flower shapes are filled in *left* with washes of thin color, and the darker areas of the red flower are made by building up deeper-toned washes of the same color.

5 The artist adds the lightest tones to the petals *below* by mixing white with the main color. The addition of white makes the color opaque and chalky, and these pastel tones should be restricted to the highlight areas and not allowed to affect the transparent quality of the main colors.

6 When the first wash is completely dry – this only takes a minute or two – a deeper wash of the same color is added for the dark areas of the flowers. The artist is painting in the ridged texture, and is paying careful attention to the shapes of the shadows which indicate the form of the petals *right*.

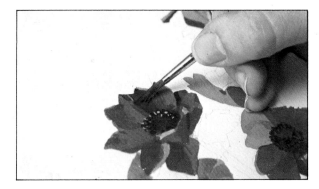

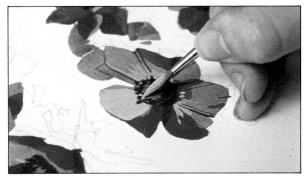

7 The dark centers are added and the flower heads completed in detail *right* before the artist moves on to the next part of the picture.

8 Chrome green and cadmium yellow make the leaf wash, with the addition of a little black for the darker tones. Light washes are put on the wood and vase *below*.

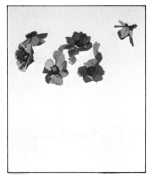

MAKING WASHES

Acrylic can be mixed with plenty of water to make thin washes of color. These can be built up in layers – as the artist is doing in the picture – to produce bright, translucent colors. Applied in this way, the color retains a brilliance which is sometimes lost when the paint is used opaquely.

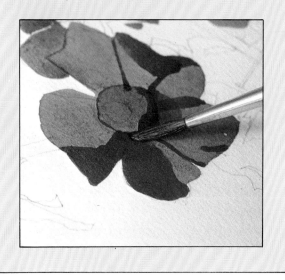

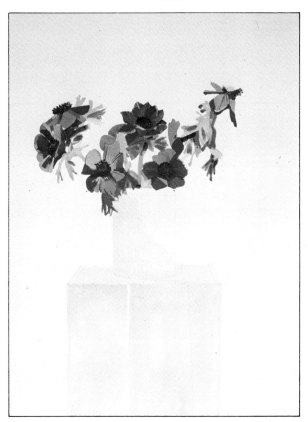

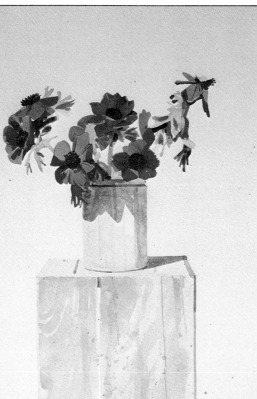

9 A wash of black, raw sienna and ultramarine is laid for the flower shadows *far left*. This is painted very thinly and applied quickly, the whole shape being filled in before the color has time to dry and create unsightly tide marks.

10 The dark areas of the wooden box are developed, bringing it into line with the tones established on the rest of the image *left*. Loose washes mixed from raw umber and black are used for the shadow of the vase and to suggest the wood grain on the box.

11 A thin wash of Payne's grey is applied to the background with a sable brush *far left*. The color is put on quickly because of the quick-drying acrylic paint, although the artist likes the slight blotchiness because it adds texture to an otherwise flat surface.

12 The background color is carried into the vase and the wooden box. Here *left* the artist is emphasizing the pattern of the wood grain by rolling the color on to the surface in loose loops with the side of the sable brush. The background color is also used to obliterate any remaining white patches.

13 Finally, pure white is used to bring out the highlights on the glossy surface of the vase *above*. These highlights are merely spotted in with the point of the brush because too much bright white would make the image look flat and would dominate the picture.

What the artist used

For this painting the artist used just two brushes – Nos. 3 and 6 sable. The support is Bockingford watercolor paper measuring 14 × 20 inches which was stretched before use. This was thought advisable because of the large areas of background wash which might have caused the paper to buckle.

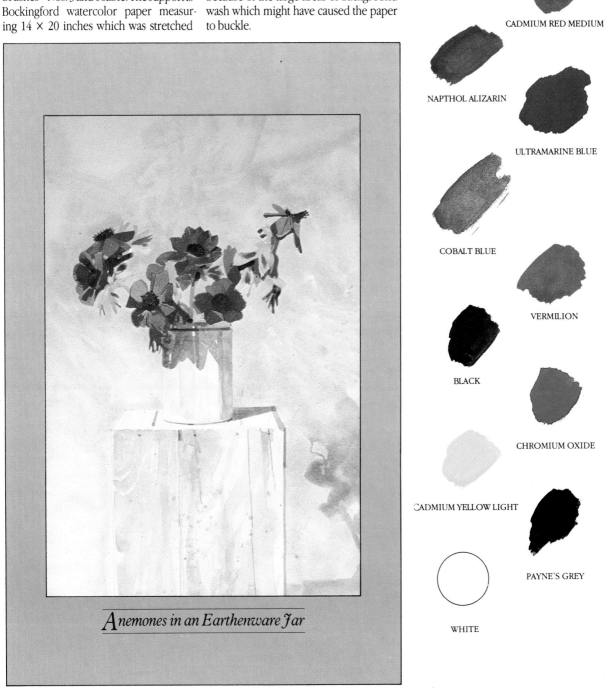

Anemones in an Earthenware Jar

CADMIUM RED MEDIUM

NAPTHOL ALIZARIN

ULTRAMARINE BLUE

COBALT BLUE

VERMILION

BLACK

CHROMIUM OXIDE

CADMIUM YELLOW LIGHT

PAYNE'S GREY

WHITE

Sprig of Berries

Acrylic can be applied thinly to get an effect which is not unlike watercolor, and which can be easily painted over and worked into to produce stronger colors and to develop the image. To make the most of this versatile medium, you should try to become familiar with all its many characteristics.

One way of doing this is to set out deliberately to include as many techniques as possible in the same picture. This involves making a conscious effort to imitate other media, such as watercolor, gouache or oil. It is a good way to familiarize yourself with acrylics and by this means you will learn what the medium is capable of, and how the various techniques can be effectively combined in one painting.

In this picture, the artist started by laying in the background with a thin wash. This traditional oil painting technique blocked out the stark whiteness of the paper and, although the background wash was considerably developed later, it provided an initial base for the addition of further color.

Notice how the sprig was left white so that the berries and leaves could be added without their color being affected by an underlying background color. This is a technique more often used with watercolors, because the extreme transparency of watercolor paint makes it essential to keep the colors separate, but it is also necessary with acrylics when the paint, as in this case, is being applied fairly thinly.

Because the paint dries so quickly – almost instantaneously – you will not be able to manipulate or work into the wet paint once it has been applied to the paper. But the paint is opaque enough to enable you to cover one layer with another quite easily, even when putting light paint on top of dark.

You will need to adjust the color continually to get a satisfactory arrangement of tones. This can be done directly onto the paper, because the instant drying makes almost immediate overpainting possible.

Here the artist blocked in the general leaf tones in a medium green, and added the lighter and darker tones in a thickish mixture. Used like this, acrylic feels and looks rather like gouache, and has the same opacity and rich density of color. This opacity can be maintained if you lighten the tones by mixing them with white rather than by diluting the paint with water.

Titanium white has extremely good covering power, and a very small quantity of it will lighten any colour and make it opaque. Alternatively, instead of using white paint, you can mix gesso with your colours to increase their covering power.

1 The berries *above* are simple, yet interesting and colorful, for this demonstration of acrylic.

2 After stretching a piece of heavy watercolor paper on a drawing board, the artist sketches in the broad shape of the subject and applies a thin wash of gold ocher around the outline of the sprig *right*. The paint is diluted with water and put on in rapid, lively strokes with a No. 6 sable brush. A little raw umber is mixed with the gold ocher for the shadow color. When acrylic color is to be strongly diluted with water, a little mat or gloss medium can be added to the mixture to maintain the binding properties of the paint.

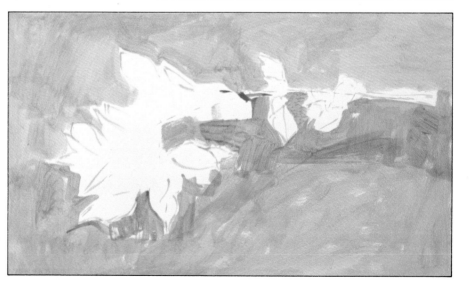

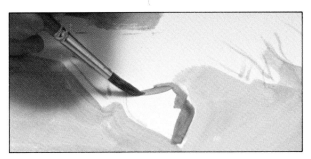

3 After putting in the background color, the artist blocks in the leaves in chrome green using a No. 2 sable brush *above*. The color consistency should be thick enough to paint clean, opaque strokes.

4 Continuing with the chrome green, the artist blocks in the remaining leaves *below*. The tones are varied by mixing the paint with more or less water to change the degree of transparency.

APPLYING OPAQUE COLOR

Undiluted acrylic has a fairly stiff consistency, although this varies from color to color and some paints are specially made to a more liquid formula. In these cases, the paint can be applied directly without being diluted.

Usually, however, the paint must be diluted with a little water or medium to a thick creamy consistency. To achieve flat areas of color, with little or no signs of brushwork, it may be necessary to apply more than one coat of paint.

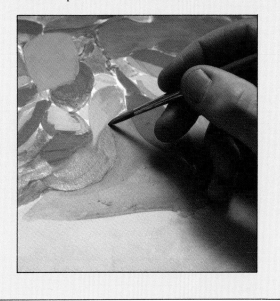

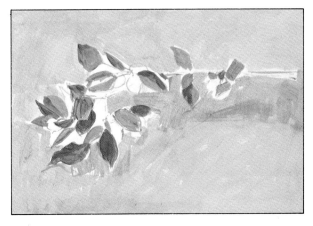

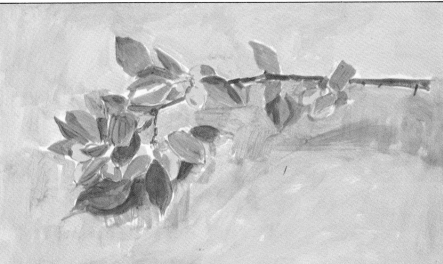

5 The wooden branch is painted in with a mixture of vermilion and burnt sienna, and the berries with a mixture of lemon yellow and vermilion. Deeper shadows are worked into with raw umber and gold ocher *left* – the darkest shadows being those immediately beneath the branch.

When using acrylic paint it is possible to make continual adjustments to the colors and tones in these early stages because the paint dries quickly and makes overpainting immediately possible.

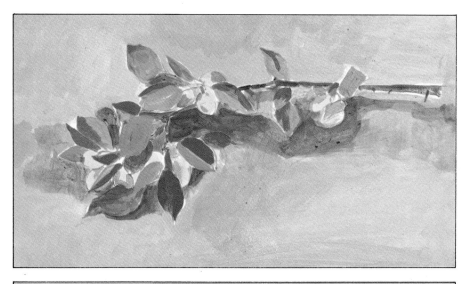

6 Using gold ocher mixed with white, the lighter background areas are blocked in. By adding white to a color to lighten it, rather than diluting it, the opacity of the paint is preserved. The artist darkens the leaf tones with chrome green and a small amount of black *left*.

7 Here the lighter tones are added to the leaves with a mixture of white, yellow ocher and chrome green, the direction of the brushstrokes being used to indicate the shape of the leaves. Vermilion is added to emphasize the darker berry tones *below left*.

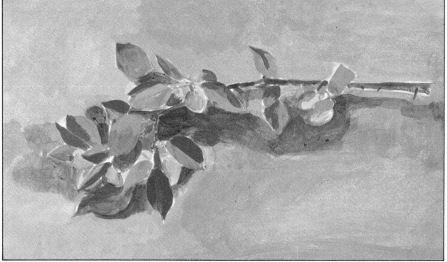

8 Raw umber mixed with gold ocher is used to strengthen further the shadows underneath the branch, and the existing leaf tones are worked over with a darker, more opaque green *bottom left*. This causes the subject to stand out as a clearly defined shape against the darkened background area.

9 A No. 2 sable brush is used to define the leaf details in chrome green, yellow and white *below*. Finally, the shadow is darkened to provide greater contrast.

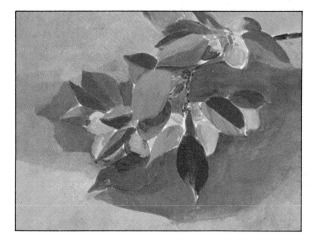

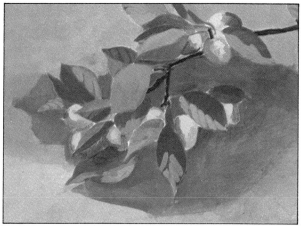

What the artist used

For this acrylic picture, the artist chose a palette of 10 colors and diluted the paints with water. The color was used both opaquely and transparently, combining the qualities of oil paint and watercolor.

The subject was sketched in with a 2B pencil on a piece of heavy watercolor paper which the artist stretched on a drawing board for extra support. The paper measured 18 × 14 inches.

Most of the work was done with a No. 6 sable brush, and the details painted in with a No. 2 sable. The artist used a synthetic white palette for mixing the colors because it is much easier to clean dried acrylic from a plastic surface than from a wooden palette.

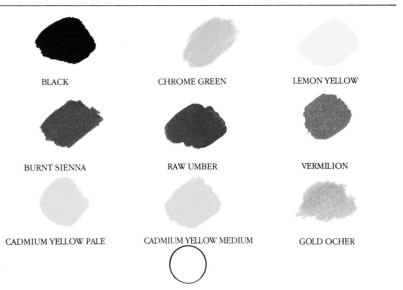

BLACK

CHROME GREEN

LEMON YELLOW

BURNT SIENNA

RAW UMBER

VERMILION

CADMIUM YELLOW PALE

CADMIUM YELLOW MEDIUM

GOLD OCHER

WHITE

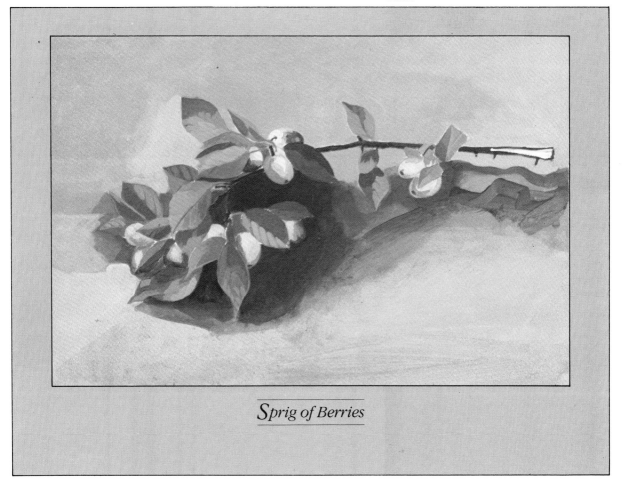

Sprig of Berries

Irises in a Green Vase

ACRYLIC WITH OIL

The work began on the irises illustrated on this page even before the artist picked up a brush. Because the vase of flowers was such a symmetrical shape, it was vital to arrange the composition of the actual subject in reality before starting to paint.

The vase of irises could have produced a stiff, boring picture, but the artist counteracted this by lighting it from one side to produce interesting, elongated shadows.

On the canvas, the artist has also paid careful attention to composition. The picture has been divided into three rectangular shapes, using the shelf and the side of an alcove. The composition has been balanced by moving the vase to one side, so that it interacts with the rectangles.

There are two main factors about this painting. The artist has used oil and acrylics together; and masking tape has been used as a stencil to achieve the clear cut-out characteristics of the highlights and shadows on the vase and some of the leaves.

The use of acrylic has worked well in this case. Many people combine oil and acrylic in this way because oil takes a long time to dry, whereas acrylic dries almost instantly. Normally, with oil, you would block in your first stage of basic colors and tones and then have to wait. If you use acrylic for this first stage, you can go ahead almost straight away.

By continuing in oil, which is slow drying, you will be able to maneuver the paint on the surface of the canvas when completing the more intricate stages of the work.

Masking tape can be useful in order to achieve a sharper edge. In this painting it was particularly effective for defining the curving planes of light and shade on the leaves. Although it is basically a simple technique, you have to be careful. You must make sure you have pressed the tape well down. If you don't, the paint can seep under the edge of the mask and bleed into the picture. It is also essential to use a sharp scalpel or blade, or the edge will become ragged and the whole point of the technique is lost.

In this painting the artist took a little creative license: some extra leaves, which were not in the subject, were painted in to improve the balance of the composition.

Some purists may not approve, but many artists feel that the important thing is the finished work, and that the subject is merely there to inspire the composition rather than to be slavishly copied.

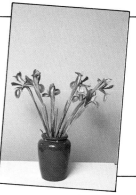

1 These tall elegant irises in the glossy vase *right* are placed against a cool background to emphasize the cold blues and greens in the arrangement. The artist uses the blurred, elongated shadows as a positive element in the arrangement.

2 A deliberately off-center composition is chosen to counteract the rather symmetrical subject, the artist first making a careful outline drawing with a B pencil *left*.

3 Because the artist intends to add the paint systematically, the drawing is detailed enough to act as an accurate guide, indicating each area of tone and color *above*.

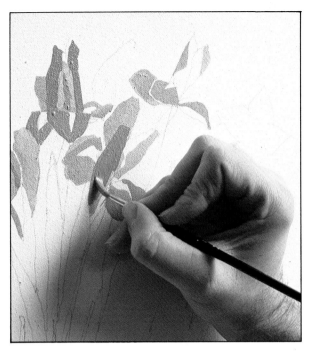

4 A main purple color is mixed for the irises from acrylic ultramarine, white, black and a little crimson. For the lighter areas *above* the artist adds more white.

5 The paint is well diluted with water, to avoid a shiny finish, and the irises are developed from light to dark, each tone being completed in flat, patches of color *right*.

6 The artist paints the leaves in three tones of green mixed from chromium oxide, ultramarine blue and white *below left*. More white is added to the lighter tones.

7 The main flower colors are blocked in with fast-drying acrylic *below*. Notice how the artist keeps the color flat without trying to blend the paint at this stage.

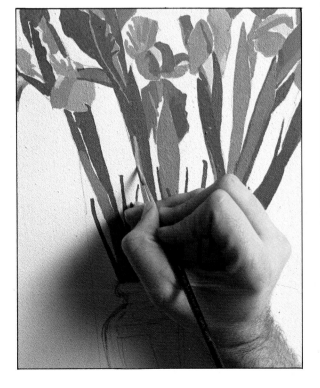

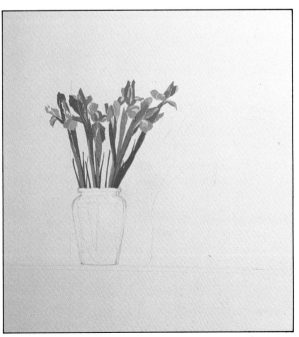

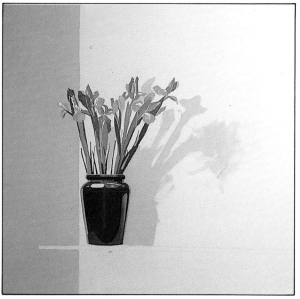

8 The main shape of the vase *above* is blocked in with a mixture of emerald, chrome oxide and raw umber. The artist paints the highlights using the basic vase color with added white and yellow ocher

9 A No. 7 bristle brush is used *right* to block in the background shadow on the left of the picture. This dark shape, painted in a mixture of grey and ultramarine, is important to the balance of the rather formal composition.

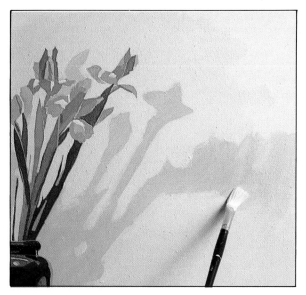

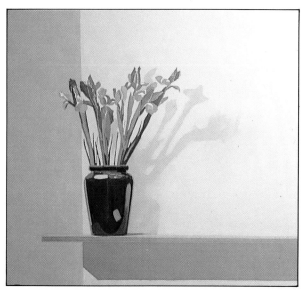

10 A very light grey background *above*, made from white with touches of black and ultramarine, is painted in. The artist uses the pale grey to redefine and redraw the shapes of the flowers, and to soften the shadows. When using fast-drying acrylic paints for large areas in this way you must work quickly.

11 The dark shadow under the shelf completes the acrylic blocking-in *above right*. This dark strip divides the square canvas into three definite geometric shapes, the straight lines providing a contrasting setting for the organic flower forms. The dark shadow color is mixed from black, titanium white, ultramarine and raw umber.

12 For the final details *right*, the artist changes to oil paint because the color is slow drying and easier to manipulate. The flowers are developed in dark blue, mixed from ultramarine, alizarin and white. Oil color is also used for the folds in the petals and the lemon flower centers.

USING MASKING TAPE

Stick a length of broad masking tape over the area to be stenciled – the tape is transparent enough to see the image underneath. Use a pencil to draw the shape onto the tape if you don't feel confident enough to cut it out direct, otherwise use a sharp scalpel or blade to cut the required shape out of the tape. Be very careful not to cut the canvas. Now lift the shape carefully, making sure the rest of the tape remains firmly stuck to the canvas.

Use thick paint, applying it firmly in the direction of the cut-out shape. If the paint is too thin, or the edge of the tape lifts, the color will bleed underneath the tape and you will lose your clean, sharp edge.

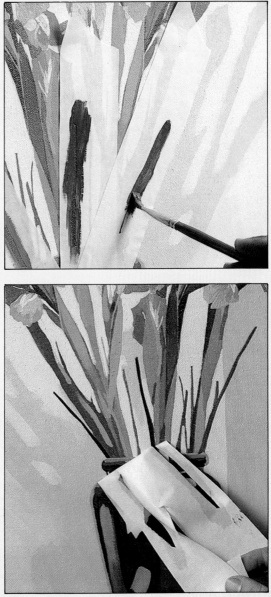

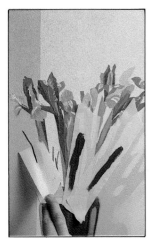

13 To obtain the clear shapes of the highlights and shadows on the leaves *above*, the artist uses masking tape and stencils the shapes in thick oil paint.

14 *Above* the straight edge of the background is repainted with a ruler. If you use this method, remember not to allow the brush to touch ruler edge.

What the artist used

The artist used acrylic paint for the initial blocking in, and developed the final details in oil paint which was diluted with a little turpentine.

A B pencil was used for the outline, and the color applied with a No. 3 bristle brush and a No. 4 sable. Masking tape was cut with a sharp scalpel.

The stretched canvas support, which measured 30 × 30 inches, was treated with acrylic primer.

ACRYLIC

NAPTHOL CRIMSON IVORY BLACK CADMIUM YELLOW PALE

EMERALD GREEN CHROMIUM OXIDE RAW UMBER

YELLOW OXIDE ULTRAMARINE BLUE COBALT BLUE

YELLOW OCHER TITANIUM WHITE

OIL

ULTRAMARINE BLUE ALIZARIN CRIMSON SAP GREEN

CHROME GREEN BLACK YELLOW OCHER

CADMIUM YELLOW RAW UMBER TITANIUM WHITE

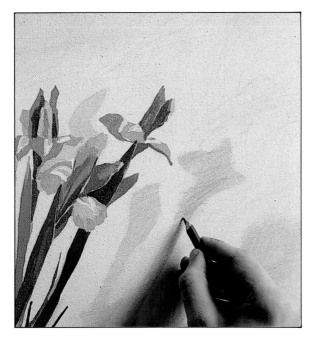

15 Because the style of the picture is so graphic, the artist decides to add a texture to the flat background color using a soft pencil *above*. The loose strokes are in complete contrast to the tight composition and precise color, providing depth and interest to what would otherwise be a rather flat painting.

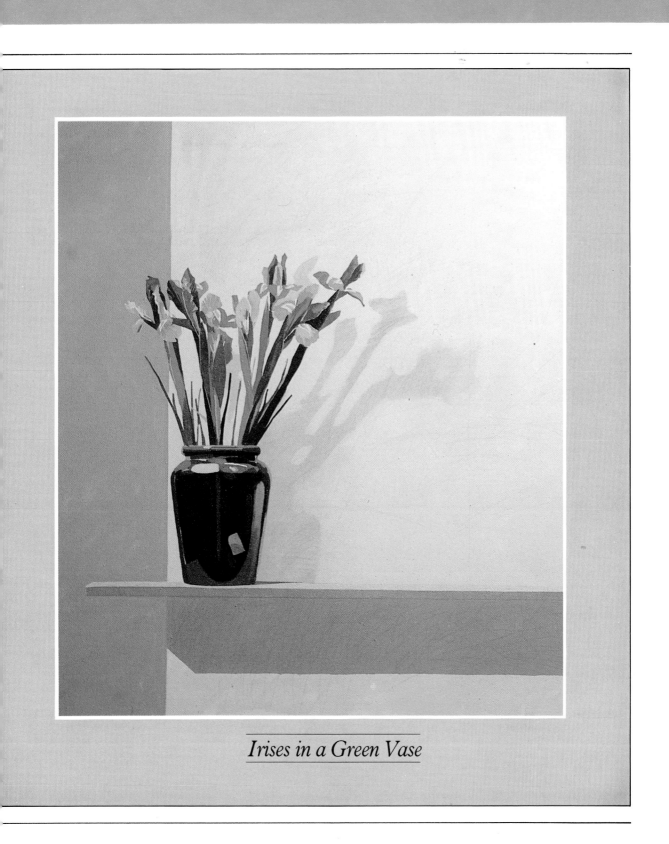

Irises in a Green Vase

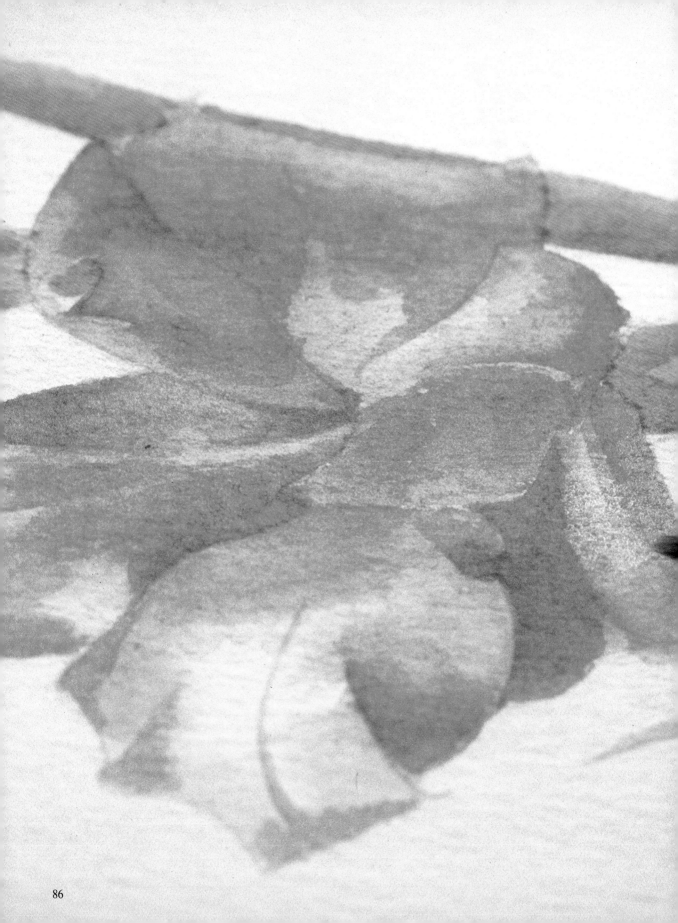

Watercolor & Gouache

Watercolor has been a favorite of flower painters for generations. The delicate nature of flowers, with their fragile petals and intricate structures, defies imitation by all but the most subtle of manmade materials. Watercolor pigment can be applied in a concentrated form to capture the vivid, luminous color of the most exotic flower, or it can be used as a pale and subtle wash, suitable for the most transparent petal.

There are basically two types of watercolor: the pure, classical variety, which is usually used by building up layers of thin color on white paper, and a more opaque paint known as gouache. The different properties of pure watercolor and gouache make them both useful to the flower artist, and they can be used either separately or combined in the same painting.

Watercolor is unpredictable, with many of the most interesting and beautiful effects being achieved by accident. While this element of chance makes it an exciting and challenging medium to use, it can also make it a difficult one – especially for the beginner. When the unexpected happens, as it invariably does, it is essential not to panic. Frantic corrections while the paint is still wet frequently lead to disaster, and the best policy is usually to let the painting dry before continuing work.

The step-by-step paintings in this chapter have been designed to include basic techniques using both watercolor and gouache, as well as demonstrating how different effects are achieved.

DESIGNER'S GOUACHE

Materials

WATER JAR

Good watercolor materials, like most artist's equipment, are not cheap, and the quality is always reflected in the price. However, the watercolor painter is lucky in one respect – that the materials, once bought, last a long time. Nor is it necessary to go out and purchase vast quantities of paint, brushes and papers. Most artists work with a limited amount of color, and a small selection of well-chosen brushes are adequate for most purposes.

Paints

Watercolor paint is made from powdered pigment which is mixed with a binder, usually gum arabic. Real watercolor contains no chalk or other opaque material, which is the reason for its transparency. Gouache is similar to watercolor, but here the pigment contains a proportion of chalk, or body color, and this gives the paint its opaque quality.

Sadly, there is no substitute for real watercolor and only the best quality artist's pigment will give the pure translucency and color quality that most painters require. Student's paints are available, at considerably lower cost, but the colors are vastly inferior and dull when compared to the real thing. Watercolor comes in tubes, cakes, pans and half-pans (pans are small plastic containers of solid color). The choice is a personal one, but pans and dry cakes are generally the most economical to use.

WATERCOLOR BOX
WITH HALF-PANS

CERAMIC PALETTE

Gouache is usually bought in tubes. As with watercolor, there is a large selection of colors to choose from, only a few of which are necessary for the beginner. Most artists start with a basic palette, and gradually add to this as the need arises. Poster color and powder paints are often used instead of gouache but, again, the color and texture bear little resemblance to the real product.

Brushes

The most useful watercolor brushes are the common, or round type. These come in a range of sizes, starting with the very fine 000 size and going up to 12 and larger. For most purposes a selection of five or six of these brushes is quite adequate, and the very small sizes are only used for particularly intricate work.

Some brushes have flattened ends. These flat, chisel-ended brushes are especially useful for making washes of color. Again, there is a wide choice of sizes, but two or three different ones are more than enough for general use. Other types of brush, such as the blender and the fan-shaped bright, are available for obtaining particular effects, and a decorator's small brush can be extremely handy for applying large areas of color.

Watercolor brushes can be expensive items, but cheap ones are certainly a false economy, usually resulting in scratchy work and unsightly hairs coming out on the wet paint. A good brush, on the other hand, will last for a long time if it is well cared for.

The quality of a brush depends to a great extent on the type of bristle it is made of. Sable is the most common quality bristle, although some artists prefer the stiffer oxhair brushes. Cheaper

BROWN TAPE

MASKING FLUID

GUM ARABIC

GUM WATER

CERAMIC MIXING DISH

WATERCOLOR
MEDIUM

brushes are made of squirrel, camel-hair and synthetic materials, none of which has the pliable springiness which characterizes pure sable.

Supports

Paper is the usual support for watercolor painting, although artists also use cardboard, silk and, occasionally, even skin.

Cheaper, light-weight paper must always be stretched before use. This entails thoroughly soaking the sheet of paper and sticking it to a smooth drawing-board with paper tape while it is still wet. The paper is ready for use as soon as it is completely dry. Failure to stretch such paper in this way will result in buckling, uneven color and a generally disappointing result.

Purpose-made paper, however, needs no such treatment. It is specially made to take the wet color, and is the ideal support for watercolor painting. The biggest problem for most people is deciding which of the hundreds of papers available is the best type for any particular purpose.

Texture must be a main consideration when using watercolor. If the paper is too rough, the paint does not sink into the deep depressions on the surface, and this causes the color to be flecked with white when it dries. Sometimes this is done deliberately, but as a general rule it is wiser to stick to less textured papers to start with.

The best, and most expensive, papers are made by hand. These are usually made of linen rag and contain none of the impurities found in factory-produced paper. They are sized on one side only,

NO. 6 SABLE ROUND

NO. ½ SABLE FLAT

TINTED PAPERS

NO. 18 SYNTHETIC ROUND

NO. ¾ SYNTHETIC FLAT

and the best way of finding the correct side for painting is to look for the watermark of the manufacturer's name, which should be the right way around.

Less extravagant, and perfectly adequate, are the machine-made papers. These can be divided into three main categories: Hot-Pressed, Cold-Pressed, and Rough. Hot-Pressed paper is rather smooth and not really suitable for watercolor, unless a particularly flat finish is required. Cold-Pressed paper, often referred to as 'Not', is the most popular, and most of the papers available in art stores fall into this category. The third type, Rough, is heavily textured and usually only used when a specific effect is required.

Colored, or tinted paper is only suitable for gouache and other opaque types of paint. For genuine watercolor, the paper should be white or very pale. The transparent nature of the paint makes the color susceptible to change if it is applied on to a strongly tinted paper.

Palettes

Here, at last, is an area where economies can be made without jeopardizing the quality of the work in hand.

Most of the palettes available are made of plastic or ceramic, with special recesses to hold the different colors. It does not really matter what material the palette is made of, but the plastic ones are usually cheaper. They are both available in different sizes and shapes, the traditional palette with the thumb-hole being particularly useful for outdoor work.

NO. 6 GOAT HAIR BLENDER

NO. 4 STENCIL BRUSH

SKETCHBOOKS

NO. 40 WASH BRUSH

91

Pink Gladiolus

WATERCOLOR

One of the golden rules of watercolor painting is knowing when to stop work. There is a common tendency among artists who are not used to the medium to carry on painting after the picture is finished, often spoiling what they have already done. With watercolor it is often better to stop too soon, and have a rather unfinished look, than to overwork your painting and then regret it.

For flower painters the temptation to carry on adding unnecessary color and detail is particularly prevalent because flowers often appear to be much more complicated than they really are. For this reason it is a good idea to take a careful look at the subject before you start painting. Decide which colors you are going to use – for this purpose, the fewer the better – and how you can express the shape of the flower in its simplest terms.

Watercolor has a translucency which is particularly suitable for the pure color and film-like quality of flower petals. The best way to achieve this effect is to apply layers of wash, starting with the lightest tone and gradually building up the color until the darkest areas are also established. By using a limited range of colors, and mixing them as little as possible, you will ensure a clear, luminous result. If you use too many colors, or overwork the paint with the brush, the result will be muddy and heavy.

The gladiolus is more complex than many flowers, yet the artist used only four colors to create this painting. At first glance the image looks highly finished and detailed. Closer inspection, however, shows that the picture is actually built up of loose washes of color applied with a fairly large brush. The illusion of form and detail is achieved entirely by the carefully placed areas of wash, and the variety of tones which each additional layer of color creates.

Each wash was laid before the paint underneath was totally dry, allowing the colors to blend naturally on the paper without leaving a hard edge. It is also possible to apply color directly onto an area of paint which is completely wet, but this method, often referred to as 'wet into wet', allows far less control and the results – though often delightful – are largely a matter of chance.

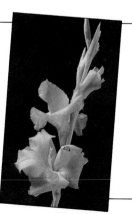

1 This elegant pink and yellow gladiolus *right* provides plenty of scope for the watercolor artist. Watercolor washes, and the subtle blended effects which they produce, are ideally suited to the almost transparent quality of the petals and leaves of the gladiolus flower.

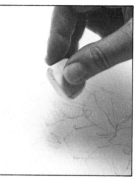

2 After sketching in the main shapes of the flower on watercolor paper, the artist uses a soft eraser to remove most of the dark line *left*. This leaves a faint outline which can be used as a guide for the color, but which will hardly show in the finished painting.

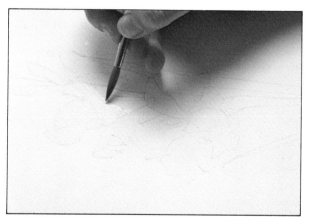

3 With a No. 6 sable brush the artist first wets the flower shapes, then applies a very diluted wash of lemon yellow to the dampened areas *above*.

4 While the first wash is still wet, stronger yellow is added to the flower centers *below*, and the color allowed to bleed outward into the petals.

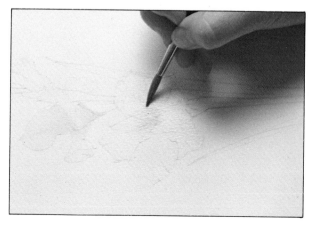

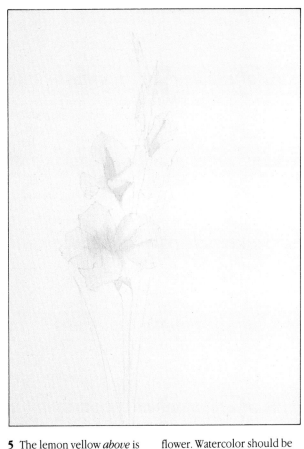

5 The lemon yellow *above* is allowed to dry partially, and this brightly colored base will show through subsequent washes with a translucency similar to that of the real flower. Watercolor should be mixed in a white palette so the correct color can be seen *top right*, and tested before use *right*.

BUILDING UP WASHES

Working with watercolor washes can be a tricky business. If you allow the paint to dry between each wash, the color dries in harsh tide-marks – an effect which is especially unsuitable for most flower painting, where softer effects are usually required. On the other hand, applying a wash to a painted area while it is still completely wet is an unreliable method of blending colors.

 An alternative way of laying washes is to allow one color to dry partially before applying the second. In this way the colors blend naturally by running together very slightly at the edges.

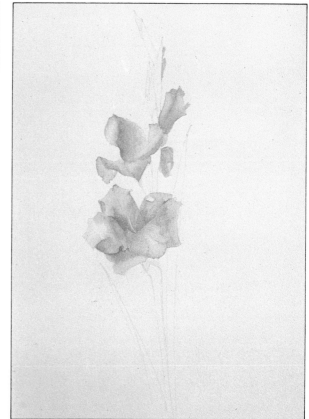

6 Because watercolor is hard to correct, each color should be tested separately for strength before use. After testing the pink wash – mixed from permanent red and lemon yellow – the artist starts to put in the darker tones of the petals *above*. The initial lemon underwash is not quite dry, and this allows the two colors to blend together quite naturally without leaving a hard edge.

7 The darker petal tones are blended into the light areas with water and a clean sable brush to prevent any unnaturally hard edges. This ensures a delicate tonal balance, which is effectively realistic, but which is actually achieved with just two colors *right*.

8 A very pale olive green wash is applied all over the leaves and stem. When this is almost dry, the artist develops the deeper areas with a slightly darker wash of olive green and hookers green *right*. The light olive underpainting is left to depict the light areas.

9 The artist adds the darker wash to the leaves *below*, using confident, flowing strokes to show the shape and character of the elongated, twisted shapes

10 When the washes are completely dry, sharp details, such as petal folds, are added with the tip of a No. 6 sable brush *left*.

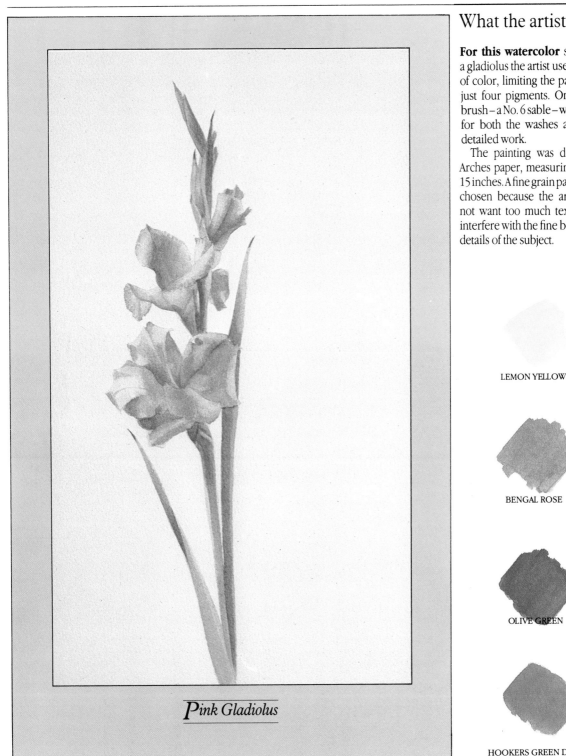

Pink Gladiolus

What the artist used

For this watercolor study of a gladiolus the artist used tubes of color, limiting the palette to just four pigments. Only one brush – a No. 6 sable – was used for both the washes and the detailed work.

The painting was done on Arches paper, measuring 18 × 15 inches. A fine grain paper was chosen because the artist did not want too much texture to interfere with the fine botanical details of the subject.

LEMON YELLOW

BENGAL ROSE

OLIVE GREEN

HOOKERS GREEN DARK

Country Garden

WATERCOLOR AND GOUACHE

For most of us the old-fashioned country garden is something we see in magazines and picture-books, not something which belongs to our everyday lives. If we are lucky enough to have such a place to paint in, the chances are that the most colorful blooms are at opposite ends of the garden, or that all the favorite flowers bloom at different times of the year. Very rarely is everything in the right place at the right time.

This dilemma underlines a problem which many artists face, but which affects flower painters in particular – the problem of availability. Because they are seasonal commodities, only certain flowers are available at certain times of year. And in winter the choice of subject is often very restricted indeed.

The Dutch flower painters of the sixteenth century had an excellent solution to this problem. They made detailed drawings of flowers and plants throughout the whole year, and referred to these drawings whenever they needed new subject matter for their paintings. Most of their floral masterpieces are composed of flowers which, in reality, bloom at different times of the year.

This painting of a country garden was composed in a similar way – not from drawings, but from photographs. The artist took pictures of flowers, trees, walls and other garden items over a period of time, and chose a few of these to make up the composition.

Of course, taking photographs is not the only way of getting good reference material. Sketchbooks, gardening magazines and even seed catalogs can be rich sources of visual information, as well as providing ideas and inspiration for paintings. It is also a good idea to keep your own collection of such cuttings and drawings, which can be referred to when inspiration fails, or when real flowers are in short supply.

In this painting, the artist used gouache to obtain the strong, bright colors, and watercolor for the lighter areas. The contrast between the two types of paint is often used quite deliberately, such as in the pink hollyhocks, where the bright centers of the hollyhocks are painted in gouache and the pale, transparent petals in watercolor.

1 The garden in this watercolor exists only in the imagination of the artist, who combined several elements *right* to make the composition.

2 After drawing the outlines lightly with an H pencil, the artist puts a watercolor wash of cadmium yellow and alizarin on the hollyhocks. A darker mixture of the same color *left* is used for the centers.

3 The dark centers of the hollyhocks are put in while the wash is still slightly wet. This enables the colors to merge softly, in much the same way that colors occur in real flowers. The tiny flower centers are dotted in pure cadmium yellow *right*.

4 The leaves of the hollyhocks are painted with a thin watercolor mixture of olive green, hookers green and cadmium yellow *above*.

5 *Below* the artist is darkening areas of the leaves by working gouache shadow into the base color before the latter is completely dry.

USING WATERCOLOR AND GOUACHE TOGETHER

Both gouache and watercolor are water-soluble paints and can be used easily together. The main difference between them is that watercolor is transparent, while gouache is dense and opaque.

Because it is difficult to get a thin wash using gouache, and equally difficult to obtain an opaque covering with watercolor, it is sometimes useful to use both types of paint in the same painting.

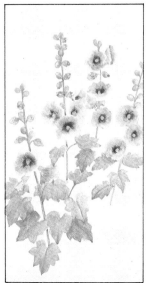

6 The hollyhocks are complete *left* and the artist leaves them against the white background for the time being while moving on to paint the next element in the composition.

7 White gouache is used on the anemones to make them stand out against the duller white paper. The leaves and stalks are painted in with viridian watercolor *right*. The artist uses a No. 6 sable brush throughout this painting, touching in small areas with the tip of the brush.

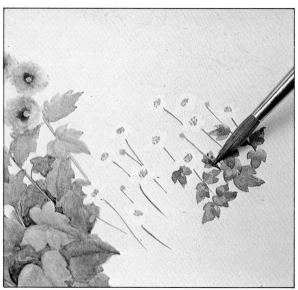

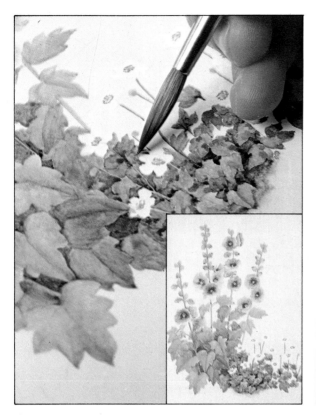

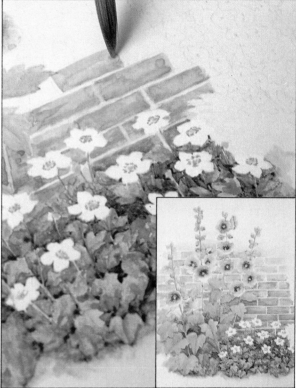

8 The dark areas between the anemone leaves are added in gouache because the artist wants to create opaque shadows to add depth to the rather pale image. The artist touches in the dark areas *above* with a mixture of sepia and mistletoe green.

9 With the tip of a sable brush, the leaf color is taken right up to the edge of the anemones *above*. At the same time the artist carefully redefines the tiny shapes, making them stand out clearly against the foliage.

10 Sepia, yellow ocher, white and a touch of red are mixed to make the wall color *above*. The artist uses gouache in order to provide a fairly opaque background for the delicate flowers.

11 The addition of a little white makes the bricks look more irregular and natural *above*. Water is used to blend some of the bricks, fading them into each other and softening the edges to modify the rigid lines.

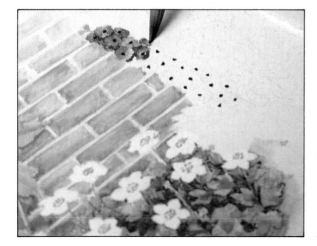

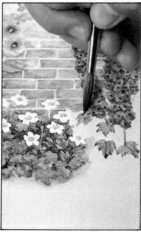

12 The artist paints the delphiniums by first painting a dark mauve dot in the center of each flower. These are painted over with a wash in the same color, and the dark centers are blended into the light color *far left*.

13 Green and sepia gouache are used for the leaves, and the artist paints these quickly by 'drawing' a rapid brush outline for each one and filling this in with the same color *left*.

What the artist used

Two types of paint were used in this picture – watercolor and gouache. Those areas which were required to be pale such as the petals and the light parts of the leaves, were painted in watercolor; for the opaque areas the artist used gouache.

The color was applied with a No. 4 sable brush to stretched watercolor paper measuring 12 × 8 inches.

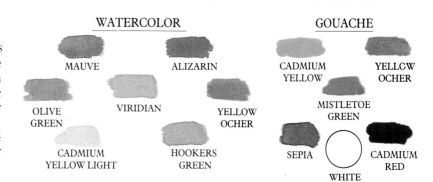

WATERCOLOR

MAUVE

ALIZARIN

OLIVE GREEN

VIRIDIAN

YELLOW OCHER

CADMIUM YELLOW LIGHT

HOOKERS GREEN

GOUACHE

CADMIUM YELLOW

YELLOW OCHER

MISTLETOE GREEN

SEPIA

WHITE

CADMIUM RED

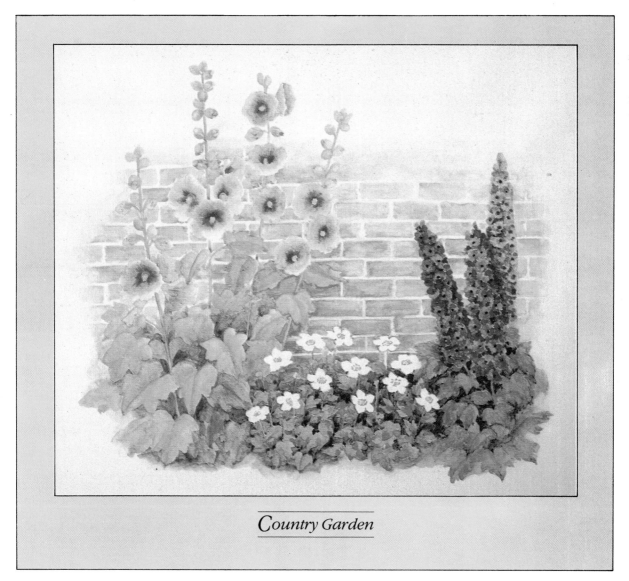

Country Garden

Red Tulip

WATERCOLOR

This single tulip placed in front of a stark white background gave the artist ample opportunity to concentrate on the flower head without being distracted by a mass of foliage or a complicated background.

The pure watercolor paint was used to create both color and tone – in other words, layers of thin red were gradually built up to make the darker, shadowy areas on the flower. Although, in this case, a little darker pigment was occasionally added to the local color, it is quite possible to create form with watercolor by using different strengths of a single pigment.

Patience is the secret of successful watercolor painting, and any attempt to speed up the process, such as painting onto an area which is still wet, is a sure way of spoiling a painting.

The tulip was painstakingly worked in layers of wash, each layer being allowed to dry before the next was added. This method of using watercolor is sometimes called 'wet into dry', and is especially useful when a subject calls for a very precise approach. Here the artist was interested in the tiny fragments of tone which made up the flower petals, and felt the only way to do justice to the subject was to use the 'wet into dry' technique.

Although the precision and expertise evident here might seem rather daunting to a less practiced artist, you should not be put off trying. And there are a few rules which, if followed, will make the task very much easier.

The first thing to remember is that pure watercolor should always be worked from light to dark – if you make a color too dark in the first instance, it is difficult and messy to correct afterward. So start off with the lightest of washes, and build up the color very gradually to the density you require. Test each color on a separate piece of paper before using it on your painting if you are at all unsure about it.

Try to keep the color clear. If you are using more than one color, it is all too easy to lose the brightness by accidentally mixing them. So, make sure the brush is absolutely clean by washing it each time you use it; if possible, use a different brush for every colour.

Finally – be patient. Allow the paint to dry properly before working into it, and limit your palette to as few colors as possible to ensure the maximum strength and brightness from each one.

The finished painting has all the clarity and detail of botanical illustration, but the vibrant, transparent colors keep the subject alive in a way which many detailed flower paintings fail to do. As with all watercolor painting, the secret lies in keeping the color simple, and knowing when to stop, rather than in slavishly trying to include every visible detail in the picture.

1 The single red tulip *right* is placed against a plain white background because the artist wants to make a detailed study of the flower and to look closely at the form and color of the subject rather than paint it in elaborate surroundings.

2 An F pencil is used to draw the tulip carefully on stretched Bockingford watercolor paper *right*. The artist is using a hard pencil because it is necessary to make light, precise lines which will not smudge or dirty the paint when it is applied. Although the tulip and leaf are basically simple shapes, the artist is anxious to include as much information as possible in this initial pencil drawing to provide a detailed guide for the paint.

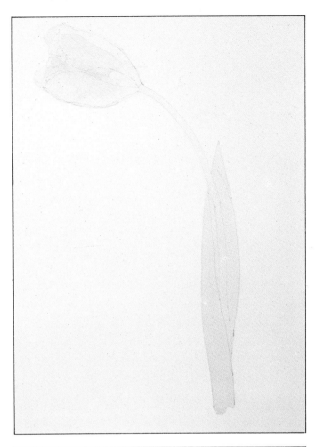

3 The artist puts a thin wash of color over the entire image *left*. A No. 4 sable brush is used to apply the paint – cadmium red to the flower head, and a mixture of sap green and yellow for the leaf and stem.

4 When the first wash is dry, a slightly darker cadmium red wash is loosely painted in to suggest the deeper areas of color on the tulip head *right*.

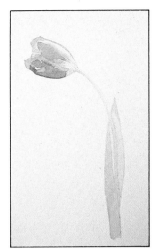

'WET INTO DRY' WASHES

Watercolor can only be used with precision if each color is allowed to dry before the next is added. This method can be time-consuming, especially if you are working with several layers of wash, and have to wait for each one to dry.

Sometimes it is possible to work on another area of the picture while you are waiting for a wash to dry or – as many artists do – save time by working on two paintings simultaneously.

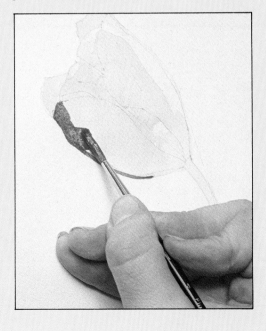

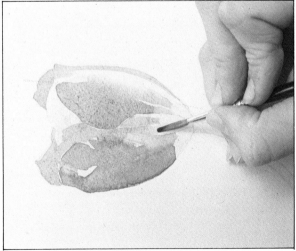

5 Here the artist adds more color to the flower *above*, looking carefully at the light and dark tones of the petals and trying to interpret these as areas of wash.

Watercolor is very transparent and has very little covering power, so it is always necessary to work from light to dark, as the artist is doing here.

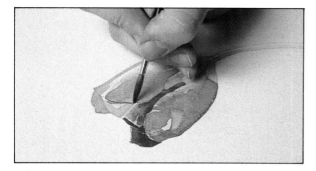

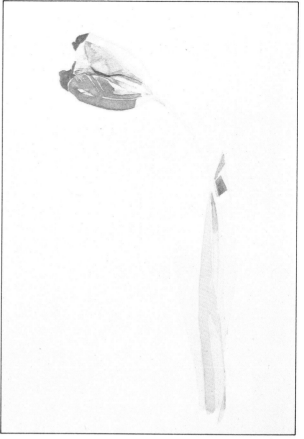

6 The color of the inside petals is intensified with cadmium red mixed with a little black *above*. The artist is paying careful attention to the tiny shapes of tone in the petals and uses the tip of a No. 4 sable brush to paint in a fine line.

7 Darker leaf tones are developed with sap green, strengthened with a little black *above right*. The paint is applied in long, smooth strokes, the light and dark tones blending together to show the form of the curved leaf.

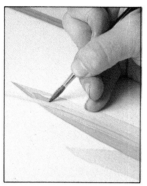

8 Using few colors and a limited range of tones, the artist has established the main form *right*, which is now ready for details and final touches.

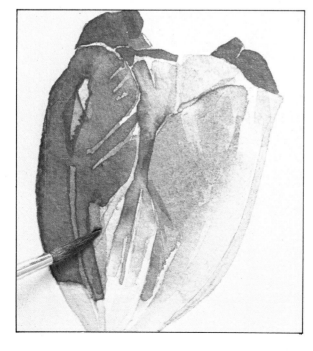

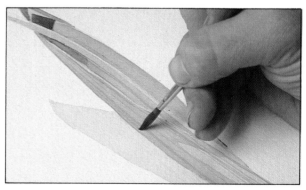

9 Looking carefully at the subject for reference, the artist adds touches of thin cadmium yellow to certain areas of the tulip head *left*. This brings the flower to life and lends a realism and vibrancy to the painting which the monochrome red lacked.

10 The darkest and final tones are painted on to the leaf. To give a feeling of unity to the whole image, the artist is working with the basic leaf color mixed with a little of the cadmium red used on the petals *above*.

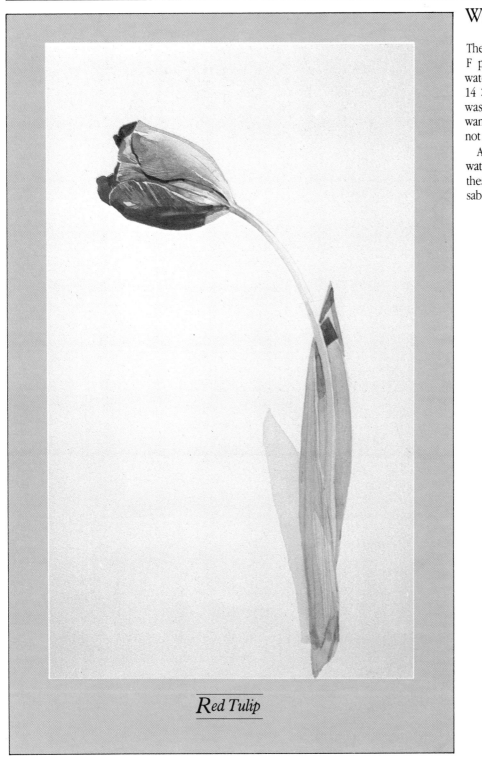

Red Tulip

What the artist used

The outline was drawn with an F pencil on to Bockingford watercolor paper measuring 14 × 19 inches. A hard pencil was used because the artist wanted a light line, which would not affect the final picture.

A limited palette of four watercolors was chosen, and these were applied with a No. 4 sable brush.

CADMIUM RED

CADMIUM YELLOW

SAP GREEN

IVORY BLACK

Wild Rose

GOUACHE WITH STENCIL

Stenciling with paint looks complicated, but it is actually very simple. It is also one of the quickest and most effective ways of painting flowers.

For this picture the artist chose a wild rose as the subject because of the pretty two-tone petals and the serrated leaves, but almost any flower will do as well, provided that it is not too complicated. Remember that whatever you choose will eventually have to be cut out, so stick to strong, simple shapes.

Work of this sort, which has a strong element of design in it, is well suited to gouache. The gouache colors are strong and quick-drying, and the thick consistency of the paint enables it to be stippled onto the stencil easily without the colors running.

Flowers have been traditional favorites in stencil designs for a long time – on wood and fabric as well as paper. In the past the stencils were made of stiff paper or cardboard, but modern stenciling film, now widely available, is easier to manage and leaves a sharp, crisp edge on the stenciled shapes. The film is adhesive on one side to hold it in position on the paper, but it also tears easily if it is not carefully handled, so you should use a sharp blade or scalpel to cut it.

There is no need to stick rigidly to the subject once you have cut out the shapes you want. The success of the final painting will depend largely on how you arrange the various flower and leaf forms, so move the different elements around freely on the paper, experimenting with possible arrangements until you find a satisfactory design.

The colors, too, can be changed and simplified to suit the design. One of the most effective stenciling techniques is the blending of two or more colors together within one shape – the pink and white rose petals are a good example of this. To do this successfully, it is essential to allow one color to dry thoroughly before applying a second color on top.

There are various ways of stippling color onto stencils. The one demonstrated here, using synthetic sponge tied round a paint-brush handle, produces an even, delicate texture, but different effects can be obtained by using fabric, natural sponge or a stiff brush.

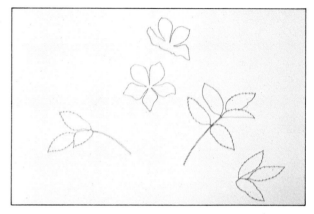

2 The artist starts by drawing some leaf and flower shapes onto a piece of cartridge paper *above*. These need not be in any particular order as they will be rearranged into a design later.

3 A sheet of tracing film is laid over the drawings and the artist carefully cuts round the shapes with a sharp knife or scalpel *below*.

1 These wild roses *right* were chosen as the basis for a stenciled painting because their strong shapes and simple colors make them both easy to cut out and effective as elements in a design.

4 Each shape is lifted out with the blade *left* – great care must be taken not to tear the fragile film. It is possible to use oiled paper or cardboard for making stencils, but the edges are usually less sharp, and proper tracing film has the added advantage of being adhesive – it can be stuck into position before the paint is applied.

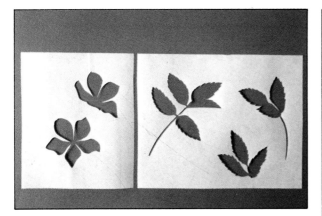

5 Details are important when making stencils. For instance, the petal shapes and the serrated edges on the leaves must be accurately cut *above*, otherwise the subject loses its character and the design can be spoiled.

6 The film has a paper backing which is peeled off before the film is stuck into position *below*. Once the backing is off, the film should be stuck down at once, so it is wise to decide on the design while the backing is on and the shapes can be moved around.

MAKING A STIPPLING STICK

You can make a special tool for stippling quite easily by wrapping a piece of foam rubber round the end of a paintbrush. This will normally give a more even texure than a chunk of sponge or rag.

Cut a strip of foam rubber about 5 × 2.5 inches. Double this to prevent the sharp point of the handle from sticking through, and tape it firmly into position.

7 The film is carefully lifted into the correct position *left* and pressed on to the paper. It is very important to press the edges down firmly.

8 Here the artist starts to stencil the edges of the petals *right* using a mixture of white and Bengal rose gouache on a stippling stick (see adjacent panel). The gouache should be quite thick so very little water is mixed with the paint.

9 The color is graded and built up gradually *left* with a gentle tapping of the stick. It is a delicate technique, and excess paint is removed before the stick is applied to the stencil.

10 Here the artist adds the flower centers in yellow gouache *right* on a fresh stippling stick – a new stick should be used for each color.

11 When the paint is completely dry the stencil is slowly removed *left*. The film tears easily, so great care is taken to peel it off evenly.

12 The painting is now ready for the second stencil *right* – the leaves. Again, the shapes should be moved around and tried in different positions before the paper backing is removed.

13 The stencil is stuck in place and the artist applies a basic leaf color mixed from viridian green, white and a touch of Bengal rose *left*. Stencil film can be safely stuck on top of dry paint without pulling the color off when it is removed. Patience is essential, and the leaf color is allowed to dry completely before the stencil is removed ready for the next stage.

14 The artist sticks the final stencil in position and presses the edges down firmly *below*. It is often necessary to use several stencils, especially if the design is a complicated one or if any of the components overlap each other.

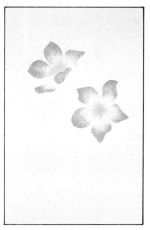

What the artist used

In this picture the artist used tracing film for the stencils, cutting this with a sharp scalpel to ensure clean edges to the shapes. The support is cartridge paper, measuring 11 × 8.5 inches and the artist chose gouache paint because of its stiff consistency and opaque color which make it ideal for stenciling.

Stippling sticks were made from paintbrush handles, pieces of foam and some tape.

LEMON YELLOW

VIRIDIAN

BENGAL ROSE

WHITE

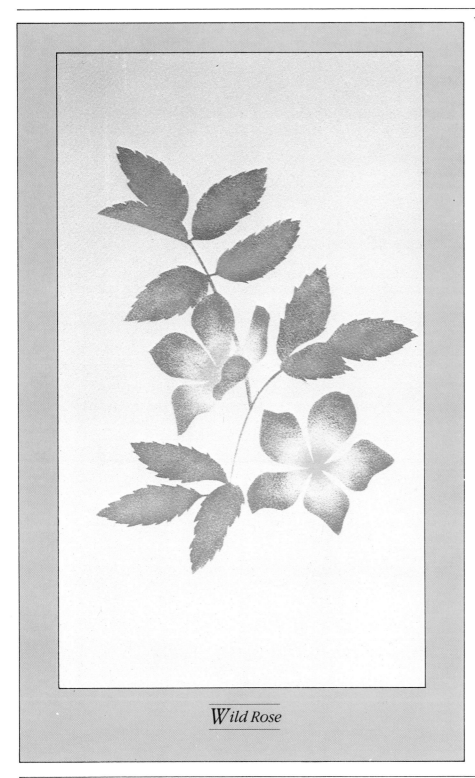

Wild Rose

Ivy

GOUACHE

Not all plants benefit from the delicate and detailed treatment which is generally associated with flower painting. Indeed, this approach is not favored by all artists, and you may find that you prefer a bolder, more direct method of working.

The ivy here was painted in gouache, a medium which is especially well-suited to the strong shapes and bold patterns of the leaves. By using very little water with the paint, the artist managed to keep the color flat and opaque.

Used in this way, gouache is similar to oil paint, and you can apply the color thickly with a large brush to give the paint a textural quality – an effect not possible with regular watercolor. The great advantage of using gouache instead of oil is that it is quick-drying, enabling you to work rapidly, without having to stop for long periods between stages, waiting for the paint to dry.

Because gouache is such an opaque medium, it is possible to obliterate areas of color completely by painting over them. This applies even when the underneath colors are much darker than the top coat. With gouache, therefore, you can put down the dark colors first – as the artist did in the ivy painting – rather than being

restricted to working from light to dark, which is always the case when using pure watercolor.

In this example, the initial drawing was made in charcoal. The soft, dusty lines created a strong structure for the paint and were less inhibiting than a tight pencil drawing would have been.

Charcoal dust can mix with the paint and cause the colors to become muddy, so it is a good idea to brush off any excess dust before starting to paint. Keep the drawing as simple as possible, putting down only enough information to establish the position and general shape of the subject – areas of color, tonal variations and details should all be left to the painting stage.

There is a tendency for inexperienced artists to start worrying about details before the main areas of color have been established – a temptation which is especially difficult to resist when the subject is something as intricate and small as a flower or plant. If you find this becomes a serious problem, or you feel you would like to work in a looser, more direct way, there are certain measures you can take.

One obvious precaution is to work on a larger scale than you

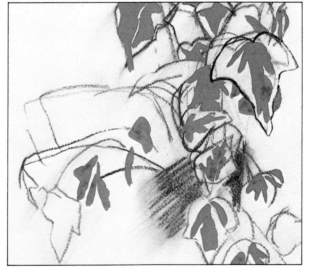

2 The artist first sketches in the outline with charcoal *left*, the soft, dusty black creating a strong structure for the work. The drawing is quite free and is corrected where necessary by light rubbing over the lines. It is not necessary to use an eraser as the opaque paint will cover mistakes.

3 Any excess charcoal dust is brushed away from the surface to prevent the fine black powder from mixing into the paint and deadening the color. The general shape of the dark green leaf areas are then put in with a No. 6 brush *above*.

would normally choose. Although paintings and drawings of flowers and plants are often fairly small, this does not mean that your own work is limited to any particular size. The artist here is working on a sheet of paper measuring 15 × 19 inches and your own painting can be larger if you prefer.

Another way of 'loosening up' your style, is to work with large brushes. Use oil painting brushes to lay in the initial areas of color, reserving the finer, sable brushes for the final details. By doing this, you will be forcing yourself to develop the subject as a whole rather than getting lost in detail and, perhaps, overworking certain areas in relation to the rest of the picture.

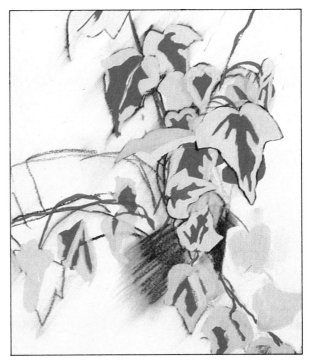

1 Because of its varied tones and shapes, ivy makes an interesting subject for a painting *right*. The plant is placed in a well-lit position against a plain background, and the artist is sitting far enough away to be able to see the whole form.

OVERPAINTING WITH GOUACHE

Because gouache is opaque, it is possible to paint a light color over a darker one without the top color being affected by the color underneath.

When you are working from dark to light in this way, mix the paint to a thick, creamy consistency. If the mixture is too watery the two colors will run together.

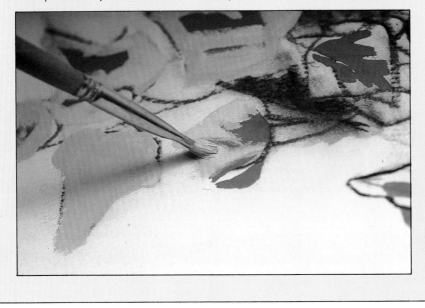

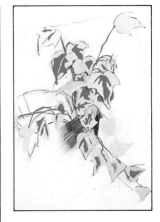

4 The lighter areas of the leaves are blocked in with light green *top*. Because gouache is so opaque it is possible to paint light colors, such as this, over darker ones, thus enabling continual changes to be made to the painting.

Using the tip of the brush, the artist begins to draw in the stalks of the plant in red *above*. The brush strokes are laid quite freely, following the sinuous direction of the ivy stalk.

5 A creamy yellow color is added to the outside of the leaves, and small areas of light green to the leaf centers *right*.

Notice how the artist uses white gouache to make corrections to the composition. The strong red of the stalks, for instance, is modified to tone with the rest of the painting; other smaller alterations and revisions are made in charcoal.

Because of the opacity and thickness of the paint, it is essential not to overmix the colors. Here the gouache is laid quite thinly in the initial blocking in stages, but a slightly thicker consistency is used for building up the forms and adding the details.

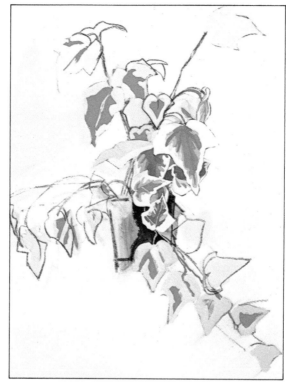

What the artist used

Before starting to paint, the artist first drew the image in willow charcoal on to a piece of stretched cartridge paper measuring 15 × 9 inches. The gouache paint was applied with a No. 9 flat bristle brush, the details being added with a No. 6 sable.

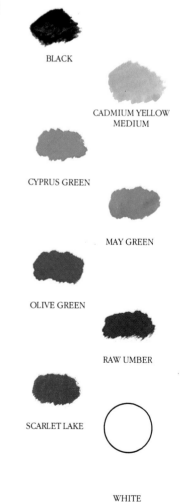

BLACK

CADMIUM YELLOW MEDIUM

CYPRUS GREEN

MAY GREEN

OLIVE GREEN

RAW UMBER

SCARLET LAKE

WHITE

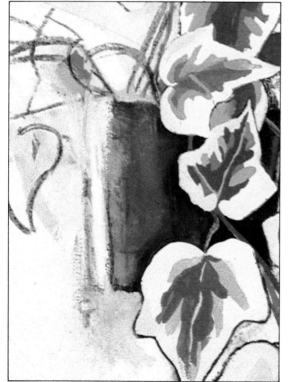

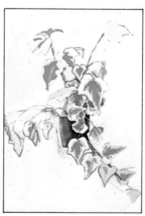

6 The artist blocks in the local color of the dark plant pot *left* using black, yellow and white.

Elsewhere in the picture the color is built up piece by piece *above*, gradually adding to the detail and redefining the shapes.

Ivy

Field of Daisies

WATERCOLOR WITH MASKING FLUID

Flowers are usually at their best when seen in their own environment – whether they are growing wild in the fields and hedgerows or in a garden border. But, although many artists prefer flowers in this context, comparatively few have painted them in their natural surroundings.

One of the main reasons for this reluctance must surely be the bewildering number of flowers which would need to be included in the picture. A single daisy, or even a bowl of daisies, is a feasible proposition. But a field full of daisies requires a rather different approach. The problem is even greater for the watercolor painter, because the transparency of the paint makes it impossible to paint white flowers onto a darker background, such as green grass.

An effective solution to the problem is to use masking fluid, as the artist has done in the picture here. This liquid, rubbery solution can be painted onto those areas of the picture which need to be left white – in this case the daisies. When the fluid is dry, these areas can be painted over quite safely without the color affecting the paper underneath. The rubbery masks are then rubbed off, leaving the crisp white shapes.

However, this almost magical technique does have a drawback. The areas treated with masking fluid always have a hard edge,

which stands out in the painting, usually in a very graphic way. This is fine for some purposes – it is a method favored by many illustrators – but it is not compatible with other, more spontaneous methods of painting.

In this picture, the artist has tried to counteract some of these effects by using the masking fluid in an unusually free way – splattering it onto the paper, as well as applying it with a brush. Combined with lively brushstrokes and the added textural interest of oil pastel, this approach demonstates the wider possibilites of masking fluid.

1 To paint white daisies in a green field *right*, the watercolor artist must treat the flowers as negative shapes – that is, use the white paper for the flower color instead of trying to use white paint, which is too transparent.

2 Without any preliminary drawing, the daisies are picked out with masking fluid on white paper *right*. The fluid preserves these areas as eventual white shapes, at the same time allowing color to be painted directly over them to block in the background and surrounding leaves.

3 Oil pastel is water resistant and can be used in the same way as masking fluid. Here the artist is sharpening a pastel *above* ready to make fine lines.

4 The sharpened pastel is used for the delicate flower stalks *left* which would have been hard to achieve with masking fluid. The artist keeps the strokes spontaneous and lively, using them to give texture to the picture.

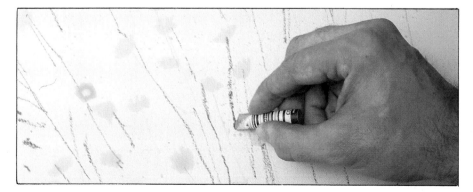

5 Tiny yellow dots in oil pastel help make an overall pattern *above*, effectively capturing the scattered nature of the subject.

6 The artist covers the entire picture with a watercolor wash of sap green and yellow *left*, applying this freely with a No. 6 sable brush. Areas of white paper are left to prevent the scene looking too flat.

7 In order to keep the picture busy, the artist enlivens the green wash with strong directional brushstrokes in the same color *below*. This texture produces a lively effect of windblown grass which will contrast effectively with the scattered white shapes of the daisies.

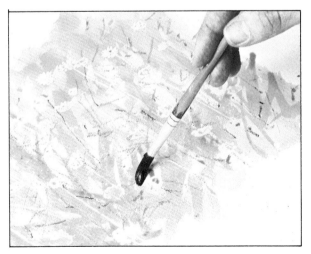

USING MASKING FLUID

Masking fluid can be applied with a paintbrush – preferably an old one, because it does tend to ruin the bristles, dip pen or sponge. It can also be dripped or, as used here, splattered on to the paper.

Whichever method you use, the fluid must be allowed to dry before it can be painted over. It is not difficult to remove, but the surrounding painted areas must be thoroughly dry before the masking fluid can be rubbed off. You can do this by gently rubbing it with a clean finger.

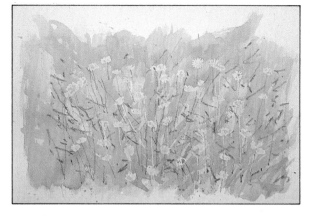

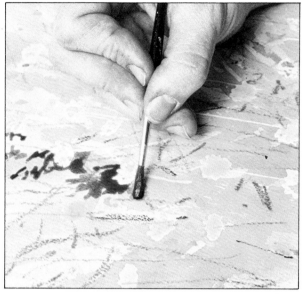

8 By allowing the paint to dry between stages, the grass color is built up into a lively textural surface *above*. The painting is then allowed to dry.

9 Here the artist intensifies the color with chrome green and black watercolor mixed with gum water to give body and sheen to the paint *right*.

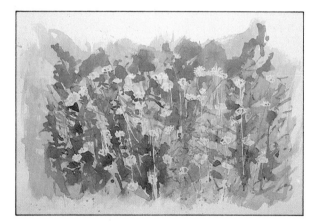

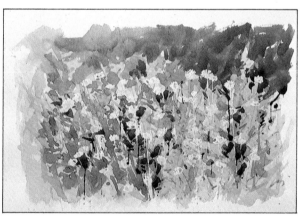

10 Some of the darker green areas are painted tightly, others treated in a looser way *above* to keep a feeling of spontaneity in the picture.

Gum water, like gum arabic, enriches the colors and thickens the paint to give body and texture to the work. It also dissolves dried watercolor and can be splattered onto a painting to create speckled textures and break up monotonous areas of flat color.

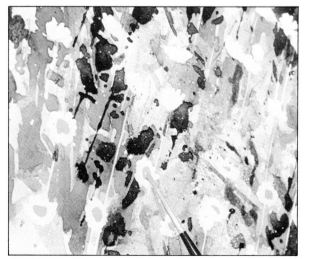

11 The deepest grass shadows are painted in black mixed with a little sap green *above*. These areas are carefully drawn with a fine sable brush and filled in to create the deeper tones.

12 When the paint is completely dry, the masking fluid is rubbed off – this should be done gently with an eraser – and the artist carefully paints in the daisy centers in cadmium yellow gouache *left*.

What the artist used

Watercolor paint with masking fluid was used to create this picture of a field of daisies. Some of the detail was added with olive green and orange oil pastels – oil pastels 'resist' watercolor in a similar manner to masking fluid. Gum water was added to give extra texture and body to the paint.

A small decorator's brush was used to splatter and dribble the masking fluid and gum water. Otherwise the painting was done with sable brushes, Nos. 4 and 6.

The support is Arches watercolor paper measuring 12 × 18 inches.

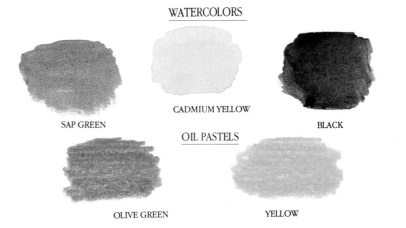

WATERCOLORS

SAP GREEN

CADMIUM YELLOW

BLACK

OIL PASTELS

OLIVE GREEN

YELLOW

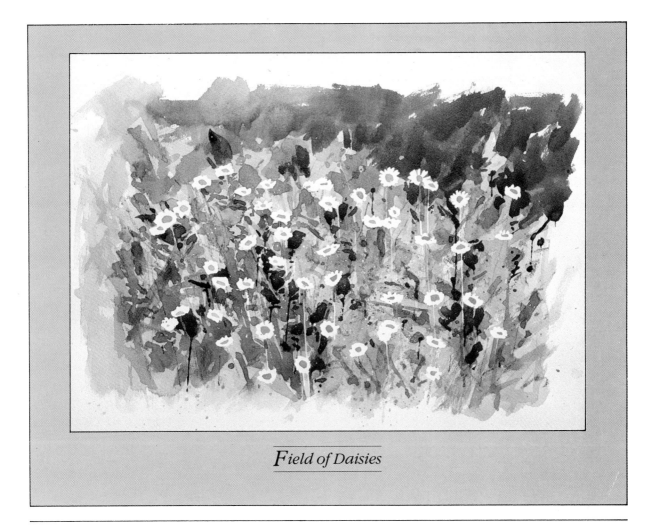

Field of Daisies

Wild Flowers

WATERCOLOR CONCENTRATE WITH MASKING FLUID

Like the previous painting, the wild flowers in this picture were painted by first blocking out the light areas with masking fluid. But in this case the artist concentrated on making a deliberate design, rather than creating a spontaneous effect.

The paint used was watercolor concentrate, a very strong pigment which comes in bottles, and which can be diluted accurately to any strength. Each bottle comes with its own dropper – rather like an eye-dropper – and, although it is expensive compared to the price of a tube of regular watercolor paint, a bottle of concentrate lasts longer.

These bottled colors are extremely vivid, and it is easy to understand why they are so widely used by designers. Their extraordinary luminosity and intensity makes them also invaluable to flower painters, many of whom have difficulty in finding synthetic pigments to match the brilliant colors displayed by nature.

It is a good idea to practice a little before using color concentrates – a small amount of pigment goes a long way, and only experience will enable you to know exactly how much to use. Another potential problem is that the color tends to dry unevenly unless it is applied quickly – and again, only practice will help you to master the technique.

In this painting of wild flowers the mass of green foliage was the main problem which confronted the artist. To paint every leaf in its exact color would have been time-consuming and difficult, but it would have been equally inappropriate to express such a wide variety of green tones as a single color.

Eventually, the leaves were simplified as a range of three tones: light, medium and dark. This enabled the artist to create a feeling of space in the foliage, without having to paint each leaf separately.

These tones were built up with three layers of green wash, the lightest color being laid first. When this was dry, the appropriate light leaves were blocked out with masking fluid. This procedure was repeated twice more, the wash getting progressively darker each time.

2 Working on heavy watercolor paper, the artist sketches in the main shapes and then paints out the flower heads with the masking fluid and an old sable brush *left*.

3 The edge of the picture is blocked out with the masking fluid *below* to give a clean finish to the final painting. A few minutes drying time is allowed before the next stage.

1 Normally it would be too time-consuming to paint these wild flowers *right* in their natural setting because of the mass of blooms and complicated foliage. For this reason, the artist decided to simplify the process by using masking fluid.

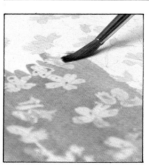

4 A few drops each of moss green, emerald and scarlet concentrate are mixed with water to make a thin wash. The artist applies this across the whole picture with a No. 4 sable brush *left*, working quickly to cover the area before the color has time to dry.

5 The fluid resists the paint *left* which cannot stain the paper underneath the masked areas. Before further work, the wash must be allowed to dry.

6 The artist masks out those leaves which will appear the lightest in the final picture *above*.

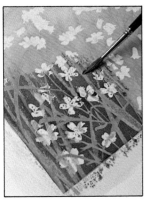

7 When the masking fluid is completely dry, the artist applies a deeper version of the green wash across the entire picture surface *left*.

8 The second coat of paint is allowed to dry *right*. Although the image can be seen clearly at this stage, it is difficult to assess how the final colors will look, because the tones will appear in reverse.

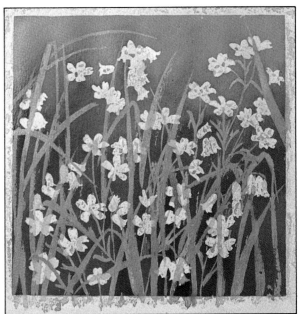

DILUTING WATERCOLOR CONCENTRATE

You should always use a white palette or mixing dish for the color – this enables you to see how strong or weak the color is. The dropper will help to control the amount of pigment you put out.

Finding the right tone is a question of trial and error, so gradually add water until you are satisfied with the result. It is always a good idea to test the color on paper similar to the one you are working on. Some colors change when they dry, usually tending to get lighter rather than darker.

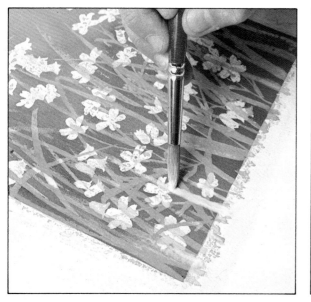

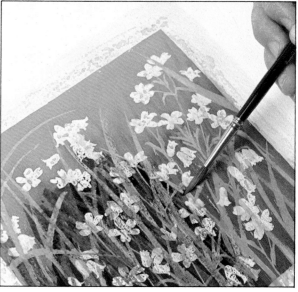

9 A second 'layer' of leaves is masked out *above* – these leaves will appear darker than the previous ones in the finished picture. The artist works in free, fluid brushstrokes to ensure a crisp outline to the eventual image.

When working with masking fluid, it is essential to clean the paintbrush after use because the dried rubbery solution can ruin the bristles. Or, even better, keep an old brush specially for the job.

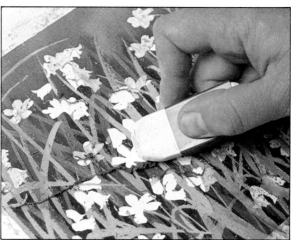

10 The third and final wash is applied *above*, the artist working quickly to avoid blotches and uneven color in the built up layers of paint. Again, the painting must be absolutely dry before the next stage.

11 An eraser is used to remove the dried masking fluid *left*. This must be done carefully to avoid rubbing out the paint or getting the white areas grubby.

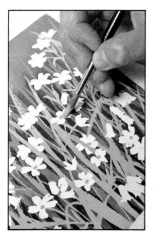

12 The daisy centers are dotted in with cadmium yellow *left*. Gouache is chosen for these details because watercolor concentrate is difficult to control on a small scale.

13 For the bluebells the artist uses a diluted gouache mixture of ultramarine blue and Bengal rose *right*. The paint is applied thinly to give the flowers a transparent quality, in contrast to the dense background.

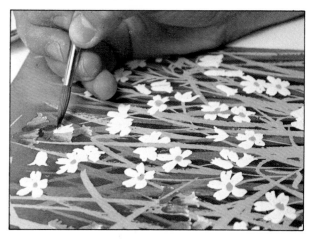

What the artist used

The main colors here are watercolor concentrates and gouache. Masking fluid was applied with a No. 6 sable. The support is Bockingford watercolor paper measuring 15 × 12 inches.

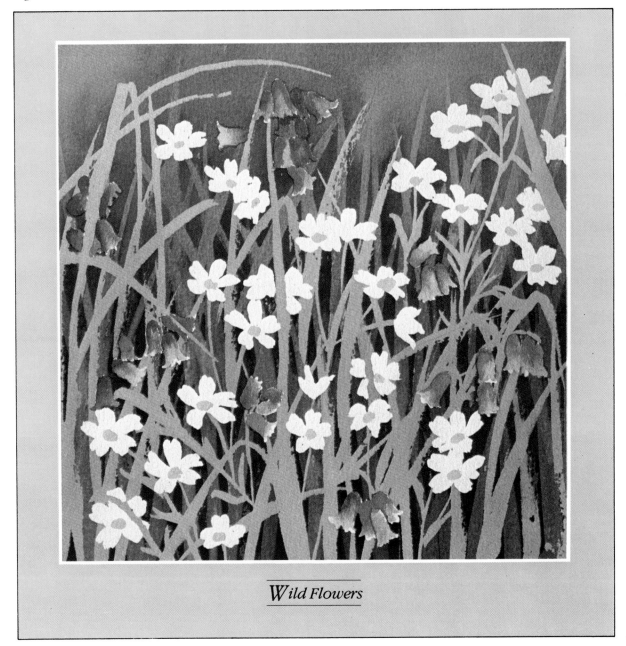

Wild Flowers

CHAPTER NINE

*P*astel

Pastels have a versatility which makes them difficult to equal for rapid, on-the-spot painting or sketching where strong colors and a lively, spontaneous approach are required.

Their adaptability makes pastels especially valuable to the flower artist, who sometimes needs the means to make a quick, colorful sketch of a subject which is constantly changing and often short-lived. They can also be used for more detailed work, and by building up and blending the colors you can obtain a highly finished rendering of quite complicated subjects.

Pastels fall into two basic categories: soft pastel and oil pastel. The soft pastels are crumbly and smudge easily, and need to be fixed immediately; oil pastels are more stable, but slightly more difficult to blend.

The great advantage of all pastels is their portability. For most purposes, you will only need a fairly small set. This has most of the advantages of a box of paints, but requires none of the accompanying paraphernalia, such as water, turpentine, brushes or unwieldy supports.

In this chapter, we have tried to demonstrate some of the many different techniques which are possible with pastels, a medium which is as suitable for tackling wide vistas – which often include a variety of plants and large areas of sky or grass – as it is for making a study of a single bloom.

OIL PASTELS

TURPENTINE

PASTEL HOLDER

TORCHON (FINE)

TORCHON

SABLE BRUSH

PUTTY ERASER

FIXATIVE

SOFT PASTELS

Materials

There are two main types of pastel: the original pastel and, more recently, oil pastel. Chalk and conté have similar properties and are sometimes included in the same general category.

Soft Pastels

Soft pastels consist of powdered pigment mixed with enough gum to bind it together. The pastels come in molded sticks, and are made in three qualities: soft, medium and hard.

There is a vast range of colors to choose from – one manufacturer supplies an assortment of nearly 600 different colors and tints. While this may seem excessive, it should be remembered that pastels cannot be mixed before use. They can, of course, be blended on the paper, but there is a limit to the amount of pastel dust which can be rubbed into the paper surface before it becomes clogged and unworkable. It is, therefore, often very useful to have not only a wide range of colors to choose from, but also to have a selection of tones of the same color.

Choosing a suitable range of colors is very much a matter of personal taste. A basic set of 12 or 20 sticks would probably be sufficient for working out of doors, and small enough to carry in your pocket. For studio work, a wider selection could prove useful – possibly 40 or 50 colors.

Pastels more than almost any other medium require a systematic approach. Start by laying out your colors on a piece of cloth or corrugated

cardboard, arranging them according to color and tone. This may seem unduly regimented, but if you can get into the habit of replacing each color as you finish using it, you will be able to see at a glance which color you want next and your work will be quicker and easier as a result. Because they smudge so easily, pastel works should always be fixed.

Oil Pastels

As the name suggests, in this pastel the chalk and pigment are mixed with oil. Oil pastels are more stable than traditional pastels because they are harder, and do not smudge or crumble. This does mean, however, that they are more difficult to blend on the paper and, although it is possible to merge the colors to some extent by rubbing them, this method is limited.

Oil pastel is at its best when used for quick interpretations of plants and flowers. It is also useful for roughing out the initial stages of oil paintings, as well as being effective in many types of mixed media work.

Supports

Texture is the most important factor when choosing papers for pastel work. The surface should be rough enough to act as a key for the fine pastel dust, otherwise the color merely falls off the paper. It is also important that your support should be a good quality one, otherwise it will buckle and tear as you work.

There are papers which are specially made for pastels – one particular paper has a velvety surface, another is rather like fine sandpaper – but good quality drawing or watercolor paper is usually perfectly adequate. Many of these papers come in a variety of colors and tints, all of which are highly suitable for the dense, opaque color of pastels.

INGRES TINTED
SKETCHBOOK

A Bowl of Mixed Flowers

The word 'pastel' has come to mean something which is pale and delicate, probably because there is a high percentage of white chalk in sticks of pastel color.

This description is rather misleading, however, because pastel can actually be very bright – as is aptly demonstrated by this colorful rendering of a bowl of flowers. The pure, vivid pigments which the artist used show how little the white content actually affects some of the brighter colors.

In this case, careful attention was given to the choice of paper. The artist wanted a neutral color which would not detract from the subject, as well as requiring a coarsely textured surface to take the heavily applied color. The final choice was a medium grey Ingres paper, which looks well with the vivid flowers and white background. Pure white or a stronger tint would have been less successful – white, because it would have been too glaring and stark; a stronger color, because it would have affected the pure pigments of the pastel.

The artist worked from a large set of soft pastels, 24 of which were used in the picture. In the painting, the colors look simple, almost primary – at first glance it seems as if only one version of each color has been used. In fact, there are four reds, four purples, five greens, and four yellows in the finished painting, as well as a selection of browns and greys.

Another aspect of the painting which is deceptively simple is the artist's method of working. The colors and composition seem almost naive in their simplicity, with the bowl placed centrally in the picture, and the flowers – in the primary colors of red, blue and yellow – orderly arranged.

But the artist's method of working was not at all naive. The composition was carefully sketched out in black, to ensure that the flowers were correctly positioned, and in proportion to each other. After that, the colors were added one at a time, the lighter tones being laid down first. The colors were used very much as if they were paints – with the picture being developed as a whole, rather than put together as a series of separate components.

Finally, the finished picture was sprayed with fixative to ensure that the dusty pigments did not smudge or rub together.

2 First the composition is sketched in charcoal *above*. The neutral grey background is a deliberate choice so that the white flowers and background can be put in as positive shapes.

3 The artist works dark blue into the shadow areas of the flowers and foliage *below*. This dark tone provides a structure to which color and detail can be added.

1 For this pastel painting, the artist chose a brightly colored arrangement against a plain background *right*, with different types of flower and foliage to add interest and variety to the composition.

4 With the dark areas established *left*, the artist is now ready to introduce color. When using colored pastels, it is better to work from dark to light to avoid the dark pastel dust scattering on light colors.

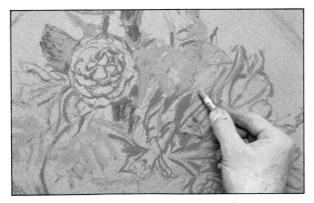

5 Working in different greens and browns, the artist picks out the colors in the foliage *above*. At this stage no attempt is made to blend the colors or put in detail – just the broad areas of local color.

6 The flowers are gradually filled in, each one being carefully worked in several different tones of the same color *below*. A wide range of tones should be kept readily to hand so the correct color is always available.

USING A TORCHON

Small areas of pastel can be blended with a torchon. These are sold in art shops and come in a variety of sizes, or you can make your own by simply rolling up a piece of thick paper. The torchon can be used to blend areas of color which are too tiny to be rubbed with your finger or a cloth.

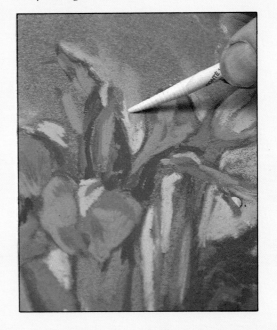

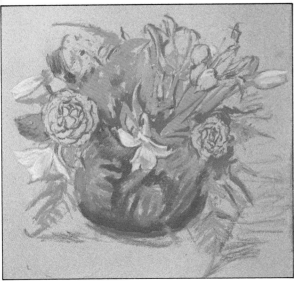

7 The terracotta pot is blocked in with two tones of warm brown *left* – a slightly yellowish brown being used for the lighter side of the pot. A little green is worked into the shadow to modify the bright colors.

8 Here the artist is putting the finishing touches to the iris. The petals are made up of three tones of purple – light, medium and dark – with yellow markings *right*. There is no actual detail in the flower, although the exact colors give a realistic impression.

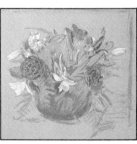

9 The roses are blocked in – again, using three tones of the same color *above*. Small areas of grey paper are left showing to separate the petals.

10 Tiny white flowers are put in *right*, and the artist works across the whole image adding other details where necessary.

11 White pastel is used to block in the table top and parts of the background *right*. This is applied quite densely, the artist taking the white almost up to the edge of the flowers.

12 The picture is sprayed with fixative to prevent smudging *below*. This is held about 12 inches away from the paper and lightly sprayed across the surface.

What the artist used

For this colorful subject the artist worked from a set of more than 100 pastels. Some of these were blended with a torchon.

A grey Ingres paper measuring 20 × 20 inches was chosen so that the white background and light flower colors would show up. The finished work was sprayed with fixative.

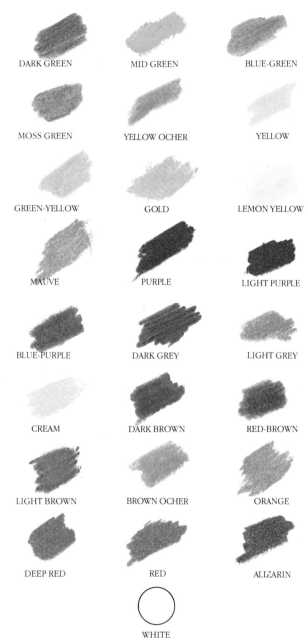

DARK GREEN MID GREEN BLUE-GREEN

MOSS GREEN YELLOW OCHER YELLOW

GREEN-YELLOW GOLD LEMON YELLOW

MAUVE PURPLE LIGHT PURPLE

BLUE-PURPLE DARK GREY LIGHT GREY

CREAM DARK BROWN RED-BROWN

LIGHT BROWN BROWN OCHER ORANGE

DEEP RED RED ALIZARIN

WHITE

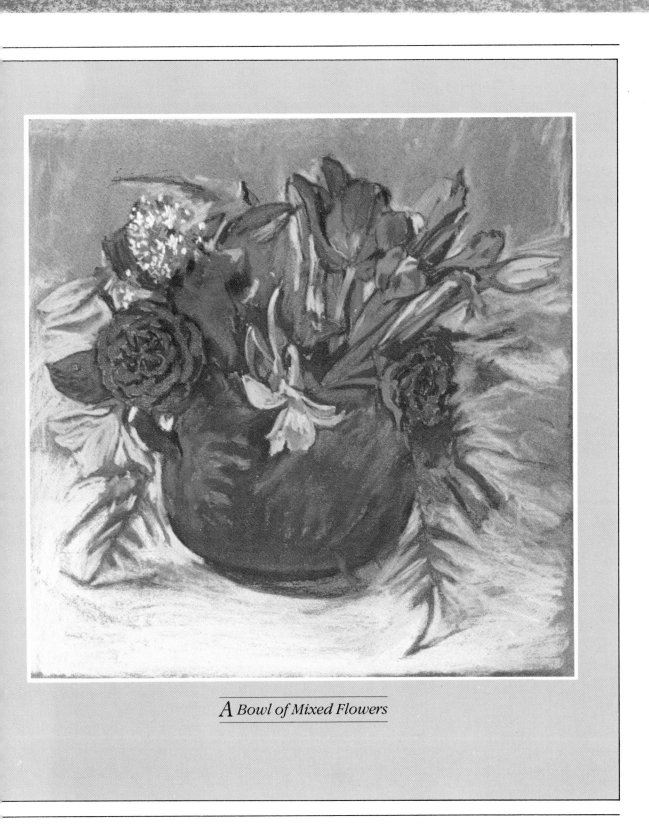

A Bowl of Mixed Flowers

Asters

The colors and shapes of these bright and attractive asters are well suited to pastel. The flowers themselves are made up of small, spiky petals – easily transferred into the short, gestural strokes of color which the artist chose to use. The leaves, too, have a flowing, streamlined quality – again, easily expressed in the strong, directional pastel strokes.

This loose treatment of the subject is endorsed by the informal composition. Instead of being placed centrally in the picture, the asters are set to one side, giving a close-up view of the flowers. This slightly unusual arrangement lends an added piquancy to the picture, and avoids what could easily have been a rather conventional flower study.

The artist chose to work with a few bold colors, keeping the treatment as simple as possible. While this might at first seem the easiest course to take, working with a few bright colors and a simple subject can often be a very difficult task.

The main problem with such strong colors is how to control their intensity – that is, how to make them bright or subdued enough for a particular purpose, and how to prevent one color from overpowering another. Although color and tone can be altered and adjusted by blending, this will eventually deaden the overall effect, and must be limited. The only real way to retain the freshness and vibrancy of the individual colors is to carefully balance the various areas of color – and one way to ensure this balance is to introduce a complementary color into a general color area.

Here, the colors of the flowers are basically complementary – red, orange and pink, being used with blue, purple and green.

These contrasting cool and warm colors have been used to produce a balance within the picture – areas of predominantly warm color, such as the red flowers, include touches of the cooler blues and greens; colder colors, like the leaves and the blue flowers, are enlivened by strokes of red.

In order to create a solid base for the textural strokes which run through the whole picture, the artist first created large areas of flat color by blending the initial pastel strokes with tissue-paper. This was especially necessary on the flowers, because the blending effectively obliterated any areas of white paper which would have shown through the final petals, making the flower heads seem less solid and realistic.

There is also a substantial amount of blended pastel in the lower part of the background. This subdued, smudgy green area provides a context for the subject, without which the flowers would be a pattern of unconvincing shapes on a stark, flat area of white.

1 The composition is deliberately arranged to give a feeling of closeness *right*, with the flowers packed tightly together to provide dense areas of contrasting cool and warm colors which are ideal for bold, colorful pastels.

2 After sketching the outlines in charcoal, the artist lightly blocks in the colors *left,* providing a basic composition which is ready to work on *below*.

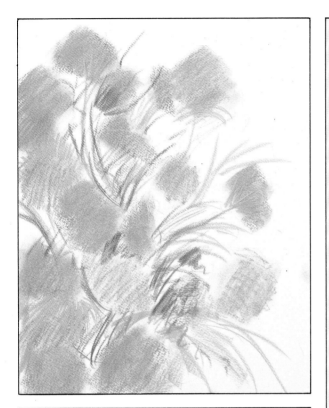

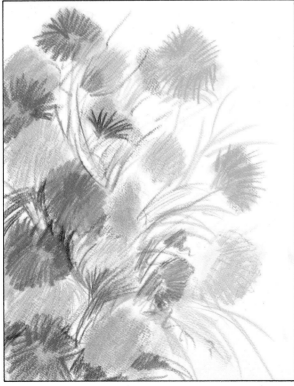

BLENDING LARGE AREAS

As long as the paper has a good surface, pastels can be blended quite easily. Rubbing the color in with your finger is probably the most convenient method of doing this, but for larger areas it is quicker to use a cloth or tissue-paper – as the artist is doing here.

Unlike your finger, tissue-paper lifts the pastel off the paper, so it can also be used to lighten to tone.

3 The artist uses a piece of tissue-paper to blend stronger colors into the image, then develops the flowers using short, sharp pastel strokes *top left*.

4 Short strokes of cadmium red, orange and blue are used to emphasize the petals, and feathery strokes of dark green are added to the foliage *left*.

5 Using the tip of the pastel, the artist describes the stem and leaf shapes with rapid, free strokes *right*. These thin strokes of light and dark tones combine to give the impression of depth and form to the subject.

6 Pastel marks can either be left as clean strokes – in which case care must be taken to avoid smudging – or they can be blended into subtle gradations. Here the artist uses a finger to blend the orange and pink flower colors *left*. Blended shades should be kept simple because too much rubbing clogs the paper and dirties the color.

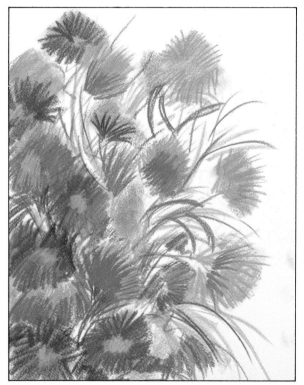

7 A heavy layer of purple pastel is laid over the blue flowers. The artist then uses the same color to add additional leaf and stem shapes in order to integrate the image *above*.

8 The final and darkest tones are worked into the flowers and foliage, and the artist breaks up the flat white background with a light green tone *right*.

What the artist used

Soft pastels were used for this colorful flower picture, and worked on white pastel paper measuring 16 × 20 inches. An initial outline was sketched in a willow charcoal, and the final picture was sprayed with fixative to prevent the colors from smudging.

Tissue-paper was used for blending colors, although any soft rag would have been equally suitable. For smaller areas of color which are too detailed to be blended with a finger or tissue, a torchon made from tightly rolled paper, can be used.

BLUE-GREEN

CADMIUM RED MEDIUM

CADMIUM YELLOW MEDIUM

COBALT BLUE

DARK GREEN

LIGHT GREEN

ORANGE

PALE PINK

PINK

PRUSSIAN BLUE

WHITE

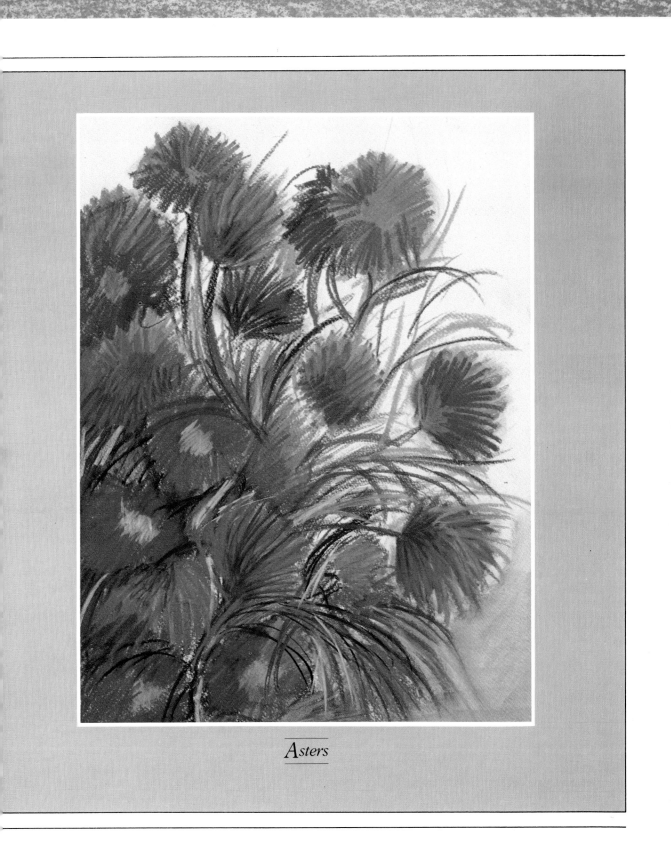

Asters

Water-Lilies

OIL PASTEL

Oil pastels are a comparatively recent invention, and totally different from the traditional pastel. Instead of the soft powdery effects which we get from other pastels, oil pastel has a hard, textural quality which makes it unsuitable for certain types of work.

Water-lilies might seem an odd choice of subject for what is often thought of as rather an uncompromising medium, but the artist was anxious to demonstrate that there are various ways of using oil pastels, some of which can be used for smaller subjects such as flowers.

Blending the pastels with turpentine is one such technique. By using this method, you can apply the color in the normal way, and then work different colors together with a little turpentine. The turpentine dissolves the oil which binds the pigment, enabling you to work the color into flat, smooth areas. This method was used effectively in the water-lily picture, to obtain the shiny leaves and smooth petals on the flowers.

Pastels of any type are difficult to correct, and oil pastels are more difficult than most. Without the aid of turpentine, the strokes you put down are permanent. For this reason it is always advisable to use fairly light strokes in the early stages.

There are other ways of blending oil pastel colors, but none of them produce the smooth, controlled tones which you get with turpentine, although subtle colors can also be obtained by using the side of the pastel and lightly rubbing the colors on top of one another. Notice how each color changes when another color is placed over it.

The artist used a scalpel to scratch back into the yellow flower centers. This is a popular technique with painters who are familiar with the medium, and is especially useful when the paper surface becomes heavy or clogged with color.

Obviously oil pastels should not be used for very detailed work. Even if you blend the colors with turpentine – as the artist did here – they are still a comparatively clumsy medium, and are generally more suited to a bold, direct method of working, when their strong colors and heavy texture can be put to better use.

The pastels should be used only on heavy paper, especially if you are going to use turpentine to blend the colors. Don't be alarmed if the turpentine makes oily patches on the paper when you first put it on – these will evaporate and disappear.

Colored paper can be an effective support for oil pastels, although a tint which is too dark will deaden the pastel colors. On the whole, white or light colored paper – like the one used here – produce more luminous results because the tiny flecks of paper can be seen shimmering through the pastel.

1 Oil pastels are excellent for painting strong, bright colors and simple shapes, and less suitable for detailed or linear subjects. The artist chose the single water-lily *right* for its simplicity and its pure, clear colors.

2 After drawing the outlines of the main shapes in pencil on to a piece of thick watercolor paper, the artist uses these lines as a guide for blocking the shapes with a pale yellow oil pastel *left*.

3 White is laid over the yellow to lighten the highlight areas on the petals *right*. Although at this stage the artist uses the direction of the strokes to show the shape of the petal, these strokes will eventually be blended to produce a smooth surface.

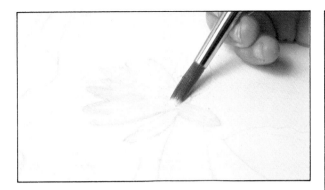

4 Using a No. 10 sable brush, the artist starts to blend the pastels together with turpentine *above*. This produces a smooth surface which is then ready to work into with further color.

5 The leaves are worked in a similar way. First the artist adds the color – this time using a mixture of green-yellow, blue-green and green – and blends it with turpentine *right*.

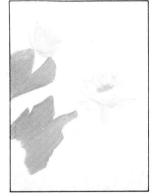

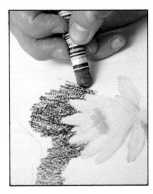

6 The artist starts to block in the darker areas of water in black pastel *left*. With light, regular strokes, the color is laid as flatly as possible so that the eventual water surface will look smooth and reflective.

7 Care is taken to take the pastel strokes up to the edge of the lily without spoiling the outline of the flower. The larger leaf is blocked in with a combination of dark, medium and light greens and a light blue *below left*.

Oil pastels can be easily sharpened with a blade or scalpel for smaller areas of color or to obtain a more controlled line.

8 Here the artist adds the water highlights in bright blue, and lightens this in certain places with a little white *right*. Again, the color is applied as evenly as possible to ensure a smooth finish.

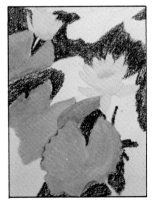

BLENDING OIL PASTEL WITH TURPENTINE

You can get a wash effect with oil pastels by dissolving the pastel marks with a brush dipped in a little turpentine. This produces a smooth texture which is often easier to work into than the rather hard, cloying pastel strokes. Large areas can be wiped with a cloth dipped in turpentine.

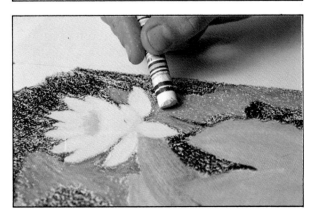

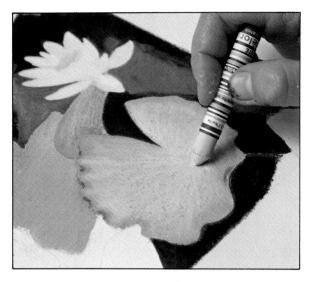

9 The artist starts to work across the entire image, changing and adjusting tones and colors to work with those in the rest of the composition. Here a leaf is lightened with a little pale blue *left*.

10 With turpentine and a bristle brush, the pastels are blended to form a flat finish *right*. Only a small amount of turpentine is loaded on to the brush at a time to avoid flooding the paper and making the color blotchy. Notice how the turpentine darkens the tone of the pastel colors.

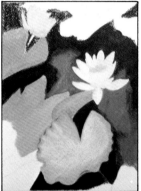

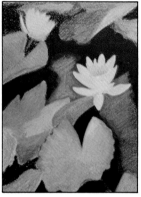

11 Many of the shapes and colors are now established *far left* and the composition is ready for the final blocking in and some detail.

12 The blocking in is completed in blue-green, green and green-yellow *left*. These colors are strengthened and developed *right* to match the tone and color on the actual subject.

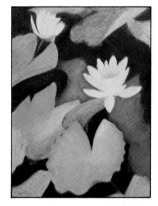

13 Final highlights are added with white pastel and blended with turpentine *left*. The artist avoids breaking up the main shapes into fussy or complicated arrangements of tone – preferring, instead, to keep the composition as simple and graphic as possible.

14 A scalpel is used to add texture to the dark yellow center of the lily *right*. Various textures and effects can be added with a scalpel blade or other sharp instrument, and practice and experiment will provide the artist with a wide range of possibilities.

What the artist used

For this picture the artist used oil pastels on heavy watercolor paper measuring 12 × 10 inches. The colors were limited to two or three on any one area to avoid the painting becoming overdone and muddy; these were blended with pure turpentine and a No. 9 sable brush.

The pastels are oil-bound pigments in a solid form, and the effects they produce are very different from those of regular pastels.

Since oil pastels are inclined to be more clumsy than regular pastels it is best to use them on a small scale, like the one here. The images they produce are fluid and malleable and the pastels are versatile enough to create a wide range of effects.

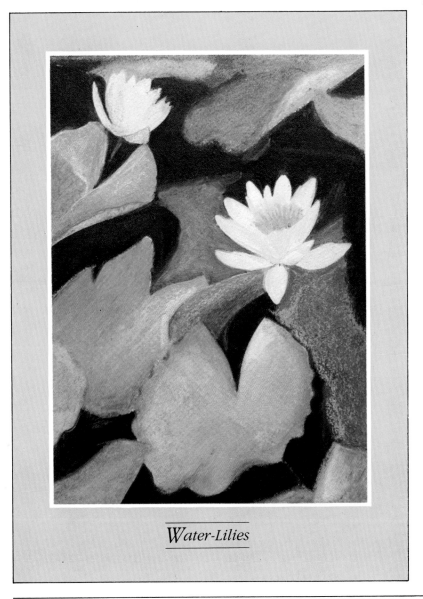

Water-Lilies

COBALT BLUE

LIGHT BLUE

ULTRAMARINE BLUE

GREEN-BLUE

GREEN

GOLD

GREEN-YELLOW

LIGHT BROWN

DEEP YELLOW

LIGHT YELLOW

BROWN

BLACK

WHITE

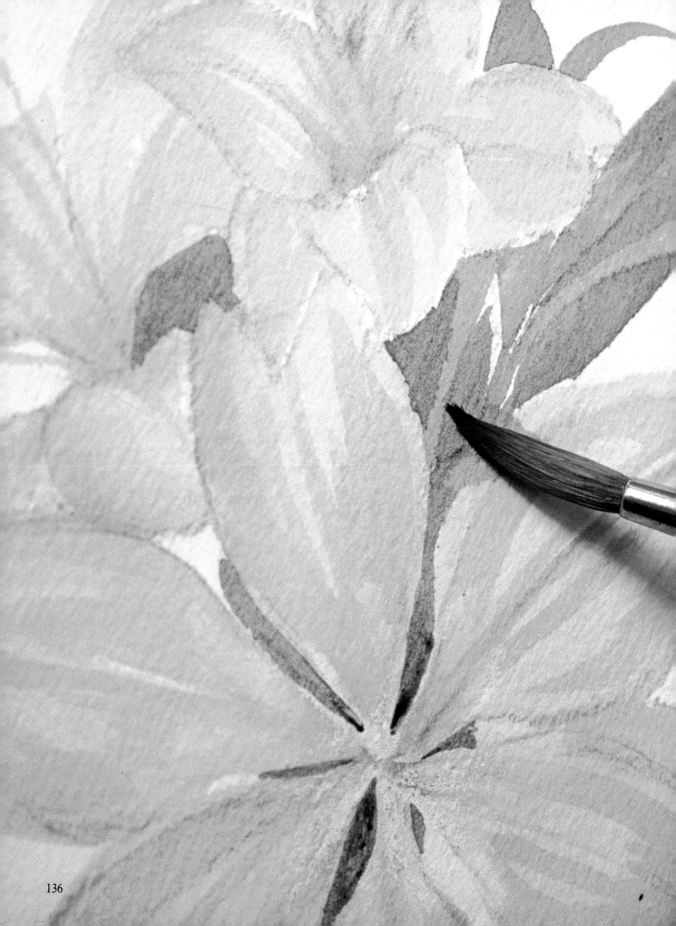

CHAPTER TEN

*I*nk

I nk has been closely associated with the art of flower painting for hundreds of years. In Japan and China the technique of using a brush to paint the ink directly on to the paper without first drawing an outline has been a highly respected art form for at least a thousand years.

Then, as now, ink painting looked easy. But the apparent simplicity of the pictures is deceptive. Ink is a medium which requires a lot of patience and practice – especially if you want to achieve the effortless effect which the flower painters of the East were so good at.

The transparency and vivid colors of artist's inks make them an exciting prospect for the flower painter, in a field where the brightest pigments available can still fall short of what is required. Because the color is so concentrated, you might find it necessary to dilute the inks with water to get exactly the right tone. Colored inks have a strong staining power and cannot easily be corrected, so always try the colors on a piece of paper before applying them to the painting.

There is no formula for successful ink painting, but the better acquainted you can become with the nature of the medium, the more you will be able to choose – and invent – techniques to suit your own way of working.

Materials

Various types of ink are available for painting and drawing. Indian ink is probably the most common, and comes in two forms: waterproof and soluble.

Traditionally inks were rarely mixed with another medium, but nowadays they are regarded as being the most versatile of materials and are frequently used in conjunction with watercolor, gouache, pastels and other media. Flower painters often find it useful to combine the translucent quality of colored inks with a more opaque medium.

Indian Ink

Real Indian ink is made from lampblack pigment and a binder. It is usually sold in small bottles and can be either water-soluble or waterproof.

Waterproof Ink

Waterproof ink can be worked and blended while it is still wet but, when dry, it is permanent and will not dissolve or bleed. It is, however, difficult to paint over once it has dried, and has a rather resistant surface. The waterproof properties of the ink can be used to obtain various effects – the ink 'wash-off' technique, described later in this chapter, is a good example of this.

WATERCOLOR PAPER, ROUGH TO
SMOOTH (TOP TO BOTTOM)

COLORED DRAWING INKS

CERAMIC MIXING DISH

INDIAN INK

CHINESE INK STICKS

WATERPROOF DRAWING INKS

Soluble Ink
Water-soluble inks, which also come in a variety of colors, are more like watercolor paints, both to use and in their final effect. Water-soluble inks will dissolve even after they have dried.

Japanese and Chinese Inks
These distinctive inks come in stick form, and are made from the carbon of charred pine, or from lampblack. The pine produces a blue-black; the lampblack, a dull brown. The ink sticks need to be ground down on a soapstone palette with distilled water to release the pigment.

Brushes
Watercolor brushes are suitable for ink, the best ones being made of pure sable. These come in a range of sizes from the very fine 000 to the largest, No. 12. Flat brushes are available for making washes and for laying down areas of flat color.

 Japanese 'boneless' brushes are traditionally used for ink painting. These come in three sizes: large, medium and small, and are usually recognizable by their bamboo handles. Japanese 'outline' brushes are smaller, and the bristles can be stiff or soft depending on the type of line they are used for.

Supports
Good quality watercolor paper is ideal, and will take washes without buckling. If you intend to apply a heavy wash of ink, it is best to stretch all papers before use.

JAPANESE 'BONELESS' BRUSH

SYNTHETIC FLAT

NO. 5 SYNTHETIC ROUND

NO. 6 SABLE ROUND

JAPANESE OUTLINE BRUSH

A Single Lily

COLORED INK

The color of this single lily is so bright and luminous that the artist felt the transparent and brilliant pigments of colored inks were the best means of expressing this quality.

Used in this way, ink is very similar to watercolor. The paint was laid in thin washes which were gradually built up to obtain the denser areas on the petals and leaves. The tiny stigmas were put in with colored pencil when the ink had dried.

The transparency of the medium makes it generally unsuitable for detail unless, of course, you change to a pen for the finer work. Otherwise, details can be added in another medium when the ink is dry. Pencil, pastel and gouache all produce opaque colors which stand out well against the transparent ink.

Colored inks soon lose their brightness and start to get muddy if too many pigments are mixed together, so use as few colors as possible – the artist used just green and yellow in this painting, creating all the subtle variations of tone and hue from this extremely restricted palette. You will learn more from working with limited colors and a simple subject, than from using a wide range of colors and working from a complicated subject.

Inks are slightly more difficult to control than watercolor, and if you have time to practice a little before embarking on a specific project, the extra effort will be rewarded. It would also be a pity if an over-ambitious project in the early stages dissuade you from using a medium which has so much to offer the flower painter when it is properly used.

When you work with ink, always try a little of each tone or color on the edge of the paper before applying it to your picture. This may seem cautious and time-consuming, but even experienced ink painters find this necessary, and there is no other way of knowing whether the mixture is what you want.

A white palette or dish is best for mixing because it helps you to gauge the colors more accurately. The inks dry quickly, so always keep a good supply on the palette. Once it is allowed to dry, ink goes hard and grainy and the resulting dark specks can affect the smooth, transparent nature of the color.

2 The artist draws the flower lightly in light brown pencil and applies a wash of diluted yellow ink with a No. 6 sable brush *above left*. The deeper areas are added in stronger yellow *above right*.

3 Areas of light yellow wash are left to depict the highlights on the petals *below*. The deeper tones are applied in the direction of the petals to give an impression of their ridged texture.

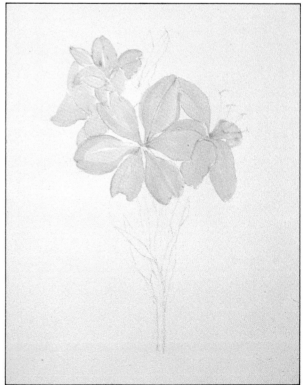

1 The yellow lily *right* is made up of two basic colors – yellow and green. Because the colors are so intense, the artist prefers to use a medium which captures this luminous quality and which does not lose its brightness when dry – in this case, colored inks.

4 A little green is mixed with the deep yellow and the petal shadows darkened to give an indication of the shape and form of the flowers *left*.

5 More green is added to the shadow color and the artist works into the center of the flower, intensifying the dark tones and emphasizing the texture on the petals *below*.

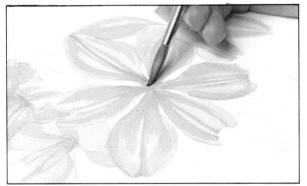

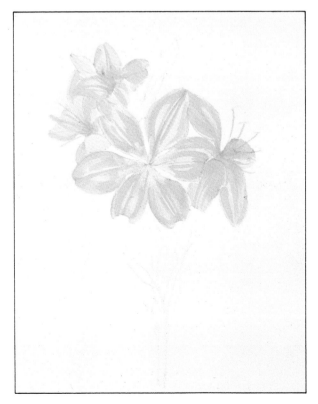

TESTING COLOR STRENGTH

It is very difficult to gauge the strength of color of ink before you actually see it on the paper. If you make a mistake and the color is too strong, it is almost impossible to correct this once the ink has been applied.

For this reason, it is advisable to test each new color or tone on the edge of your picture or on a separate sheet before you use it.

6 Using just two colors the artist completes the bright yellow flower heads of the lily – a little permanent white is added to the center of the main flower *left*.

7 Green ink is diluted with water and applied over the entire leaf area *right*. The artist uses the direction of the brushstrokes to help form the shape of the leaves.

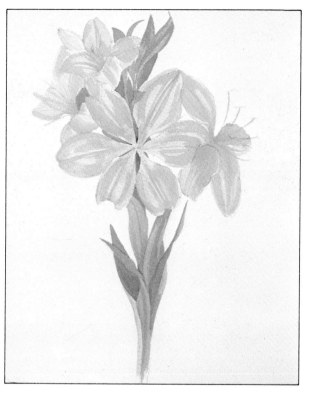

8 When the first wash is dry, the artist picks out the dark shaded areas of the leaves with a deeper green *above*. There should not be too much difference between the two tones of green otherwise the result looks artificial.

9 The main areas of color are now complete *right*. The picture looks highly realistic and detailed, but the brushstrokes are quite free and the whole painting is much simpler, in fact, than it seems, being built up of washes of bright green and yellow.

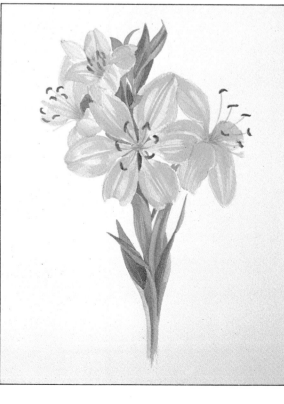

10 The artist draws in the stamens using a yellow ocher felt nib pen *above*. Each one is depicted as a single stroke to avoid them looking too heavy.

11 The stamens give a light structured look to the painting, and help to establish the character of the flower *right*. Now is the time to assess the picture and decide on any final details.

12 Here the centers of the flowers are further lightened, with a little permanent white on the tip of the No. 6 sable brush. Because ink is so transparent, it is difficult to lighten the pigment once dry. Corrections and light tones should therefore be carefully added in an opaque white, such as gouache or permanent white *above*.

What the artist used

Just two drawing inks were used in this painting, with a little permanent white for lightening and touching up. Felt nib pen was introduced for the stamens.

The artist chose fine grain Arches watercolor paper measuring 12 × 10 inches and the inks and paint were both applied with a No. 6 sable brush.

INKS

EMERALD

YELLOW

FELT NIB PEN

YELLOW OCHER

OPAQUE COLOR

WHITE

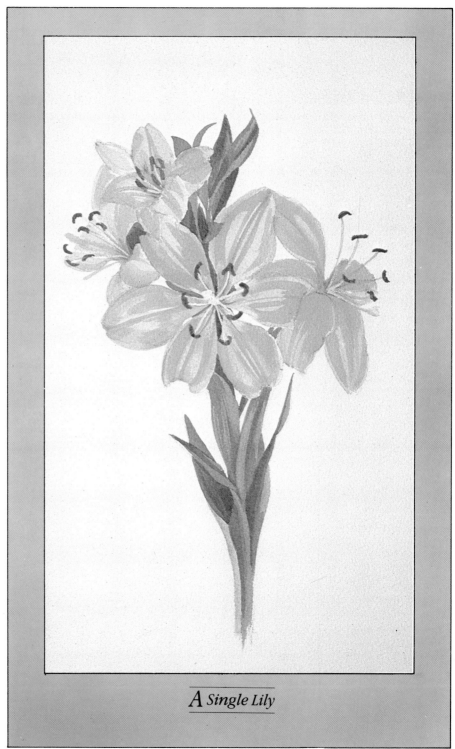

A Single Lily

Cut Chrysanthemums

INK AND GOUACHE 'WASH-OFF'

Ink 'wash-off' is a basically simple technique which requires a systematic, patient approach – and provided that you carry out each stage carefully, without hurrying, a successful result is almost guaranteed.

The method exploits the properties of waterproof Indian ink and gouache paint, which is soluble, to produce a negative image. This image can then be worked into and developed, creating a sharp, textural effect rather similar to that of a woodcut or lino print.

The chrysanthemums are a good choice of subject because they have many interesting textural petals and leaves. These can be treated in a free, painterly manner, the brushstrokes being used to suggest the form and movement within the subject.

Ink 'wash-off' must be done on good quality white paper – one that will not tear when wet. This should first be covered with a color wash and allowed to dry. The next stage involves painting the image in thick, white gouache paint – it is essential to use white, because a color would stain the paper and affect the final picture. The whole paper is then covered with an even coat of flat, black, waterproof Indian ink and allowed to dry.

The principle behind this technique is that when the painting is held under running water, the gouache dissolves and is washed off. This causes those areas of dried ink which were covering the gouache to disintegrate and wash off at the same time.

When this 'wash-off' stage is complete, you should be left with the negative image of this subject standing out against those areas of black ink which were applied directly onto the paper and did not cover the gouache paint.

Although this is a somewhat lengthy process, it is not a particularly difficult one. And the results are often spectacular. To be sure of success, each step has to be carried out thoroughly, and the wash, gouache and ink stages must all be allowed to dry before the next stage can be started.

The paper should be taped to a drawing-board before the first color wash is applied, to prevent it from wrinkling. Even so, it will probably buckle a little when it is wet, but this should correct itself if the paper is allowed to dry naturally.

Ink 'wash-off' is a versatile technique and, once you have learned the basic principle, there is no reason why you shouldn't evolve your own methods and ways of working. The artist here developed the black and white design with watercolor, but you can just as easily use another medium, or even leave the painting as black and white if you prefer.

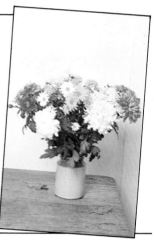

1 These chrysanthemums *right* were chosen for their warm strong colors and textural flowers. The ink 'wash-off' technique relies heavily on the texture and quality of different brushstrokes – the textural petals and leaves of this bunch of chrysanthemums are ideal. A simple setting and plain vase emphasize and enhance the flowers.

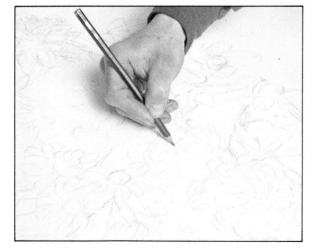

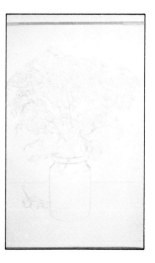

2 With a 2B pencil the artist sketches in the main shapes *left*. The centers of the flowers are carefully positioned as a guide to the rest of the composition.

3 The pencil drawing is free and sketchy, with only the basic shapes drawn in *right*. Notice how the artist uses the available space, taking the image up to the edge of the paper.

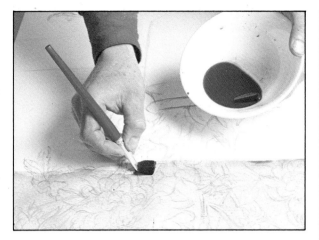

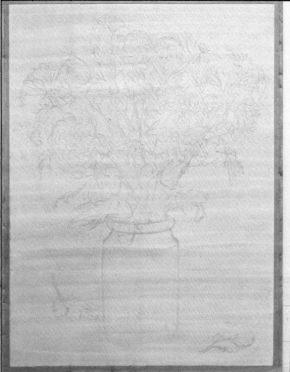

4 The paper is stuck to a drawing board with tape and the artist applies a watercolor wash of burnt sienna *above*. This color is diluted with a lot of water to make a pale, neutral wash and is applied in even, horizontal strokes with a No. 16 sable brush.

5 This all-over wash is allowed to dry naturally *right*. If it is put near artificial heat it will dry too quickly and the paper will tear. The sienna wash enables the white gouache – which will eventually be used to pick out the image – to show up on the light colored paper.

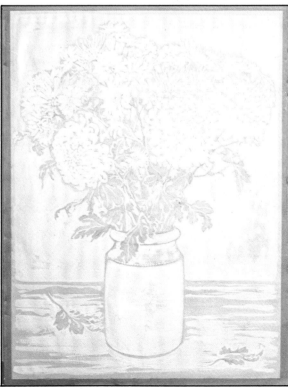

6 With white gouache the artist starts to paint in the shape of the flowers *far left*. A No. 8 sable brush is used for the large areas, and a No. 3 for the finer details. It is important not to overload the brush with paint.

7 The vase and table top are blocked in *far left*. The gouache will eventually be washed off, leaving negative shapes on a black background, so the artist avoids large, flat areas of blocked-in gouache.

8 The artist takes the background almost up to the edge of the flowers but leaves a narrow band of paper between the two *left*. Areas of paper are left showing through the table top, giving a texture to the flat surface.

9 When the gouache is dry the ink is laid on with a No. 16 sable brush in horizontal strokes *above*. Each area must only be covered once otherwise the gouache comes off.

10 The ink is allowed to dry naturally until it is completely dry *right*. There should be no areas of paper or gouache showing through otherwise the result will not be successful.

APPLYING INDIAN INK 'WASH-OFF'

One of the trickiest parts of this technique is laying the waterproof ink over the white gouache image. It is not really difficult, but there are no short cuts, and you must be patient or the effect will be ruined.

The white paint must be thoroughly dry before the ink can be applied. This should be done with a large, soft brush – the one in the picture is a size 16 sable. Shake the ink thoroughly and check that you have enough to cover the whole sheet of paper. Then, starting from the top, start to apply the ink in broad, horizontal, strokes. Only go over each area ONCE, otherwise the white gouache will start to come off and mix with the ink.

11 Large quantities of cold water are poured over the paper and the ink comes away in large chunks *left*. This process takes several minutes before all the removable ink is off.

12 The ink on top of the white gouache comes off leaving a silhouetted image *right*. It is important that all the white paint is removed otherwise it will affect the other colors.

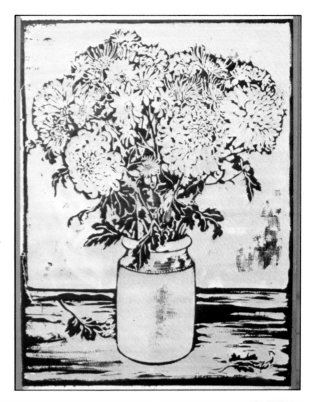

13 The artist uses a paintbrush to remove any excess gouache paint *above*. This comes away quite easily leaving the waterproof black areas firmly attached to the surface of the paper.

14 The picture is allowed to dry before color can be added *right*. There is no reason why the painting should not be left as it is in this black and white stage, but the artist preferred to develop it by adding color.

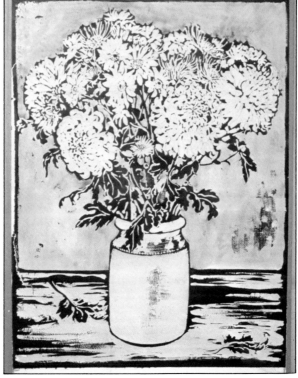

15 The first color to go on is a very thin background wash of Prussian blue watercolor *above*. This is applied with a No. 14 sable brush.

16 Because the background color is transparent, the process is speeded up by painting over the black *right*. However, this cannot be done with opaque colors, or colors which contain white.

17 Burnt umber is painted into the spaces on the table top *above*. Because this is a pure color, the artist paints over the black without any risk of it looking chalky.

The color is filled in quickly, each area being treated as a flat, almost decorative shape without any attempt being made to suggest space or form.

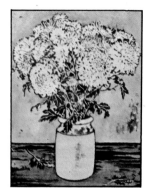

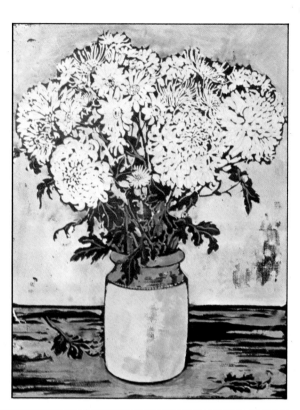

18 The two largest areas of color – the background and the table top – are blocked in *far left*. All the remaining colors can be added gradually. It is not necessary to stick rigidly to the local colors of the subject, and sometimes the painting can be improved by interpreting the subject rather than imitating it.

19 The artist continues to fill in the color *far left*. The pot is painted with a mixture of raw sienna, Prussian blue and white; the leaf veins in chrome oxide and ocher.

20 The artist develops the pot, indicating the shape by adding the subtle color variations and reflections. More leaves are blocked in with a mixture of ocher and chrome oxide *left*.

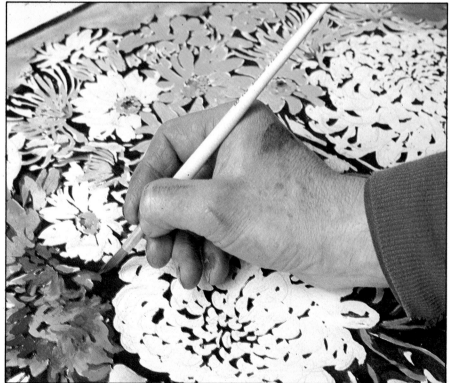

21 Working across the picture, the artist quickly paints each flower head in its local color. Here a second, darker tone is being worked into the golden chrysanthemum *left* with a mixture of orange, vermilion and scarlet.

The white flowers are completed with green centers, and the artist emphasizes the spiky petals with white paint *above*.

What the artist used

For this painting it was essential to use a good quality paper which would stand being saturated with water as well as standing up to the various stages. The artist chose heavy watercolor paper measuring 29 × 22 inches which was stuck to a drawing board with brown tape.

A whole bottle of waterproof Indian ink was used to cover the initial image, which was painted with white gouache.

Finally, watercolor paint was applied with sable brushes, Nos. 3 and 8. The flat background wash was put on with No. 14 flat sable brush, and the Indian ink with a No. 16.

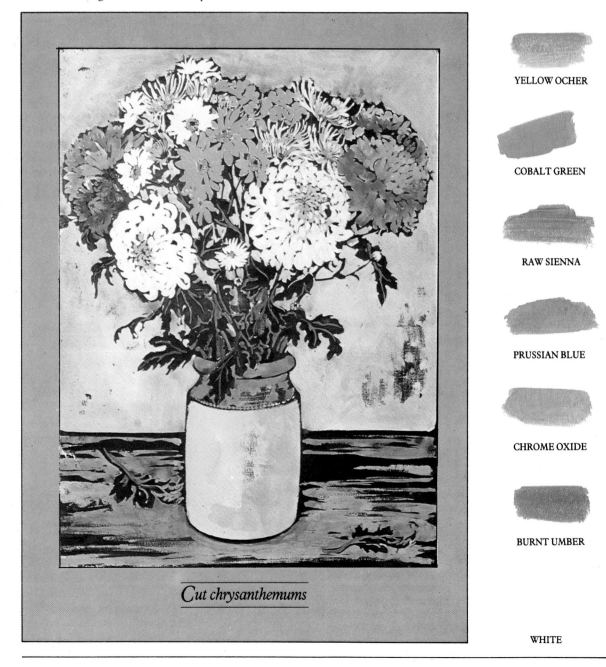

Cut chrysanthemums

LEMON

YELLOW OCHER

COBALT GREEN

RAW SIENNA

PRUSSIAN BLUE

CHROME OXIDE

BURNT UMBER

WHITE

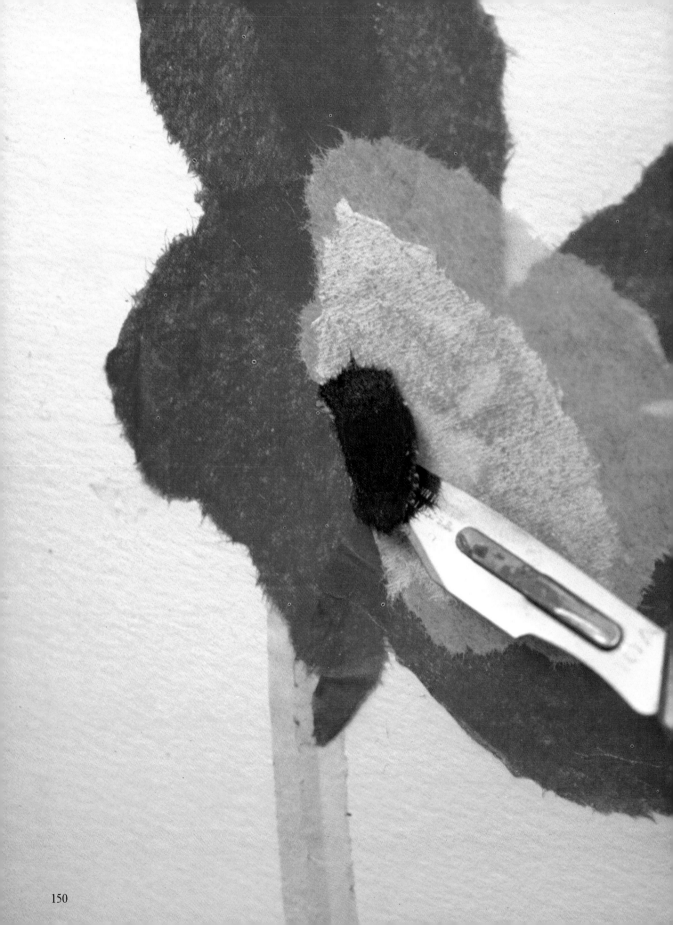

*C*ollage

Although in recent years, collage has been used more by designers than by fine artists, this was not always the case, and as a medium, it has certain advantages over paint which are especially valuable to flower artists.

For one thing, if you are working with flat shapes rather than a palette and brush, it is impossible not to consider the basic design of the picture. When painting and drawing flowers, it is very easy to neglect the composition and design aspect because the obvious emphasis is on color and detail, and while this is not necessarily wrong, it can be restricting, and can prevent your work from reaching its full potential.

It would be impossible to talk about flower collage without mentioning Matisse, whose large and brilliantly colored works have had such a profound influence on twentieth-century art. His flat, brilliant flower patterns, made of pieces of colored paper, are a breath of fresh air to those of us who have come to associate flower painting with miniature watercolor boxes and minute sable brushes. These extrovert works are defiant reminders that flower painting can be also be enjoyed in terms of pure color and design.

In this chapter the artists used colored tissue-paper to demonstrate two different approaches to a similar subject. The first collage uses flat graphic shapes, the emphasis being on the design and arrangement of color; the second demonstrates a more experimental approach, using texture and raised color to express the subject.

SCALPEL BLADES

SCALPEL

SCISSORS

CRAFT KNIFE

GOUACHE

Materials

A collage is a picture built up with pieces of paper, fabric and other materials. The technique was much favored by the Cubists, who would glue various materials on to their pictures – including newsprint and other pieces of ephemera – to create images. Their choice of materials was often symbolic as well as visual.

Although some of the more experimental collage materials are perhaps not really applicable to flower painting – a field where color and shape is generally more important than texture and object association – there are, nevertheless, many materials which can be usefully adopted by the flower artist to broaden the scope of the subject.

Matisse developed various collage techniques throughout his life, his later works being the most experimental in terms of materials. In some of his pictures he used gouache, crayon and other materials, combining these with colored paper to bring pattern and texture into the design.

Colored Paper

Papers are available in an enormous range of colors and textures – tissue, crêpe and wrapping paper being just a few of the many types available. Tissue-paper is probably the most popular because its semi-transparency enables it to be built up in layers which can produce various tones of any one color.

Transparent acetates and cellophanes are used to obtain overlapped color effects, but only aerosol glues should be used to attach these,

COLORED INK

TINTED PAPER

TISSUE-PAPER RUBBER CEMENT

STATIONERY GLUE

STICK GLUE

because other glues can be seen through the film.

Most of these papers are relatively cheap, although if you go to art and design stores to buy your materials they will obviously cost more.

Glue

Rubber adhesive is the general favorite, but almost any type of paper glue can be used for collage. Liquid glues tend to be messy – one of the great advantages of rubber adhesive is that it is easy to rub away any excess without marking the paper. Some artists prefer sticks of glue, because they are dryer and don't affect the color of the paper.

Aerosol glues are increasingly popular, but can also be messy because it is not possible to aim them at a specific area. With this type of glue, it is advisable to reserve a special 'gluing area' well away from where you are working.

Mixed Media

Paper collage can be used as a basis for paint, pastel or ink. The advantages to flower painters of using brightly colored paper to establish the local color, before working into this with other materials, is obvious when one thinks of the nature of the subject. Most flowers are extraordinarily brightly colored – more vivid than many artist's pigments – yet they contain fine markings which are more easily applied with a fine brush or pencil.

Cutting Tools

A pair of sharp scissors is essential for cutting tissue and other fragile paper. For thicker materials, such as drawing-paper and cardboard, use a scalpel or other sharp blade.

PASTEL

CREPE PAPER

WATERCOLOR PENCILS

SABLE BRUSH

FINE MARKER

TISSUE-PAPER

Anemones in a Blue Vase

TISSUE-PAPER

These brightly colored anemones in the vivid blue vase are the ideal subject for a tissue-paper collage. The flower petals – in pinks, reds and purples – already suggest a range of tissue-papers, and are so harmonious that they could almost have been chosen from an artists' color chart.

When tissue-paper is overlapped, especially on a bright, white background, you get richer, darker tones of the same color. Many flower petals have this variegated quality naturally, and tissue collage is especially suitable for such subjects.

The anemone petals have light and dark ridges, which the artist conveyed by tearing the tissue into small pieces and overlapping them – where the thickness of the tissue is double or treble, the color is proportionately darker. By this means the subtle shadows on the petals were suggested without any other color being introduced.

A sharp contrast was maintained between the different characteristics of the vase and the flowers. The vase – a clean, curved shape – was cut out of blue tissue-paper with a sharp scalpel. The flowers, with their irregular edges and variegated colors, were torn from different colored tissues to obtain ragged, undefined outlines. The pure, translucent colors of tissue-paper make it ideal for the petals of the brightest flowers – which anemones certainly are. It is less than ideal, however, when it comes to defining the feathery leaves and tiny linear details which are also features of anemones.

For this purpose, the artist chose a finer, drawing technique, using green-colored pencils for the leaves, and colored pencil and black felt-nib for the black flower centers.

1 The natural colors of these bright anemones in the blue vase *right* are reminiscent of the vivid dyes used in tissue paper. They are placed against a pale neutral background which shows up the colors.

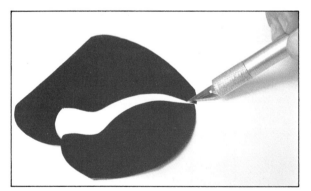

2 Looking carefully at the curved shapes of the reflections, the artist cuts out blue tissue shapes for the vase *left*.

3 The vase is stuck down with stick glue and the artist uses a scalpel to cut out a jagged shape for the overlapping flower *right*.

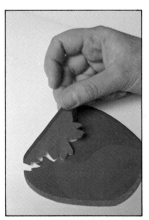

4 The cut-out shape is easily lifted away *left*. Stick glue is probably the cleanest of several possible adhesives, one of its advantages being that shapes can easily be lifted off and repositioned.

5 The artist starts to tear bright red shapes for the flower petals *right*. When working from most natural objects, such as flowers, a torn edge looks more realistic than a hard, cut one.

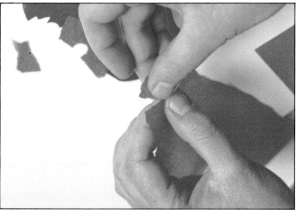

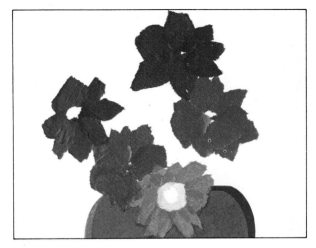

6 The main flower shapes are stuck in position *above*. By overlapping the tissue-paper petals, the artist creates different tones of the same color on every flower – the glue brings out the brilliance of the tissue-paper colors.

7 Once the main shapes are established, it is possible to use a variety of other materials with the tissue paper. The artist put the tiny dots in the center of the anemones with a purple pencil *above right*.

8 The feathery leaves are drawn in with a green colored pencil *below*, providing a contrasting linear element in an otherwise flat design composed chiefly of pure color and simple shapes. Two tones of green, a light and a dark, are used to suggest highlights and shadows on the foliage.

USING STICK GLUE WITH TISSUE

This type of glue is rather inflexible and sticky, but it has the advantage of being compact and clean to use.

Tissue-paper tears easily, so hold the shape firmly and apply the glue from the center outward using firm, light strokes. Any slight pull or tension near the edge of the paper will cause it to tear.

What the artist used

Colored tissue cut with a scalpel and mounted on stiff cartridge paper measuring 18 × 15 inches. Details were drawn with colored pencils.

PURPLE, DARK BLUE, LIGHT BLUE, ROSE, RED

PURPLE

LIGHT GREEN　　DARK GREEN

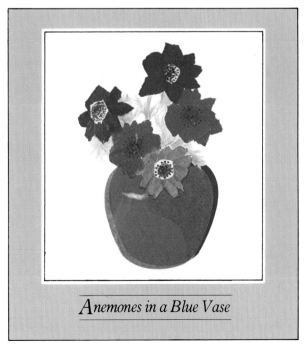

Anemones in a Blue Vase

Tall Anemones

TISSUE-PAPER

Although the subject is similar to the one on the previous pages, the artist here took a slightly different approach.

The result is less graphic, with less importance being attached to the intrinsic quality of the flat colors. Instead, the artist has concentrated on the texture and patterns of the subject, trying to use the medium to express the character of the leaves and petals rather than produce a polished likeness of the subject.

Here the main forms were made entirely from tissue, the leaves being cut with a scalpel to get the fine feathery effect of the anemone leaves. These were stuck down in a crumpled fashion so that the tissue strands were folded in some places, breaking the green down into fragmented areas of light and dark.

As in the previous picture, some of the petals shapes were torn from tissue to provide the characteristic 'uncut' edges. But here, the pale blue flower has been treated differently. Instead of applying the shapes separately, the artist used a folding technique to give the impression of tightly folded petals. The finished flower is slightly raised and has a three-dimensional quality which provides added interest to the image as a whole.

This experimental collage is an invaluable way of investigating the possibilities of the many different materials. Collage is infinitely versatile, and not every attempt will be successful, but only by trying out the different techniques will you eventually develop your own personal way of working.

1 This flower arrangement with the tall anemones against a white background *right* calls for a slightly more adventurous approach than the one on the previous page.

2 The artist uses a sharp scalpel to make the feathery leaves by cutting slits in a piece of light green tissue paper *above*.

3 This leaf shape is stuck on to a piece of stiff cartridge paper with stick glue, and the artist gently molds the tissue into shape with the scalpel point *above right*.

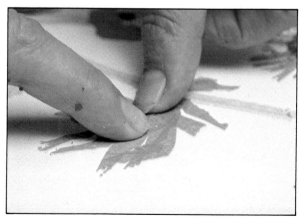

4 The artist presses the leaf shape firmly onto the paper *left*. The tissue strands are arranged so they overlap each other, producing an irregular leaf-like effect rather than a flat cut-out shape. Where there is more than one layer of tissue paper, the tones appear darker.

5 The stems are made from narrow strips of pale tissue *left*, These are cut to the same width but separated slightly before being stuck down to create a rounded, tube-like stem.

6 Small pieces of torn red tissue paper are arranged as a flower head *right*. A fragment of pink is laid over the petals to form the pale center of the anemone.

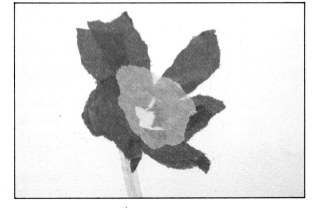

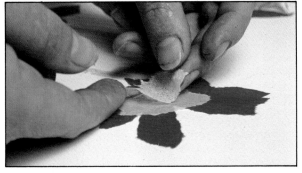

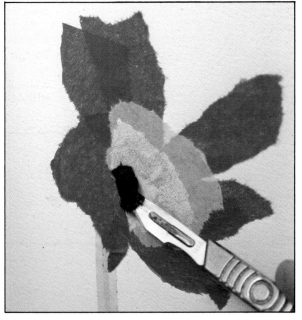

7 A tiny fragment of white tissue is laid over the pink *above*. As each new layer is added the colors underneath show through, producing a subtle, velvety texture similar to the mat quality of the anemone petals.

8 The black center spot is too small to be maneuvred with the fingers and is lifted into position with a scalpel blade *right*. When using stick glue – as the artist is here – it is possible to move the shape around on the design before pressing it into its final position.

USING CRUMPLED PAPER

Collage is by no means restricted to flat shapes of color, and there are a host of exciting materials and techniques which make it one of the most innovative and experimental of art forms.

Here the artist makes a flower by folding and crumpling a piece of tissue paper before sticking it to the support. The handle of the scalpel is then used to lift and mold the tissue into the tightly folded petal forms, causing the flower to stand out from the paper as a relief shape.

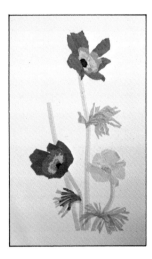

9 The artist continues to work on the flowers, building up each one from pieces of torn tissue paper *left* according to the colors of the actual subject.

10 Even when the tissue has been stuck down, it is possible to cut out several layers at a time with a scalpel to allow the color of the support to show through. The artist cuts out a white shape for the flower center *right*.

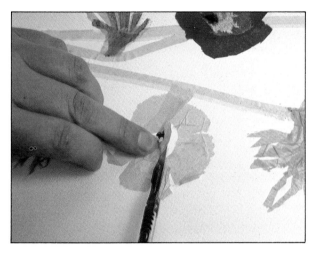

11 The last flower is made from crumpled up paper (see page 157) which brings a three-dimensional element to the collage *right*. The artist achieves this sculptured effect by molding the tissue into shape before sticking it into position on the paper.

12 Tiny dark centers provide focal points to the colorful flowers. Here the artist adds a final touch to the pale pink anemone by giving it a deep purple center *far right*.

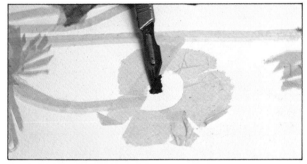

13 Single layers of white tissue can be used for toning down areas which are too bright or too dark – one thickness makes surprisingly little difference to the colors underneath and can be used to obtain very subtle effects. Here the artist uses the technique on one of the flowers *below left*.

14 A flat, pale green shape is used as a basis for the glass vase. A second shape, the same size as the first, is cut from a sheet of white tissue paper. Out of this second piece, the artist carefully cuts away the shape of the curved, dark reflections and sticks this over the green base *below*.

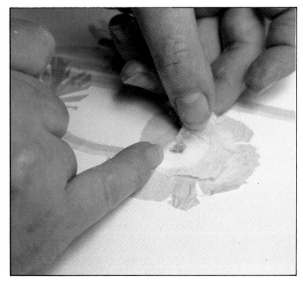

What the artist used

A selection of seven colored sheets of tissue paper was used in this collage. Although most of the flower shapes were torn, a scalpel was used for sharp edges, such as the stem and vase.

Ordinary stick glue, obtainable at most stationery stores, was used to mount the tissue paper on stiff cartridge paper measuring 18 × 15 inches.

TISSUE PAPER

RED

LIGHT PINK

LIGHT BLUE

LEAF GREEN

DARK GREEN

BLACK

WHITE

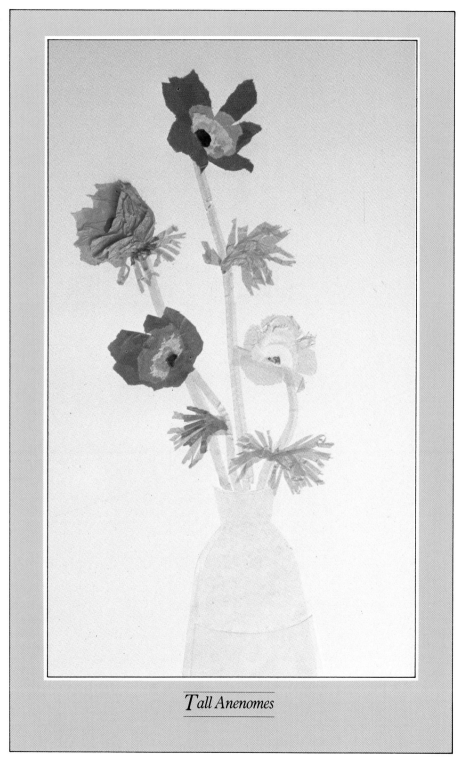

Tall Anenomes

159

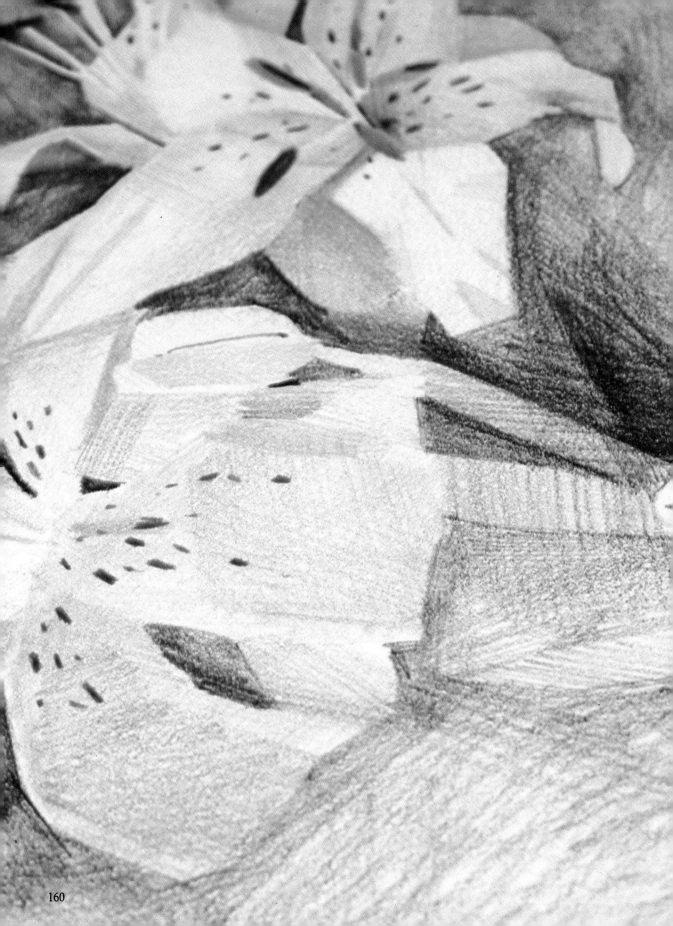

CHAPTER TWELVE

Drawing

The vital key to painting flowers is first being able to draw them. Whether you are doing a preparatory drawing for a painting, or whether you are aiming at a finished drawing, you have to draw the subject. Do not be discouraged by this, for you can follow some simple principles and skill will come with practice.

The essence of drawing is to look carefully at a subject and be able to suggest a sense of mass and volume using line. It means aiming specifically at the fundamental shape and form of an object.

When drawing flowers, it is the structure that counts. Get used to looking at flowers and thinking of them in simple terms. See them as objects which are fragile yet possess volume and definite mass. In this chapter you will be invited to examine the basic construction of flowers in the same way as you would be introduced to anatomy if you were going to draw the human figure. You will need to be aware of the growth patterns of plants and flowers in order to capture their character.

Nowadays there is a mass of material to help you draw. Traditionally, drawing was done with pencil and charcoal. These are still the mainstay of the draftsman's equipment, but a host of new items have been added to the list in modern times, when the ballpoint pen, for which an eighteenth-century writer might have given a fortune, is so easily obtainable that it is treated almost with contempt. Even in the field of the more traditional tools, such as pen and ink, enormous progress has been made by technology, so that you are no longer confined to black or sepia inks, but have at your disposal an array of different hues.

BRUSH PENS

FIBER-
TIPPED PENS

PERMANENT
PEN

CALLIGRAPH
PEN

SANDPAPER BLOCK

Materials

If you are going to learn to draw you can use any material, although each one has its own characteristics and provides a different effect. When learning to draw, you might as well start with a pen or pencil or something cheap. Going out to buy a whole range of expensive equipment will not rescue from the need to sit down and get going!

Soon, however, you will want to experiment with different materials and understand their potential.

CONTE HOLDER

Charcoal and Conté

Charcoal is a good material to start with because it makes you aware of the main characteristics of the shapes. Because it is a heavy, chunky medium, you are forced to concentrate on the bold essentials. For the picture on page 109 the artist used charcoal to sketch in the basic composition of what was later to become a gouache painting of a sprig of ivy.

You can obtain sticks of charcoal made of vine or willow. It also comes in pencil form, and can be bought as dust which is rubbed into the paper to produce areas of tone.

Charcoal tends to smudge while you are working, so take care. It rubs out easily, and the best eraser to use is one made from kneadable putty. When your drawing is complete, spray it with fixative to stop further smudging.

Use charcoal on white paper to get the benefit of extreme contrast between light and dark tones. Rough paper is best because charcoal tends

'SCENE PAINTERS' WILLOW
CHARCOAL

THIN WILLOW CHARCOAL

CONTE

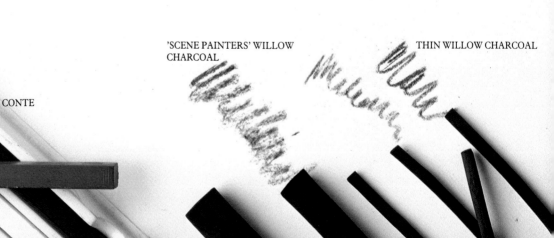

SIGN PEN

ULTRAFINE

PENCILS

PLASTIC ERASER

to slide off a smooth surface. Using charcoal with white chalk will enable you to work highlights into the drawing.

A similar effect can be obtained by using conté, which also comes in broad sticks and is unsuitable for very detailed work. But conté is harder than charcoal, being molded from a mixture of graphite, clay and paste, which makes it easier to manage. Conté is usually available in black, white, sepia and a brownish red.

Pencil

The common graphite or lead pencils are perfectly suitable for your initial excursion into drawing.

A soft lead enables you to draw a broad but blurred line. With hard pencils, you would be aiming at tighter details.

Unfortunately the labeling of pencils varies from maker to maker, but the most common categories run as follows, starting from the very hard: 8H, 7H, 6H, 5H, 4H, 3H, 2H, H, HB, F, B, 2B, 3B, 4B, 5B, 6B, 7B.

Most of the H pencils are for office or technical use. You would be advised to start off with a B or 2B and then choose from among the others for different needs.

Apart from the general categories, you can become more ambitious and use extremely soft pencils which have an unusually broad lead, to get a very black tonal effect. If you use rough paper, for instance, your picture will end up with the same coarse granular texture as the paper surface.

There is no single correct way to use a pencil. Simply follow your natural inclinations. Obviously pressing hard, or using the side of the pencil lead, produces different lines, and none of these ways of working is 'wrong'.

PUTTY ERASER

THICK WILLOW CHARCOAL

CRITERIUM
CHARCOAL PEN

CONDENSED CHARCOAL

Pen and Ink

With the old-fashioned dip pen, you can vary the line as you work, as opposed to the modern ballpoint and felt-nibs where the line is more regular. Many artists prefer the traditional method, but you may want to try both types – the ease with which the modern pens can be used makes them an obvious choice for many occasions.

Any cheap holder will do as long as it is comfortable to hold. When choosing a pen, the vital part is the nib, and you would be well-advised to obtain a variety, enabling you to draw a range of fine, narrow and broad lines. A fountain-pen can be useful for outdoor work because it dispenses with the need to carry bottles of ink around with you.

There are two types of ink: water-soluble and waterproof. With the water-soluble inks you can dissolve the drawn line with water and blend the colors. When using waterproof inks the lines remain intact and will not dissolve once dry, enabling you to develop the drawing by adding color washes without making the lines run.

Waterproof ink dries with a slight sheen, and water-soluble dries with a more mat finish. They both come in a wide range of colors as well as the traditional black.

Felt-nibs, fiber-tipped pens and markers are still developing rapidly, with new versions coming on to the market constantly. Some felt-nibs are made with a flexible tip to give the effect of brush and watercolor, but most of these products produce an uncompromising line, and some artists dislike them for this reason. But they are useful and convenient to carry around, especially for on-the-spot sketchbook work.

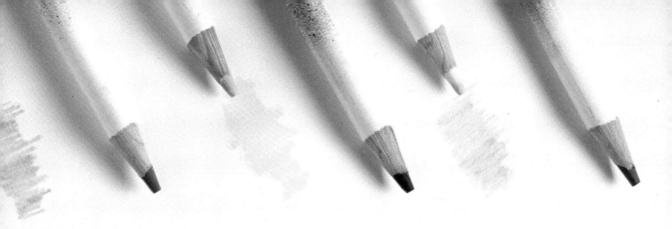

Colored Pencils

These form a compromise between a lead line-drawing and a colored painting. Their range is more restricted than oil paints, acrylic or watercolor, but new sets are coming on the market continually and they are gaining in popularity.

They are softer than lead pencils but are more difficult to rub out, and errors usually have to be scraped off the paper with a blade.

Although you cannot mix the color first, as with paints, you can mix them 'optically' on the paper by lightly overlaying different colors to obtain a range of subtle hues.

Watercolor pencils

These are a cross between colored pencils and watercolor paints. Apply them as colored pencils and then use a fine sable brush dipped in water to blend the colors together, giving the effect of watercolor.

This is especially suitable for the flower artist. You can get controlled and instant color, as you can with colored pencils, but you can also produce a washed effect. An area of color or a line of color can both be produced by the same piece of equipment.

Drafting Pens

For drawing lines of an even thickness use a specially designed pen which has a tubular nib, called a drafting pen. These are particularly good for drawing where shading by hatching and cross-hatching is involved, such as in the narcissus drawing on page 170. Some artists feel that this is an unsympathetic medium, especially for something as organic and natural as flowers. But as our artist demonstrates, this need not be the case, and the narcissus emerges from the sensitive shading as a living image.

Orange lily

COLORED PENCIL

This elegant orange lily is made up of sharp detail and complicated planes of color. Because it was necessary to draw the structure in some detail in order to do justice to the subject, and because the bright color seemed such an important aspect of the flower, the artist decided to use colored pencils.

In many ways this is the ideal medium for the flower artist. Colored pencils can be used for the most precise line drawing, and yet they come in a range of colors which are bright enough to render the very vivid pigments found in many flowers. Alternatively, they can be used lightly to indicate the pale, transparent nature of other varieties.

Nor are you limited to using one color. Two or more colors can be blended on the paper to produce a range of shimmering tones which it is not possible to obtain with any other medium. For instance, if you use yellow and red together, you will have the exact shade of orange which you require, and also be able to see the separate red and yellow strokes on the paper.

This optically mixed color looks more luminous and transparent than would be possible with a flat color, and there are literally hundreds of combinations to be made from a limited set of pencils.

To blend the colors in this way, you must keep the pencils very sharp, otherwise the effect becomes fuzzy and you lose the benefit of the combined colors. Nor must you make the penciling too dense or use too many colors on top of one another, otherwise the drawing gets dull and the surface of the paper becomes clogged. So, keep the pencil strokes light and regular, and restrict your colors to two or three.

The best way to rub out colored pencil is to lightly scratch the paper with a sharp blade – but, beware. This roughened area will be much more difficult to work over, and will pick up color more readily than before.

To avoid mistakes, always work from light to dark where possible. Start with the palest areas, applying the color lightly and evenly, and work up the remaining colors slowly from that point.

Choose a good quality paper with a fairly rough surface. If the paper is too smooth, the surface will not take the color properly, and the result will be slippery and unpleasant.

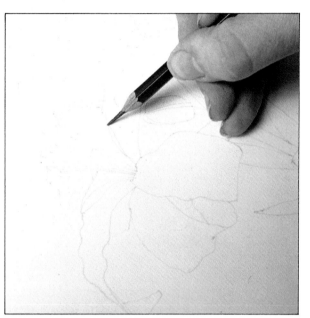

1 The delicate nature of the orange lily *right* is well suited to the subtle and intricate effects which it is possible to produce with a set of colored pencils.

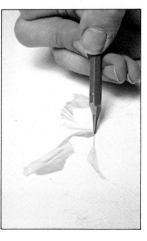

2 First the artist draws the outline with an H pencil *above*. The drawing must be accurate to guide the rest of the work, but need not be detailed – only the stem and petal positions are necessary.

3 Colored pencils should be kept meticulously sharp if a sharp, clear image is to be obtained. The best way to sharpen them is with a scalpel – as the artist is doing *above left*.

4 With a sharp orange pencil the artist adds the color to one of the flowers *left*. The color is built up gradually in layers of lightly rendered strokes, each layer being applied in a different direction. By using several layers of light color instead of applying the orange as one dense layer, the artist captures the fragile, ephemeral color of the flowers.

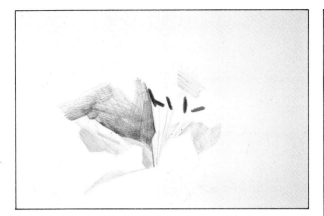

5 Background areas are developed with the flowers *above*. The two are worked on simultaneously, the artist relating the flower and background tones to each other instead of doing the background last.

6 The artist works carefully around the petals with the background color, taking care not to spoil the delicate outline *below*. Short overlapping strokes are used to produce an even texture.

MIXING COLORS

You can obtain any color you want with colored pencils by blending the colors.

Lay the first color in light regular, strokes – if the color is too heavy, other colors cannot be laid on top. Apply the second color in the same way, taking the pencil strokes in the opposite direction.

If you use too many colors, the translucent effect of the blended colors will be spoiled.

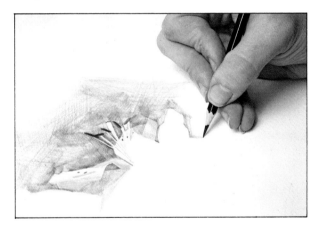

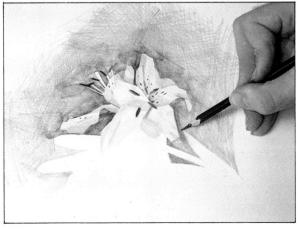

7 The artist extends the background and darkens the tone, bringing it up to the same strength as the newly established flower tones which are added with a combination of blue, brown, black and orange *left*.

8 More color is added to the flowers. Because the color of the stamens varies, the artist looks carefully at the actual subject to see which are bright and which are dark *right*.

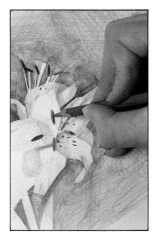

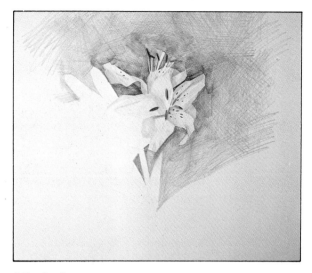
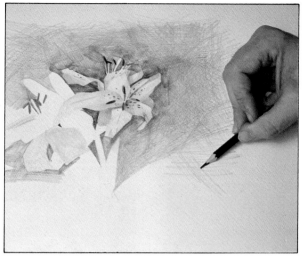

9 The first flower is now complete *above*. Instead of developing the whole drawing at the same time, the artist establishes the main flower in some detail as the center of the picture, with the intention of leaving other flowers in a less finished state.

10 The density of the background color is controlled by thinning out the pencil strokes and applying less pressure *top right*. This enables the artist to make a graded background which fades out toward the edge of the picture *right*.

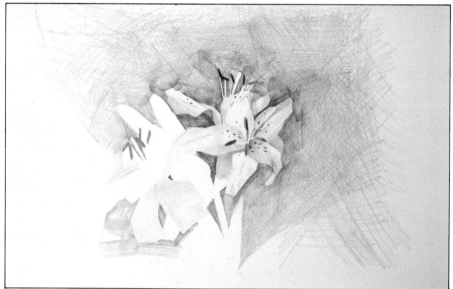

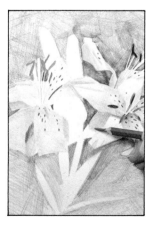

11 Brighter colors are introduced into the flowers and the artist develops the petal shapes by introducing yellow and red *left* and developing the shadows with blue, black and brown.

12 The leaves are added in sap green, lime and black *right*. The artist looks carefully for the light and dark areas on the plant and uses the direction of the strokes to show the shape of the leaves and stem.

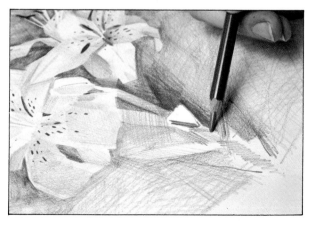

What the artist used

In this drawing the artist used 8 colors from a basic set of 12 pencils – a standard size which is available in art stores.

The support is white cartridge paper measuring 12 × 9 inches, although almost any type of paper is suitable as long as it is not completely smooth. It is possible to achieve many different effects, and a wide variety of textures can be obtained from the different paper surfaces.

In this project a scalpel was used to sharpen the pencils, although craft knives and razor blades are equally efficient. Pencil sharpeners are quicker but seldom achieve the same result.

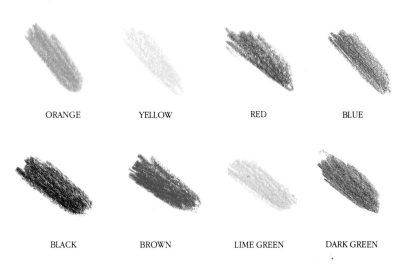

ORANGE YELLOW RED BLUE

BLACK BROWN LIME GREEN DARK GREEN

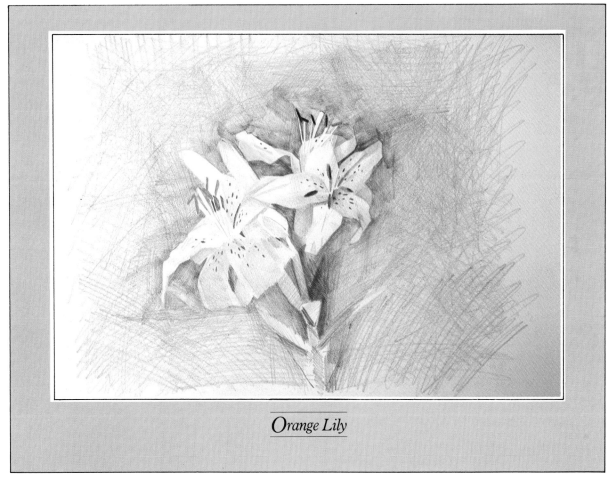

Orange Lily

Narcissi

DRAFTING PEN

The mechanical line of a drafting pen makes it an unlikely choice for the flower artist, but even when drawing flowers, there are some areas where you can actually exploit the clear, regular lines of the drafting pen to good effect.

Although the rigid line is not suitable for drawing individual flowers in any detail, because they are generally too delicate to stand such heavy handling, a drafting pen can sometimes be used to develop a particular type of composition. For instance, in this drawing of the narcissi, the artist used a drafting pen to make the light-colored flowers stand out against a darker background.

This method of developing the background instead of the flowers is a useful one, especially when the subject is rather lacking in tone and color, as was the case with the narcissi. It enables you to structure your composition by developing the negative shapes – that is, by filling up the spaces between and around the flowers, rather than working into the flowers themselves.

Although the flowers were actually placed against a plain wall, the artist decided to break up this large and rather boring background area, and to treat it as a series of tones. The different tones were achieved by patiently building up patches of cross-hatching, from which the flowers gradually emerged as a graphic, white shape.

When working with line, hatching and cross-hatching are your only means of suggesting tone. The method is surprisingly versatile, however, and by varying the number of lines and the distance between the lines, it is possible to obtain a wide variety of tones, ranging from very light to extremely dense.

You must hold the drafting pen upright to draw, otherwise the ink will stop flowing through the tubular nib and you will scratch the paper. While this might seem awkward at first – especially if you have been used to drawing with a dip pen, when the line can be varied by changing the angle of the pen – you will soon get used to holding the drafting pen vertically, and eventually gain absolute control over your drawing.

2 First the artist draws the outline of the flowers with an H pencil *above*. The petals, stalks and flower centers are lightly positioned in relation to each other. This is done with some sensitivity to counteract the rather mechanical line of the drafting pen, and the artist uses loose pencil strokes to establish these main shapes.

3 The background is gradually built up behind the flowers *below*. Using short, firm lines the artist cross-hatches the area in small patches, making dense tone by drawing the lines close together and lighter tone by widening the spaces in between the lines. The flower shapes gradually emerge as the background tones are built up around them.

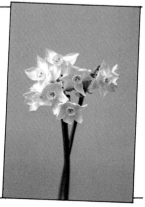

1 Because the narcissi are so light and delicate, they are placed against a darker background *right*. This will enable the artist to develop the areas around the flowers, thus providing a dark tone behind the white narcissi and ensuring that they will be clearly seen.

4 Those background areas closest to the flowers are intensified, care being taken not to lose the frail nature of the petal outlines *above*.

The negative shapes of the narcissi are gradually 'carved' out of the dark background, emerging as delicate organic forms against a solid wall.

CROSS-HATCHING

Cross-hatching is a method of shading with line. By making the lines wide apart, you can indicate a small degree of shade; by making them closer together, your shaded areas will be denser.

Keep the lines regular and evenly spaced, building them up in systematic layers until you achieve the depth of tone you require.

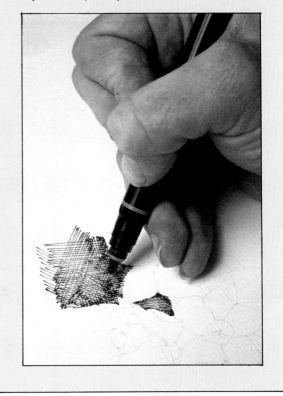

5 The most important background areas – those around the flowers – are developed first *above*. Cross-hatching is the only way to build up tone using line and, although it is a painstaking and lengthy process, it does give the artist maximum control over the work. Here the white wall is broken down into small areas of tone made up of patches of cross-hatching.

6 Moving down the drawing, the artist develops the background behind the stalk *right*. The actual stalk is toned down with diagonal cross-hatching, one side being made considerably darker than the other to indicate the direction of light and to show the flattened form of the stalk. Quite complicated surfaces can be rendered using the wide tonal range available with cross-hatching.

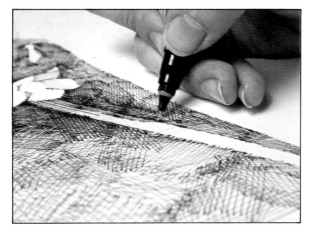

7 The artist develops the recently added background tone, bringing this into line with those already established elsewhere in the drawing *above*.

Because the stalk is a simple, fairly straight line, it is quite an easy matter to render this with the rigid line of the drafting pen. The pen is held loosely, enabling the artist to draw a flowing natural form.

8 A rectangular shape is slowly emerging as the background is taken outward away from the subject *above right*.

9 The artist continues the cross-hatching, extending the background to complete the rectangular shape *right*.

10 Returning to the flowers, the artist emphasizes the shadows of the petals and flower centers *left*. Care should be taken at this stage not to overwork the flowers, which remain light and delicate with the minimum of shading to define them.

11 Here the artist adds the final touches *right*, redrawing and clarifying tones or outlines where necessary to make the drawing work as a whole. Because of its hard line, drafting pen drawing is difficult to erase or correct. It is possible to block out mistakes with white gouache or permanent white but these areas cannot be reworked in ink.

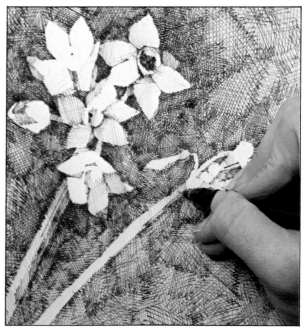

What the artist used

For this drawing chose a 0.4 drafting pen to give a medium thick line. These pens have changeable nibs which produce varying thicknesses of line. The artist used black ink, specially made for this type of pen, and worked on white cartridge paper measuring 18 × 15 inches.

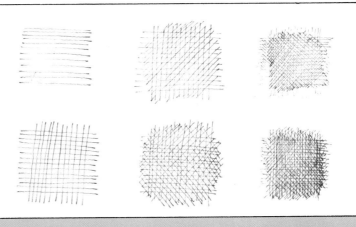

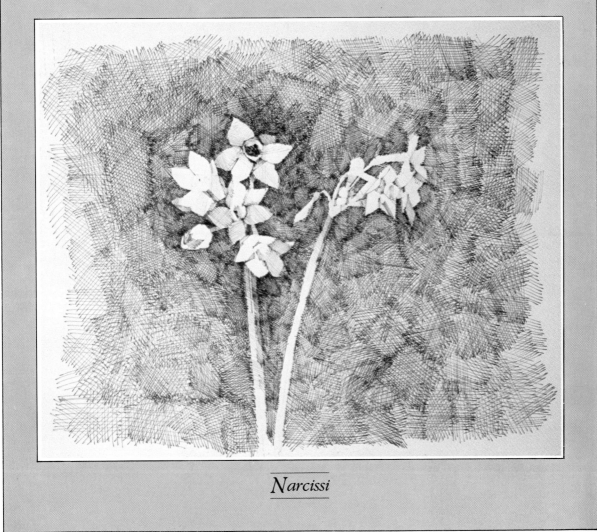

Narcissi

Rhododendron in a Glass Jar

WATERCOLOR PENCIL

Watercolor pencils combine the quality of pencil with some of the qualities of watercolor. As well as being a versatile and convenient medium, they come in a wide range of colors, and are particularly appropriate for fairly detailed work, such as flower drawing.

Apply the color as you would with an ordinary colored pencil, bearing in mind that some of the areas are going to be softened by blending the pencil strokes with water. The water will entirely dissolve light pencil strokes, blending the color until it looks similar to a watercolor wash. However, if you use heavy pencil strokes, the texture will persist and show through the wash.

Here the artist has elected to draw a single flower in a vase. The delicate colors and the complex form of the flower are an ideal subject, demanding sensitive and responsive handling. The artist exploited the fine linear qualities of the pencils by softening some of those lines and finely hatched areas with water – producing a soft, satiny quality which accurately reflects the soft bloom of the petals.

The highly textured background is rendered with a dark pencil, worked freely and loosely across the surface. Water brushed into this highly textured surface softens the effect while maintaining the contrast.

Watercolor pencils require practice and patience before you can feel really happy and confident with them. Do not hope to produce the soft washes of true watercolor, but by experimenting you will find that you are able to produce a range of interesting effects which will enable you to record both the color and structure of complex plants and flowers in this unique way.

The medium is especially useful for sketchbook work. A set of watercolor pencils can be easily carried in your pocket and is ready for immediate use. If necessary, the colors can be blended later.

You can use any good quality drawing or watercolor paper, but if you anticipate large areas of wash, it is advisable to stretch this first to prevent the paper buckling.

2 The outline is drawn in the local color – pink *above*. The right color is important because it will eventually be integrated into the final painting.

3 With even strokes the artist develops the flower picking out the colors with the appropriate pencil. These are blended with a little water on a No. 6 sable brush *left*.

4 The artist refers to the subject constantly, looking closely and selecting each color and tone carefully *below*.

1 Watercolor pencils allow for detailed rendering when blended with water, as well as being suitable for dealing with large areas when used dry.

The rhododendron *right* placed against the dark background offers the artist the opportunity to use both these methods.

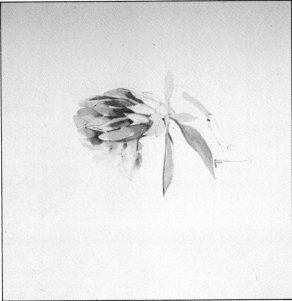

5 Working one area at a time the artist introduces subtle variations into the form in keeping with the delicate nature of the subject *above*. The leaves are treated in the same way, being rendered in a combination of different greens which are then worked carefully together with a wet brush *above right*.

6 Before dealing with the background, the artist draws the outline of the remaining leaf shapes *right*. These will be left as white shapes to contrast with the highly finished rendering on the rest of the plant, so they are not drawn in any detail or with strong color.

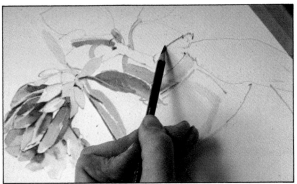

BLENDING WATERCOLOR PENCILS

Watercolor pencils can be blended by working the colors together with a wet paint brush. Here the artist is using a No. 6 sable brush to blend selected parts of the background, so breaking up the large expanse of black into smaller, more interesting areas of contrasting texture.

In this case the water is applied freely, dissolving the heavy pencil lines to produce a lively, random surface. However, the method is equally suitable for the more controlled, detailed effects often required by the flower artist.

7 Using the side of the lead, the artist begins to block in the background area in black *right*. A free, cross-hatching movement is adopted in order to fill the space quickly. The tones closest to the subject are drawn especially densely to enable the light colored flower to show up clearly. This background tone is laid quickly with crude strokes because the artist wants to avoid a large area of flat, regular tone around the subject.

8 Here the artist is blending the background texture with water *left*. The brush is taken right up to the edge of the flower, redefining the delicate petals and leaves with careful, fluid strokes. The brush is moist enough to work easily. Too much water causes flooding and blotches, and too little causes a dry, scratchy effect.

9 Only certain parts of the background are blended *right*. The artist is trying to avoid a flat expanse of black and decides to leave some of the background as textural pencil drawing to contrast with those parts which are smoothly blended.

The silhouetted white shapes lend emphasis to the finer details of the more developed leaves, and the white jar and table surface turn a simple flower picture into a well thought out, graphically composed work. The artist intends to leave parts of the flower deliberately undeveloped and to keep certain areas as empty white spaces. This device is sometimes used to maintain a feeling of spontaneity and to stop a picture looking overworked.

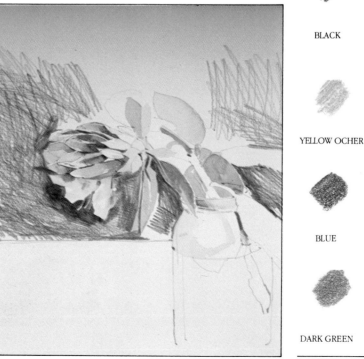

What the artist used

For this picture the artist used watercolor pencils on a piece of stretched cartridge paper measuring 20 × 15 inches. The colors were blended with a little water and a No. 6 sable brush.

DARK PINK

RED

LIGHT PINK

ORANGE

BLACK

BROWN

YELLOW OCHER

PURPLE

BLUE

LIGHT GREEN

DARK GREEN

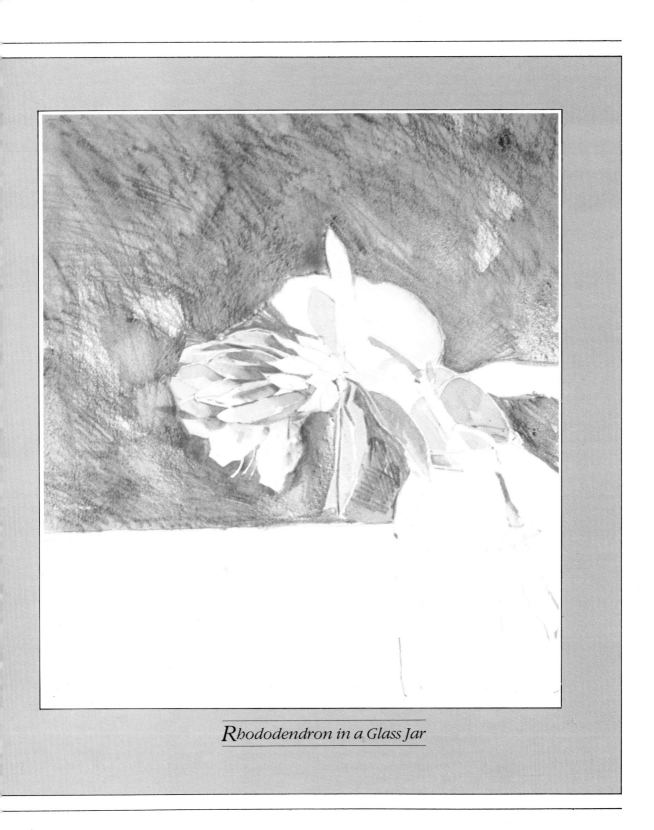

Rhododendron in a Glass Jar

Geranium and Potted Plant

PENCIL

The most common drawing instrument is the lead pencil. You can use it in conjunction with most other media – many painters draw the subject in pencil before adding color – or in its own right, either for quick, rough sketches or to produce detailed, finished drawings.

Because most of us have used pencils since childhood, there is nothing to be 'learned' about them, and we know exactly what sort of marks they can make and what their limitations are without having to stop and think about it. It is precisely this familiarity which makes them so indispensable to almost every artist.

Its versatility makes it universally popular in many fields, but it is perhaps in sketchbooks that the pencil really comes into its own. Whether you are making a quick line-drawing, a thumbnail sketch or merely jotting down visual details which you want to record and use at a later date, a pencil is often the automatic choice.

In the two sketchbook drawings here, the artist used a B pencil, but different types suit different approaches, and the only way to find out which grades suit you best is to try as many as possible. Many artists work with a combination of hard and soft pencils, using slightly harder leads for line-drawing and botanical detail, and softer ones for areas of tone.

The artist wanted to use these sketches as a possible basis for paintings. Therefore it was important for them to be accurate, but not absolutely necessary for the drawings to look finished or include a lot of irrelevant detail. Some broad areas of tone were put in, but the sketches are generally confined to simple line.

Lead pencils are easy to erase, but the habit of rubbing out every mistake is not always a good one. A sketch often benefits from lively redrawing, and a much-rubbed drawing, however accurate, can often seem flat and dull in comparison. A good general rule is to use your eraser only when really necessary, but to resist the temptation to use it all the time.

A good quality drawing-paper is the best support for lead pencil. Bristol board, ivory cardboard or other smooth surface can also be used, but a slight texture often produces a more interesting result.

2 Working on tinted paper the artist first sketches in the direction of the main stem and the position of the flowers *above*. To establish the structure and radiating growth of the plant, the artist accurately draws the shapes of the wedge-like spaces between the stems.

3 The plant is positioned centrally on the paper with enough space around it to ensure the subject does not look cramped *below*. The artist is not aiming at a detailed drawing, rather at an accurate sketch which contains the maximum amount of information.

1 The potted geranium is placed against a white background *right* so the artist can see clearly how the plant grows, the shape of the flowers and the formation of leaves.

4 Keeping the drawing in exactly the same position in relation to the plant, the artist sketches in the smaller stems and leaves *above*. The pencil is sharpened regularly to ensure a clean, clear line.

5 Because the artist refers constantly to the subject, very little correcting is needed *right*. Where necessary the pencil can be erased with a soft eraser, but too much erasing produces a 'dead' drawing and should be kept to the minimum.

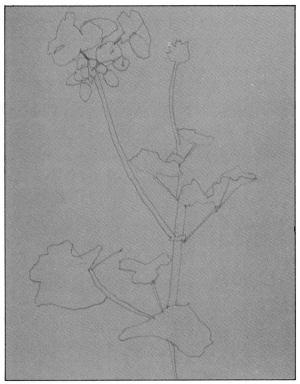

6 With precise, diagonal hatching the artist starts to shade in the dark areas of the stem. Small areas of selected shading are more effective than a lot of overworked pencil marks, and the artist restricts the hatching to the very darkest shadows, using it as a means of describing the form of the subject *above*.

7 The deepest shadows underneath the flower are hatched in a similar way *above*. This very dark shadow emphasizes the structure of the bloom and helps to describe the space occupied by the small radiating stems which carry the flower heads. The completed drawing is a simple, yet accurate, study of a growing form *right*.

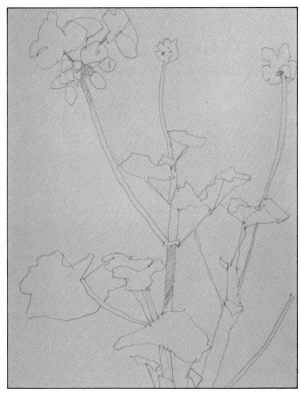

1 The artist liked the potted plant exactly where it was – on the window sill – so there was no need to 'arrange' it. As the light is behind it, the plant is seen almost in silhouette, emphasizing the importance of the shape of the leaves *right*.

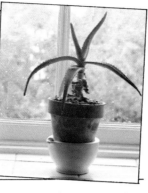

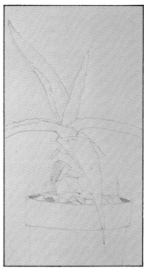

5 The artist draws the plant pot *left*. Again this is done simply, using the minimum amount of line and tone necessary to create a convincing image.

6 The finished drawing shows the potted plant in its proper setting *below*. Sketchy lines are all that are necessary to suggest the window frame and sill, thus transforming a simple plant drawing into a still-life. The background lines are deliberately oversimplified in order to retain the plant as the most important element in the drawing.

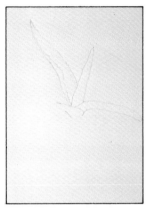

2 A B pencil is used to outline the leaves *left*, each one being carefully positioned in relation to its neighbor.

3 The shadows are indicated in neat, parallel hatching – the artist indicates the shaded side of one of the succulent leaves *below*, using the tone and direction of the lines to describe the shape and form of the subject.

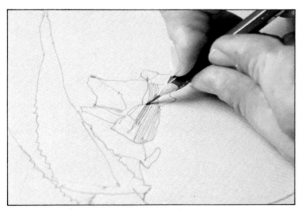

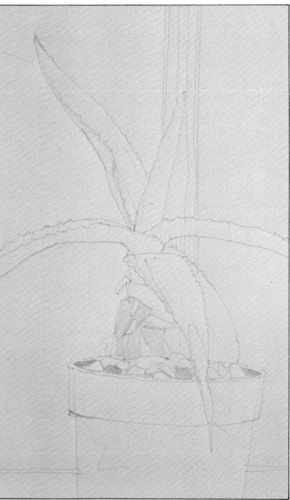

4 With very little shading so far the artist has managed to suggest solidity and form as well as capturing the living, growing aspect of the subject *left*. It is quite possible to achieve all the textures, shapes and tones present in nature with a lead pencil alone.

DIFFERENT EFFECTS

A huge range of effects can be achieved using different pencils and papers. Here are just a few of the marks and textures which can be made, but you will probably want to develop your own techniques by experimenting with hard and soft leads on various paper surfaces.

A pencil rubbed over paper laid on a textured surface will pick up that texture, whether it is stone, wood grain or an engraved metal surface. This facility, sometimes referred to as 'frottage', is worth exploiting, and a wide variety of patterns and designs, both natural and manmade, can be obtained using this simple method.

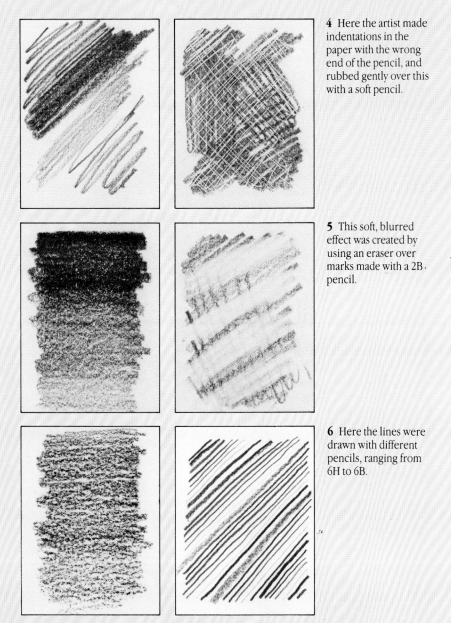

1 Lead pencils are extremely adaptable, and a great many effects can be obtained. These marks were made with a 2B pencil.

2 This graded tone was made on fairly smooth paper with a 4B pencil.

3 The same marks on a coarser paper produce a granular, textured effect.

4 Here the artist made indentations in the paper with the wrong end of the pencil, and rubbed gently over this with a soft pencil.

5 This soft, blurred effect was created by using an eraser over marks made with a 2B pencil.

6 Here the lines were drawn with different pencils, ranging from 6H to 6B.

Thistle

INK

Although ink has its own section in this book, we felt it should be included in the drawing section as well. In Chapter Ten we saw how ink can be used with a brush, in much the same way as watercolor. But in this thistle drawing, the artist used a dip pen and worked mainly in line and cross-hatched shading to create an image.

Pen and ink is ideal for tight, detailed work and dense cross-hatching, but you can also use it more informally by allowing the occasional 'accidental' effects of smudged lines and running colors to bring life to what could otherwise be a rather predictable flower study.

Here the artist has successfully combined the two qualities, using a controlled but irregular line to capture the characteristic spiky shape of the thistle, but at the same time allowing unexpected pools of color and bleeding lines to become part of the overall picture.

There is no reason why you cannot use a brush to add diluted washes of color to a pen and ink drawing. Try to apply these areas of color quite freely, using the line-drawing as a guide, but without feeling that the wash has to be absolutely contained by the drawn outline. Your drawing will benefit if you use the color in a slightly irreverent way, allowing the brushstrokes to become part of the drawing. If you are too careful and meticulous with this type of flower drawing, you run the risk of ending up with a botanical illustration instead of a lively interpretation of the subject.

With the dip pen you can vary the thickness of the line quite easily. By pressing harder you will create a thicker, heavier line, and by holding the pen lightly, you will get a fine, light line. Different nibs produce different effects, and you really need to practice with a selection of them in order to have the full range of possibilities at your disposal.

In the thistle drawing, the artist used a medium nib pen to describe the fine linear details. These were drawn on top of the color wash before the wash was completely dry, causing the lines to merge slightly with the damp color. The resulting soft, blurred lines make the details seem an integrated part of the flower, rather than a series of afterthoughts.

1 Pen and ink is well suited to fine line and cross-hatching. Combined with transparent washes of color, it is ideal for the tight detail and spiky character of this thistle *right*.

2 The general outline of the plant is described first with diluted green ink, then again in red and black *above*. By dipping the pen in water before loading it with ink, the artist is able to get an irregular, diluted color which makes an undulating, natural outline.

3 A rough outline in green is created as the artist moves the pen freely down the image. No attempt is made to obtain a careful rendering – instead, the pen is dragged loosely across the paper *left*.

VARYING THE LINE THICKNESS

You can vary the thickness and character of your lines by using the pen in different ways, and to some extent the thickness of the lines is determined by the amount of pressure you apply when you draw. For instance, if you press hard, the line will be thick and heavy; if you hold the pen lightly, you will get a finer line.

An alternative way of getting a broader line is to turn the pen on its side, causing the nib to spread slightly and make a thicker line as it is pulled across the paper. This method is used to make a flowing, undulating line.

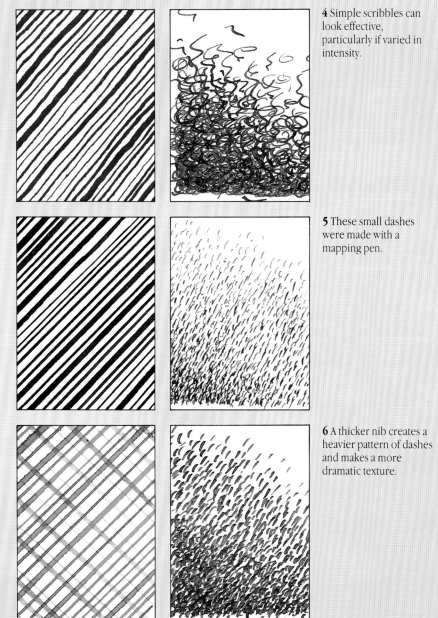

1 Lines of varying widths can be made by using different nibs. These were drawn freehand.

2 These lines of varying widths were done with a ruler to give extra precision.

3 This criss-cross pattern was done with a ruler using nibs of different widths.

4 Simple scribbles can look effective, particularly if varied in intensity.

5 These small dashes were made with a mapping pen.

6 A thicker nib creates a heavier pattern of dashes and makes a more dramatic texture.

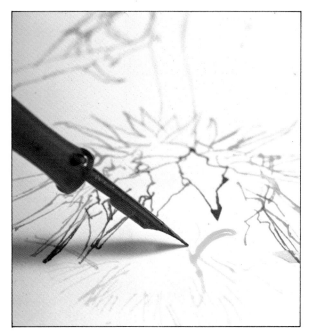

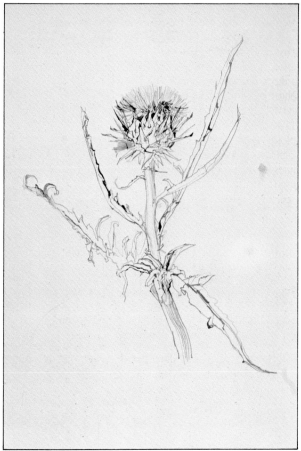

4 Although a medium nib is being used, a thick line is produced by turning the pen on its side and pulling it across the surface *above.*

The artist is holding the pen as loosely as possible to avoid a tight drawing. Instead the texture of the paper and the flow of ink dictates the nature of the line, and unexpected 'mistakes' become part of the image.

5 The blue flower is put in with quick directional, strokes; the outline is redrawn and emphasized in black *right.* Again, no attempt is made to get a smooth line and the artist allows the nib to catch on the paper.

6 After allowing the line to dry partially, a light wash of green ink and water is used to block in quickly the general color areas *left.* This is applied quite freely with a No. 2 sable brush, and the wash is allowed to dry unevenly in light and dark patches.

7 The artist describes the final details of the thistle over the light green wash *right.* Because the wash is only partially dry, the line bleeds slightly into the surrounding color to make a jagged, irregular line as the nib is dragged across the surface of the paper.

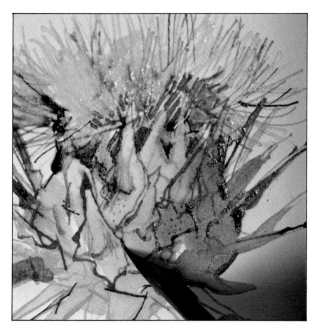

What the artist used

The colored inks used in this drawing were applied with a dip pen and a medium nib onto a piece of stretched white cartridge paper measuring 14 × 19.5 inches, the artist exploited the slightly textured paper to make jagged, irregular lines. A No. 2 sable brush was used to lay the wash.

APRIL GREEN

BLACK

BLUE

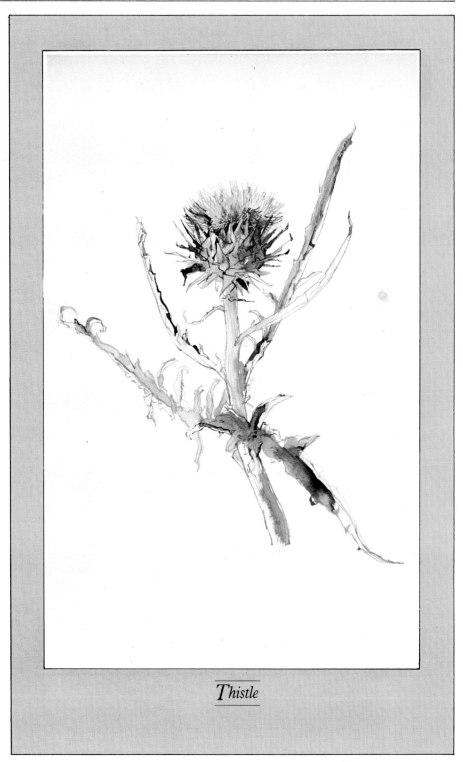

RED

Thistle

Glossary

ABSTRACT EXPRESSIONISM A form of Abstract Art and Expressionism which encourages the subconscious to express itself.

ACRYLIC A comparatively new paint in which the pigment is suspended in a synthetic resin. It is quick-drying, permanent and colorfast.

ALLA PRIMA Direct painting in which the picture is completed in one session without any underpainting or underdrawing.

ART NOUVEAU A decorative style of art of the 1890s in which natural forms such as flowers and plants were made into elegant designs.

BLEEDING The effect of color running when wet. Sometimes used deliberately for its marbled effect.

BLENDING Merging colors together in such a way that the joins are imperceptible.

BLOCKING IN The initial stage of a painting when the main forms and composition are laid down in approximate areas of color and tone.

CLASSICAL METHOD A painting technique which involves making a Monochrome underpainting before adding color.

CLASSICISM Adhering to the basic principles of Roman and Greek art.

COLLAGE A picture made up from pieces of paper, fabric and other materials glued on to canvas, paper or some other support.

COMPOSITION Arranging and combining different elements to make a picture.

CONTE Drawing material made from graphite, clay, paste and water and compressed into sticks.

COVERING The covering power of a paint refers to its opacity.

CROSS-HATCHING A method of building up areas of shadow with layers of criss-cross lines rather than with solid tone.

DARK AGES The years of barbarism and confusion following the downfall of the Roman Empire.

FIXATIVE Thin varnish which is sprayed on drawing media, especially charcoal and pastel, to prevent smudging and protect the surface.

FRESCO A wall-painting technique usually done with watercolor on damp plaster.

FUGITIVE A term given to dyes or paints whose color is short-lived, either through natural defects or natural forces such as sunlight.

GERMAN EXPRESSIONISM A rejection of Impressionism in favour of a more emotional style achieved by exaggeration and distortion of color and line.

GLAZING Using a transparent film of color over another pigment.

GOLDEN SECTION A geometric proportion used by artists since classical times, and thought to produce the most harmonious composition.

GOUACHE An opaque watercolor similar to poster paint.

GRAPHITE A carbon which is used with clay in the manufacture of lead pencils.

GUM ARABIC Used with inks and watercolors to give body and sheen. Obtained from the gum of acacia trees.

HATCHING A shading technique using parallel lines instead of solid tone.

HERBAL A book on herbs and their medicinal properties.

IMPASTO The thick application of paint or pastel to the picture surface in order to create texture.

IMPRESSIONISM A movement founded in France during the late 19th century which aimed at a naturalistic approach by depicting the atmospheric effect of light using broken color.

INK STICKS Originating from China and Japan, these sticks of solid ink are ground down on an inkstone and mixed with water before use.

LITHOGRAPHY A method of printing from the surface of a stone slab. An oily ink is painted or drawn on to the lithographic stone. Water is applied which is absorbed by the porous, non-greasy areas of stone. This means that when any greasy pigment is applied it will stick to the oily image but be repelled by the water elsewhere, so that only the drawn image is printed.

LOCAL COLOR The actual color of the surface of an object without modification by light, shade or distance.

MASKING The principle of blocking out areas of a painting to retain the color of the support. This is usually done with tape or masking fluid, and leaves the artist free to paint over the masked areas. The masks are removed when the paint is dry to reveal the areas underneath.

MEDIUM In a general sense the medium is the type of material used, such as oil paint or charcoal. More specifically, a medium is a substance mixed with paint or pigment for a particular purpose or to obtain a certain effect.

MING DYNASTY A period of Chinese history (1368-1644) renowned for its artistic and scholarly achievement.

MIXED MEDIA The technique of using two or more established media, such as ink and gouache, in the same picture.

MONOCHROME A painting done in just one color, black and white.

MOSAIC A picture built up of tiny fragments of colored pieces, traditionally tile, but sometimes done with paper or other materials.

NATURALISM The representation of a subject in a life-like way, rejecting exaggerated and distorted stylizations.

NEGATIVE SPACE Drawing or painting the space around the subject rather than the subject itself.

OPACITY The ability of a pigment to cover and obscure the surface or color to which it is applied.

OPTICAL MIXING Mixing color in the painting rather than on the palette. For example, using dabs of red and yellow to give the illusion of orange rather than applying a pre-mixed orange.

PAINTERLY The use of color and light to create form rather than relying on outline.

PALETTE This term describes both the flat surface used by the artist to put out and mix colors and the color selection used by the artist.

PIGMENT The actual coloring substance in paints and other artists' materials.

PLANES The surface areas of the subject which can be seen in terms of light and shade.

PRIMARY COLORS In painting these are red, blue and yellow. They cannot be obtained from any other colors.

REALISM Art which takes its subject matter from everyday life.

RENAISSANCE The cultural revival of classical ideals which took place in the 15th and 16th centuries.

RENDER To draw or reproduce an image.

SEPIA A brown pigment traditionally made from cuttlefish.

SIZE A gelatinous solution such as rabbit skin glue which is used to prepare the surface of the canvas or board ready for priming and painting.

STENCIL A piece of cardboard or other material out of which patterns have been cut. The pattern or motif is made by painting through the hole.

STILL-LIFE A picture of inanimate objects – including flowers and plants. The subject did not really exist in its own right until the 16th century.

STIPPLE Painting, drawing or engraving using dots instead of lines. A special brush is used for stippling paint.

STIPPLE ENGRAVING A method of engraving invented by the French artist Pierre-Joseph Redouté which produced tone rather than line and was particularly suitable for flower printing.

SUNG DYNASTY The period in China between 960 and 1279 particularly famous for its 'bird-and-flower' paintings.

SUPPORT A surface for painting on, usually canvas, board or paper.

SYMBOLISM Representation of themes and ideas by symbols. A lily, for instance, was used in painting to represent purity.

TORCHON A rolled paper stump, or bought equivalent, used for blending charcoal and pastel.

UNDERDRAWING Preliminary drawing for a painting, often done in pencil, charcoal or paint.

UNDERPAINTING Preliminary blocking in of the basic colors, the structure of a painting, and its tonal values.

WASH An application of ink or watercolor, diluted to make the color spread transparently and thinly.

WASH-OFF A technique in which the subject is first painted in gouache and then the whole paper covered in waterproof Indian ink. When the paper is held under running water, the gouache dissolves, leaving the original image as a negative shape against a black background.

WATERCOLOR CONCENTRATE Very strong watercolor pigment which is diluted with water before use.

WET INTO WET The application of watercolor to a surface which is still wet to create a subtle blending of color.

WET INTO DRY The application of watercolor to a completely dry surface causing the sharp, overlapping shapes to create the impression of structured form.

Index

Credits

QED would like to thank all those who have helped in the preparation of this book. Special thanks to Ian Sidaway for expert advice and the use of his studio, and to the staff of Langford and Hill Ltd for their patience and generosity in lending materials and items of equipment.

Contributing artists
pp *54-7, 76-9* Mark Churchill; pp *58-61* Gordon Bennet; pp *62-5, 72-5, 80-5, 100-3, 112-5, 166-9, 170-3, 174-7, 178-81* Ian Sidaway; pp *92-5, 96-9, 104-7, 116-9, 132-5, 140-3, 154-5* Nicki Kemball; pp *108-11* Judy Martin; pp *124-7, 144-9* Dietrich Eckert; pp *128-31* Victoria Funk; pp *156-9* Jan Howell

Other illustrations
pp *6, 8, 10* E and T Archives; pp *11, 12, 13, 14, 15, 16-7, 18, 19* The Bridgeman Art Library; pp *26, 28, 29, 30, 32* Rosalind Hewitt; pp *35, 36* Mac Campeanu; pp *40-1, 43, 44-5, 46* Ian Sidaway.